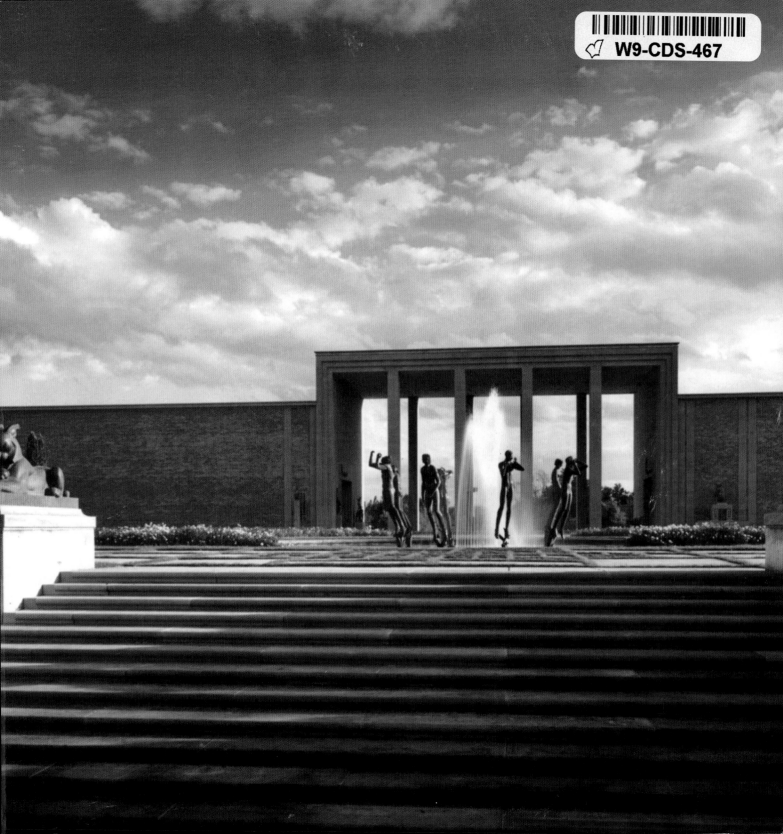

TABLE OF CONTENTS

PREFACE
Gerhardt Knodel

Everyone who recalls their first visit to Cranbrook Art Museum remembers standing on the Peristyle overlooking the fountains, landscape and sculpture that unite the studios of the Academy of Art with the Art Museum. Visitors often say they sense being in a place of uncommon experience, a place that seems to radiate potential and inspiration. Now in Cranbrook's centennial year, we sustain the dreams of our founders by nurturing one of the most important centers for new art in America.

George and Ellen Booth believed in art as a vital manifestation of human existence. As collectors and builders they actively nurtured and supported the creative work of artists, designers and architects. As responsible citizens of a growing country, they also established a place of public access to that work. At Cranbrook they built an interactive Academy and Art Museum, an idea that has blossomed and become more relevant with the passage of time.

It is no accident that Cranbrook Art Museum and its collections are physically connected to the community of Academy studios. In the Academy environment, the Museum's exhibited works become active agents in generating art of the future. As new works stand side by side with works from the past, their historic authority and cultural values are constantly re-evaluated. The power of art is accelerated in the active minds of young artists and, once discovered, it is sustained by them. The best of art lives again in each succeeding generation.

From the earliest days of his interest in collecting art, George Booth respected the power of objects as sources of aesthetic pleasure, inspiration and challenge. Following his passing in 1949, his son Henry Booth would recall for generations of Academy students his father's mantra of intention: to nurture the best that is possible in fields of art, design and architecture by example. The profound belief in art's ability to produce and inspire knowledge and passion through primary experience established the Booths' collections as essential resources for students of the Academy and their mentors.

It is especially exciting to view the work presented in this catalogue and the centennial exhibition *Cranbrook Art Museum: 100 Treasures*, not only as a sampling of powerful instruments of culture reflecting the values of the institution that houses them, but as living instruments for learning. The Cranbrook Collection functions within a vital community of practicing artists, designers and architects who mine the past for challenges that trigger creativity in new ways.

This catalogue also offers opportunities for discovering how the institution has grown in recent years. Gregory Wittkopp's essay on the evolution of Cranbrook Art Museum provides insights into a dynamic institution that by its nature continues to unfold. Faced with prosperity or adversity, it has adapted in productive ways to evolving needs. With important recent additions to the permanent collection and the vitality of contemporary exhibitions available to ever-growing audiences, a roster of new publications, an expanded architectural environment, and dedicated public and private support, Cranbrook Art Museum and its *100 Treasures* truly can be viewed as a link between extraordinary accomplishments and the potential they inspire.

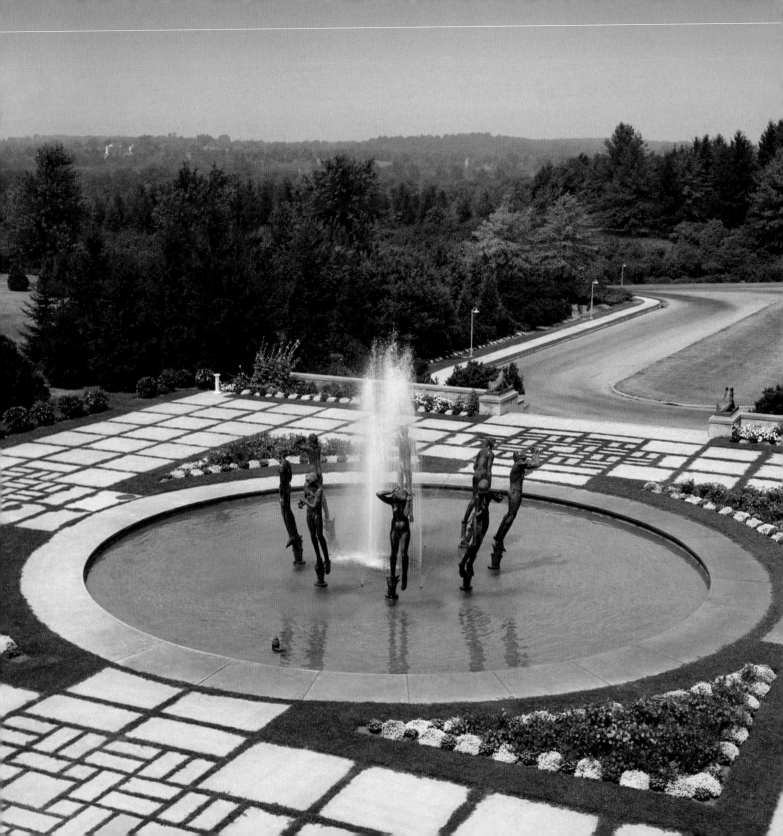

ACKNOWLEDGMENTS

Gregory Wittkopp

The realization of *Cranbrook Art Museum: 100 Treasures* as an exhibition and this catalogue—the first comprehensive guide to our collection—was an enormous undertaking that could not have happened without the hard work of many people. My heartfelt thanks go to all of my colleagues at the Art Museum, in particular Joe Houston and Ellen Dodington. My own understanding of our collection has been profoundly enhanced by the knowledge they shared as, together, we selected the 100 treasures and researched and produced this catalogue. The team also includes Roberta Frey Gilboe, who, as always, tackled a myriad of details with calm professionalism, George Doles, Elena Ivanova, Denise Collier, Vanessa Glasby, Fabio Fernández, Carol Cleaver, and Academy interns Jung Kim and Bryan Ellis. While I do not have the space to enumerate the many ways each of them contributed to this project, I am indebted to them for their tireless (and at times sleepless) commitment to this project. We also received valuable support from Judy Dyki, Alice Elwood, Mary Beth Kreiner, Felicia Molnar, Mike Paradise and Kathy Willman at the Academy; Steve Hoffman in Cranbrook's Public Relations office; and, most crucially, Mark Coir, Leslie Edwards and Diane Schmale at Cranbrook Archives.

At the core of this catalogue are the photographs of the 100 treasures, expertly produced by Shell Hensleigh and Tim Thayer, and the 100 essays. In an effort to break down the often monolithic curatorial point of view of "the museum," the essays were written by 30 different scholars and artists associated with Cranbrook. The authors' perspectives and insights will reward everyone that reads these essays, and are evidence that our collection engages a wide and diverse community. I also thank our editor, Dora Apel, for the skill and care with which she massaged these essays, helping all of us to more clearly and concisely express our thoughts. A special thank you goes to our designer, Kathryn Ambrose, who graciously accommodated our tight schedule and again turned our images and words into a sumptuous book.

This project would not have been possible without the guidance of our Board of Governors and the Museum Committee. Under the leadership of Maxine Frankel and David Klein, and with the support of Cranbrook President Rick Nahm and Academy of Art Director Gerhardt Knodel, the governors and Museum Committee have championed the development of our collection. I also thank Adele and Michael Acheson, Maggie and Robert Allesee, Jonathan and Sheri Boos, Joanne Danto, Keenie and Geoffrey Fieger, David Klein and Kathryn Ostrove, Gilbert and Lila Silverman, and Pamela Applebaum Wyett for their generous sponsorship of the exhibition and catalogue. We also warmly appreciate the many corporations and individuals that have supported this project, including our presenting sponsors American House and Standard Federal Bank as well as Artpack Services Inc. & A.I.R., Herman Miller, The Locniskar Group and the other individual sponsors acknowledged at the end of this catalogue.

Most of all, I am grateful to the artists and patrons that originally donated most of these 100 treasures to the Art Museum, beginning with George and Ellen Booth. Without their generous gifts, and belief in the vital role that the Art Museum plays in educating both Academy students and the broader public, an exhibition and catalogue like this would not have been possible.

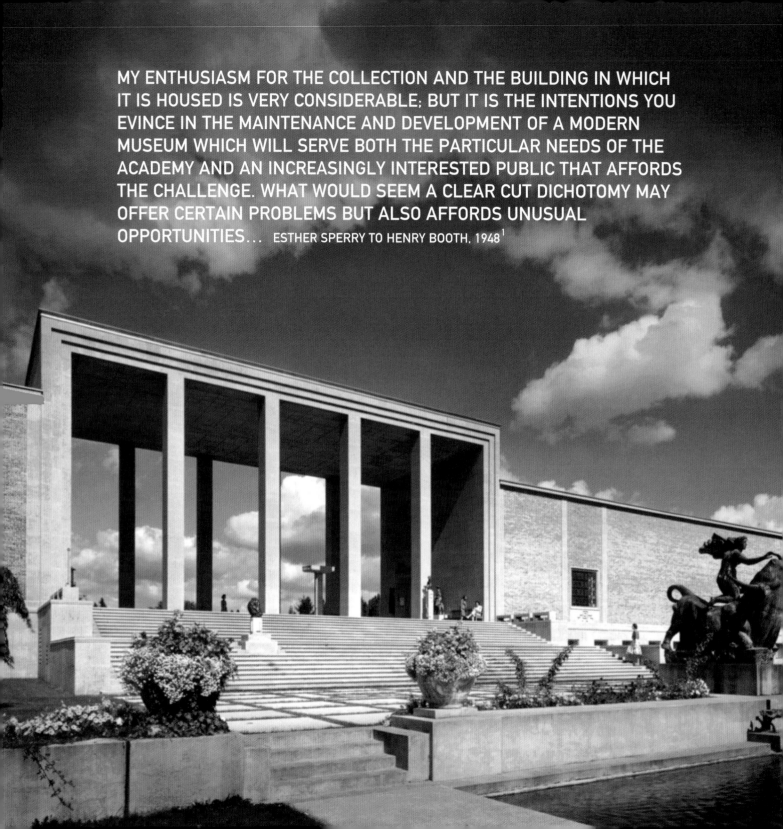

MY ENTHUSIASM FOR THE COLLECTION AND THE BUILDING IN WHICH IT IS HOUSED IS VERY CONSIDERABLE; BUT IT IS THE INTENTIONS YOU EVINCE IN THE MAINTENANCE AND DEVELOPMENT OF A MODERN MUSEUM WHICH WILL SERVE BOTH THE PARTICULAR NEEDS OF THE ACADEMY AND AN INCREASINGLY INTERESTED PUBLIC THAT AFFORDS THE CHALLENGE. WHAT WOULD SEEM A CLEAR CUT DICHOTOMY MAY OFFER CERTAIN PROBLEMS BUT ALSO AFFORDS UNUSUAL OPPORTUNITIES... ESTHER SPERRY TO HENRY BOOTH, 1948[1]

CHALLENGES AND OPPORTUNITIES
The Evolving Mission of Cranbrook Art Museum
Gregory Wittkopp

INTRODUCTION

On January 18, 1904, George and Ellen Booth purchased 175 acres in rural Bloomfield Hills and set into motion a vision that ultimately transformed their vacation property into one of the nation's foremost educational communities (fig. 1). At the heart of what is now Cranbrook Educational Community stands its Art Museum, almost seventy-five years old and one of the older art museums in the nation. This essay traces the tumultuous history of Cranbrook Art Museum, from the evolution of the private collection of founding patron George Booth to what is today Michigan's largest museum devoted exclusively to modern and contemporary art, including artistic high points and near permanent closure. While this catalogue celebrates the Art Museum's collection at the time of Cranbrook's centennial, my goal in writing this essay is to focus on the Art Museum's evolving mission within the context of Cranbrook Academy of Art and the pressures exerted by fiscal needs and disparate audiences—the challenges and opportunities that exist when a public art museum is an integral part of the mission of a private art school. These creative tensions led to crucial moments when the mission and collection policies were defined, contested and redefined. This history begins with Cranbrook's founding patrons, George and Ellen Booth.[2]

GEORGE BOOTH AND THE ARTS AND CRAFTS MOVEMENT AT CRANBROOK

George Gough Booth (1864-1949) began his career as a salesman and designer for an ornamental ironworks company in neighboring Windsor, Ontario, eventually purchasing the firm at the age of twenty.

Although it was a lucrative business, it was his marriage in 1887 to Ellen Warren Scripps (1863-1948), the daughter of James E. Scripps, founder of the *Detroit Evening News*, that provided the opportunities that made them millionaires through newspaper publishing. A year after their marriage, Booth became business manager of the newspaper, then general manager and finally president of The Evening News Association in 1906 upon Scripps's death. Booth was to remain in this position until 1929 when he retired in order to devote all his time to the development of Cranbrook. At the same time, he was developing what became the Booth Publishing Company, an enormously profitable chain of nine Michigan newspapers.[3] With his fortune assured, he could devote himself to his passion, the arts.

From the turn of the century onward, George Booth had been one of the leading proponents of the Arts and Crafts movement in America. Not only was he a founding member and the first president of the Detroit Society of Arts and Crafts in 1906, but he also was instrumental in the formation of the Society's Art School which survives today as the College for Creative Studies. Although the idea of realizing the ideals of the Arts and Crafts movement and forming a community at Cranbrook where artists could live and work may have been discussed earlier, it took concrete form in 1927 when he donated a sizeable portion of his assets, both money and much of the estate he named Cranbrook, to be used as an educational and cultural center with The Cranbrook Foundation as the governing body. At the first meeting of the Board of Trustees he announced the formation of both an Academy of Arts and a School of Arts and Crafts.

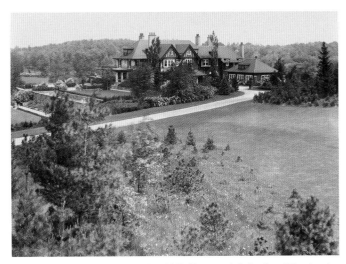

Figure 1: Cranbrook House, circa 1915. Photograph Collection of Cranbrook Archives (E455).

Although the Academy would not open until 1932, the nucleus of the Academy was formed when the Craft Studios opened in the fall of 1929 with the group of artists and craftsmen that he gathered together to help design and embellish the various Cranbrook institutions under construction at that time. The initial appointments included a printer, weavers, a silversmith (Arthur Nevill Kirk, represented in this catalogue), a cabinetmaker, an ironworker and a bookbinder. Booth made one additional appointment in 1932, that of Wayland Gregory (also represented in this catalogue), to head the Ceramic Sculpture Studio. Although Booth hoped that the Craft Studios would become self-sufficient, the artists initially were given a salary, a free residence, and the promise of commissions from Booth. They also accepted a few apprentices, establishing an educational role for their studios. The work that these artists produced at Cranbrook has a common thread. Although the Modern movement was swiftly developing by the late 1920s, Booth and the artists he appointed to the Craft Studios remained inspired by classical and medieval forms and the ideals of the Arts and Crafts movement.[4]

With the exception of Studio Loja Saarinen, a commercial weaving studio opened by Loja Saarinen at Cranbrook in 1928, the Craft Studios officially closed in 1933 in the midst of the Depression. But there were already philosophical issues that had been leading to their reconceptualization as Cranbrook Academy of Art. By the time the Academy of Art officially opened in 1932 (for the first decade as a division of The Cranbrook Foundation), Booth and Eliel Saarinen, the Academy's first president, had realized that by maintaining both an academy of "fine arts" and a school for the "arts and crafts," they were enforcing a separation with which they were not comfortable. Both men were committed to the development of the applied arts and believed that they were of equal importance with the fine arts. With the closure of the separate Craft Studios, the Academy consolidated its commitment to an integration of the fine arts and the crafts that has lasted to the present day.

THE INTERTWINED COLLECTIONS OF THE ART MUSEUMS IN DETROIT AND BLOOMFIELD HILLS
Cranbrook Museum, 1930-1932
In 1927 Booth formally presented to The Cranbrook Foundation a portion of his personal collection of art objects as well as books on art and architecture. These collections found a home in the building designed by George and Ellen's son Henry Booth and his partner J. Robert F. Swanson (Pipsan Saarinen Swanson's husband) at the northwest corner of Lone Pine Road and Academy Way (fig. 2). The collection was an eclectic mix of art and artifacts spanning the centuries, including stained glass, architectural fragments, sculpture, paintings, ceramics, glass, furniture, textiles, metalwork and known reproductions. In the winter of 1930 the Academy of Art published the first inventory of the "Cranbrook Museum" and the collection opened for the use of the art students at Cranbrook and the enjoyment of the residents in the surrounding communities (fig. 3).

In an interview that was printed that winter in the *Detroit News*, Booth outlined the mission of

his Museum which was meant to serve both students and the larger public community and to emphasize the acquisition of contemporary art; at the same time he was careful not to present the Museum as a rival to The Detroit Institute of Arts: "Perhaps the word museum suggests something a little too ambitious for the group of objects here. But we use the word for want of a better term. In any event, we are not trying to create a second Art Institute, or an art museum comparable in size to some of the great collections in the country; but rather a collection of material primarily suitable for the use of the students in the schools here, and, secondarily, for the study and enjoyment of the people in the community." Booth also emphasized the symbiotic relationship between the art library and the art collection, housed across the hall from each other at that time: "It is one thing to study a design in a book, another thing to examine the actual object. Thus, if an art student happens to be studying Gothic design he will want actually to see some object which expresses the feeling of the period. For an art library, no matter how extensive, can not tell the whole story." Finally, Booth also stated his commitment to contemporary art: "Then, too, by creating a modern collection, we want to remind our students that art is a living thing and that the record of our times is being created from day to day by the artists of this age, and in so doing perhaps to stimulate the creative spirit among those who work here."[5] By spring, the Cranbrook Museum had presented its first temporary exhibition, a traveling exhibition on contemporary interior design organized by the American Union of Decorative Artists.[6]

Cranbrook Institute of Science also traces its roots to this period. In February of 1930 the trustees of The Cranbrook Foundation opened a "Museum of Natural History" in the same building as the Art Museum. Including a large display of 313 gems and minerals, as well as exhibits of Michigan birds and "Indian life," an initial purpose of this museum also was to inspire the art students at Cranbrook, "to illustrate art in nature" and to

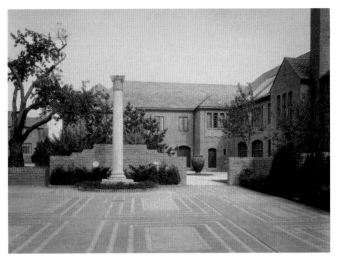

Figure 2: Cranbrook Academy of Art, Administration and Museum Building, circa 1932. Photograph Collection of Cranbrook Archives (CEC1348).

supply them with sources for their "form, design, and color."[7]

With George Booth serving as the curator, the new Museum and Art Library initially were overseen by Henry P. Macomber who served as the first Secretary of the Art Department of The Cranbrook Foundation from 1928 through November of 1930.[8] Macomber came to Cranbrook from the prestigious Boston Society of Arts and Crafts. Although Booth may have been reluctant to use the word museum to describe his newest enterprise at Cranbrook, he was in fact well connected and a significant voice in the museum community, both in Detroit, where he was a leading patron of the Detroit Museum of Art (now The Detroit Institute of Arts), and nationally, participating in a critical debate about the role of art museums. As American art museums developed in the latter half of the nineteenth century, they looked to Europe for two different models: the South Kensington Museums in London (now the Victoria and Albert) and the Louvre in Paris. The Metropolitan Museum of Art in New York followed the model of the Louvre, collecting almost exclusively "fine art" for the benefit of New York's social elite while a few museums like the

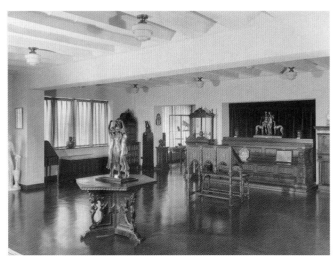

Figure 3: Cranbrook Museum with **John Kirchmayer's "Reading Desk and Bench,"** circa 1930. Photograph Collection of Cranbrook Archives (CEC1455).

Philadelphia Museum, at least initially, looked to London and privileged the industrial arts. They hoped to elevate the taste of the broader public with the ultimate goal of promoting the development of the city's manufacturers, in particular Philadelphia's textile industry.[9] By the 1920s, Benjamin Ives Gilman, secretary of the Boston Museum of Fine Arts, became the primary spokesman of the "aesthetic function" represented by the Louvre and the Metropolitan while John Cotton Dana at the Newark Museum and Library advocated an educational approach with the applied arts taking a central role. Booth clearly aligned himself with Dana.[10]

The founding and early history of The Detroit Institute of Arts also is inextricably bound to both the Scripps and Booth families. The museum had its origins in the temporary "Art Loan Exhibit" of 1883, conceived by an advertising manager for the *Detroit Evening News* and ardently supported by the paper's founder and Ellen Booth's father, James Scripps. The exhibition successfully jumpstarted a series of pledges and loans and a fund-raising campaign that led to the opening of the museum in its first permanent home in 1888. Scripps was one of the museum's eight founding

trustees and in 1889 he donated a collection of seventy-five "old masters" valued at $75,000 to form the core of the new museum's Italian, Flemish, German, Dutch, and Spanish collections.[11]

While his father-in-law and the Detroit Museum of Art were building a collection along traditional lines that privileged the venerable history of painting and sculpture, George Booth, as evidenced by his early support of the Society of Arts and Crafts, was more interested in promoting the work of contemporary artists, in particular the work of contemporary craftsmen. In 1905, a year before the Society of Arts and Crafts was founded, and with obvious admiration for the philosophy of William Morris, Booth expressed his views during an address at the opening of an annual exhibition at the Detroit Museum of Art:

America is peculiarly the land of hope unhindered by traditions, veneration for crumbling ruins, or false ideas of life. Continuously seeking new light, we are in the laboratory of life experimenting, seeking truth. Perhaps we run too quickly after the new thing, but we cast it aside as readily when we find our error.

We do not hesitate to destroy a building unsuited to our times, or faulty in construction. In this restless activity lies the opportunity and need to go forward with this arts and crafts movement. I hope that it may be possible in Detroit to have a society composed of believers in the ideals I have described. A society whose members will be zealous to spread the gospel of good work and the higher and saner standards of art in objects of use and ornament to the end that American life may progress in simplicity with purity and the growth of the nation in real greatness and goodness.[12]

At this same time, Booth began to develop a personal collection of decorative and applied arts, including historic examples that could have served as their inspiration, acquiring many contemporary objects directly from the Society of Arts and Crafts' exhibitions. His plan was to amass a collection that, like his father-in-law, he could donate to the Detroit Museum of Art. Booth's goal with this gift, however, was to use it to help transform the Detroit Museum into

what he felt would be a more progressive institution, one that was more responsive to the needs of contemporary society and the average citizen. Booth made his position clear nationally when he delivered a significant address on "The Place of the Industrial Arts in Art Museums" to the eighth annual convention of the American Federation of Arts in Washington, D.C., in May 1917. Presented in "so convincing a manner that his subject became a chief topic of discussion at the convention,"[13] Booth asserted:

If the art museum is effectively to do its work as an educational institution, then it must do it by the most direct route available, namely, by carefully chosen examples of ancient work well explained, and equally careful selections from the workshop of the modern craftsman as proof that high achievements are possible in our time. Museums may be ever so complete, but they fail to spread the influence desired if we do not get into our very being the subtle relation of the things on view to the people we intend they shall influence.[14]

The radical nature of Booth's vision, which was formalized when he donated the George G. Booth Loan Collection to the Detroit Museum of Art in 1919,[15] made the Detroit Museum of Art the first museum in the country to feature the arts and crafts of the twentieth century. A special room for the decorative arts was created in anticipation of exhibiting Booth's extensive collection of metalwork, pottery, silverware and textiles produced by modern craftsmen. The entire main floor of the museum was remodeled for this purpose.[16] The plan was enthusiastically supported by the museum's director, Clyde Burroughs, and heralded by the press:

Mr. Booth was desirous of purchasing the best of works of American craftsmen, and giving to them positions of prominence in the Museum, where they might be seen and admired by casual visitors as well as by the recognized student of art. The day of the canvas hung museum gallery and the pieces of bronze or marble scattered here and there, is going slowly but surely. Civic art centers are yielding point by point in the recognition of craftsmanship, wherever found, and, in the opinion of artists in general the time is not so distant when everything from a rat-trap to an automobile body will be displayed, to illustrate decorative design and cleverness of execution.[17]

Although Booth continued to donate works to this collection during the next decade, by the late 1920s the plan began to disintegrate and he reportedly became increasingly "annoyed at the unsatisfactory placement" of his collection.[18] By the time the new Detroit Institute of Arts opened in 1927, Booth was devoting most of his time to the development of his own educational institutions at Cranbrook, with the establishment of The Cranbrook Foundation that same year. In 1930 he declined an invitation to take the place that had been vacated by his brother Ralph Booth on the Board of Trustees at the Institute of Arts, noting that he had taken on a "sizeable task at Cranbrook."[19] The director of the Institute, William Valentiner, expressed his regrets graciously to Booth in a letter which also wistfully summarized Booth's undertaking at Cranbrook:

(…) But I understand the reason which you mention in your letter, knowing how important the work is which you are doing in Cranbrook. In fact, although I am surely fond enough of the work here in the museum, I still somehow feel that the creative work which you are advancing there is likely of more value for the future. For to build up a work in which all the arts are combined in a perfect ensemble and in which the young artists are educated to a well rounded-out culture of life, is perhaps better than the collecting of scattered fragments which we are assembling here.[20]

Although his relations with the Institute of Arts would remain cordial—and he repeatedly spoke about his art museum at Cranbrook in terms of complementing and not competing with the museum in Detroit—the active collaboration between Booth and the Institute of Arts effectively ended in 1944 when he negotiated the return of eighty-six items in the collection he had given to the Institute, exchanging the works for a bronze sculpture by Carl Milles, a larger version of the *Sunglitter* that Booth installed at Cranbrook.[21] Booth's radical plan to integrate all the arts in a perfect ensemble was now entirely the province of both his Academy of Art and Art Museum at Cranbrook.

AN AUSPICIOUS FIRST DECADE
Museum, Cranbrook Academy of Art, 1932-1942

By the mid-1930s, the Museum at Cranbrook Academy of Art had settled into an ambitious program of presentations of both its permanent collection, which now emphasized the decorative and applied arts, and temporary exhibitions. Now under the immediate supervision of the Academy's Executive Secretary Richard Raseman, the first catalogue of the Academy of Art outlined the Museum's mission, which emphasized an acquisitions and exhibition policy focused on contemporary art and design:

The Museum of Art (...) seeks to offer a representative collection of contemporary decorative art. While laying no claim to historic completeness, it contains many examples of the achievements of the past which have been chosen with special reference to their bearing on the evolution of modern design.

The policy of the Museum is to offer an ever-changing collection of the finest contemporary art from all the world, which will demonstrate the trend of modern design and thus contribute to the artistic development of the artists and craftsmen who work at Cranbrook. To this end it is hoped to keep the collections in a state of change through the frequent acquisition of contemporary objects.

Exhibition Galleries (...) include a spacious room for the display of the work of Cranbrook artists and craftsmen, as well as galleries where current exhibitions of the work of visiting artists or other worthy examples of contemporary drawing, painting or sculpture, are shown.[22]

Temporary exhibitions, which by the 1934-1935 academic year were taking place in both the Academy's "main building" and the remodeled Cranbrook Pavilion (now St. Dunstan's Playhouse) (fig. 4) on Lone Pine Road across from Christ Church Cranbrook, included the work of the Academy's faculty (Carl Milles and Zoltan Sepeshy inaugurated the Pavilion with exhibitions of their work in December 1934), ceramics by Maija Grotell who, at the time, was teaching at the Henry Street Settlement in New York (she joined the faculty at Cranbrook in 1938), an exhibition of home furnishings designed at the Academy by Eliel and Loja Saarinen and Pipsan Saarinen Swanson and

Figure 4: Cranbrook Pavilion, January 1935. Photograph Collection of Cranbrook Archives (2594).

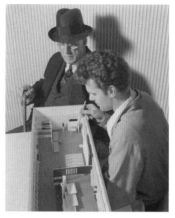
Figure 5: George Booth and Charles Eames with an installation model for the 1939 Faculty Exhibition, November 1939. Photograph Collection of Cranbrook Archives (5387).

J. Robert F. Swanson, and a controversial exhibition of "Contemporary American Painting" attended by over 1,400 people during its two-week presentation. Under the auspices of the Museum, the Academy also presented public films and lectures in the Pavilion with Frank Lloyd Wright presenting his first lecture at Cranbrook on April 25, 1935, to a crowd of 679 people (with another 100 trying to get in) followed by an equally successful lecture by Le Corbusier the following year.[23]

Of course, operating a museum in the midst of the Depression was a challenge and set the tone for a history of budget concerns.[24] Nevertheless, the program moved forward. With Zoltan Sepeshy in charge of the painting program, the Museum exhibited the best-known Regionalist painters of the period with exhibitions of watercolors by John Steuart Curry and Thomas Hart Benton in 1937 and Rockwell Kent's paintings at the Pavilion in 1938. Public lectures included Wright's second visit in 1937, Gunnar Asplund in 1938, and a visit by Eliel Saarinen's friends, Aino and Alvar Aalto, in November 1938. Periodic exhibitions of student and faculty work continued to take place,

including a faculty exhibition in December 1939 whose installation was designed by Eero Saarinen and Charles Eames (fig. 5).[25]

By the winter of 1940 the collections and exhibitions of the Museum had grown to such an extent that they were straining both the Academy's staff and the galleries of the existing Museum and the Cranbrook Pavilion. In February, the first curator was assigned to the collection and by the spring of 1940 it was clear a larger facility was needed. This was especially evident in May when the Museum presented both the first "annual" exhibition of Academy student work in the Pavilion, as well as an enormously successful survey of American painting. Organized by *Life Magazine* and selected by a national jury, the "Cranbrook-Life Exhibition of Contemporary American Painting" included the work of sixty artists, including Thomas Hart Benton, Charles Burchfield, John Steuart Curry, Edward Hopper, Doris Lee, and Charles Sheeler, as well as Detroit-based painters John Carroll and Zoltan Sepeshy. It even included Grant Wood's *American Gothic*, a painting that already had become so iconic that The Art Institute of Chicago had policies that normally prevented it from being loaned to other institutions. The exhibition certainly announced the arrival of the eight-year-old Academy on both the regional and the national art scene. Patrons of the exhibition represented a complete cross-section of Detroit's and the nation's elite, including Edsel B. Ford, architect Albert Kahn, and a whole host of museum directors and university presidents including William Valentiner, Alfred H. Barr, Jr. (Museum of Modern Art), Alexander Grant Ruthven (University of Michigan), G. H. Edgell (Museum of Fine Arts, Boston), and Daniel Catton Rich (Art Institute of Chicago), to name just a few.[26] In a *Detroit News* article, art critic Florence Davies characterized the distinctiveness, beauty and creativity of Cranbrook:

Naturally Cranbrook has every right to be in somewhat of a dither in honor of this occasion. This is not so much because the 60 American pictures chosen are a definitive measure of American art, but rather because a popular magazine with a nation-wide audience has looked the country over and picked the Academy as the most significant place in which to hold such a show. That is an important and gratifying tribute to Cranbrook.

Life Magazine picked Cranbrook not only because of the enchanting setting of the place as a whole, but more particularly because it found there "work in progress"—an atmosphere of creative activity.[27]

There was only one problem. The only site large enough to present the two-week exhibition was the Department of Painting and its studios.

A NEW BUILDING AND GROWING TENSIONS
Museum of the Cranbrook Academy of Art, 1942-1954

By the time the "Cranbrook-Life Exhibition" closed, work had in fact started on the Academy's "crowning glory," the new Library and Art Museum designed by Eliel Saarinen (figs. 6 and 7).[28] The program of the new museum, as the press interpreted it, clearly maintained the relationship between books and objects for both students and the general public that Booth established a decade earlier:

Thus the museum becomes, in a very real way, merely an extension of the library. It seeks to furnish enough illustrative material so that whether the subject being studied happens to be Egyptian sculpture, modern ceramics, ancient or modern metal work, or the technic [sic] of etching, water color, oil painting or fine enamel work, typical examples of these arts will be found for reference and comparison. The library itself, therefore, is thought of as the basis of the museum collection, and its six thousand volumes will be available for study to all Cranbrook students as well as to interested members of the art-loving public.[29]

In addition to the Library and Art Museum, the third component of the new building was described as an outdoor sculpture museum: the installations of Carl Milles's sculpture to the north and south, as well as the works by Milles and Marshall Fredericks under and around the Peristyle (initially referred to as the Loggia). The new museum was state-of-the-art and became a destination for museum directors from around

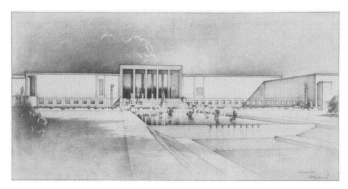

Figure 6: Eliel Saarinen, "**Cranbrook Academy of Art, Perspective of the Museum and Library**," 1940. Collection of Cranbrook Art Museum, Gift of Robert Saarinen Swanson and Ronald Saarinen Swanson (CAM 1979.6).

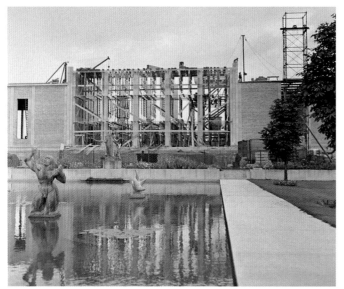

Figure 7: Cranbrook Art Museum Peristyle and "Triton Pool," October 1940. Photograph Collection of Cranbrook Archives (5553-18B).

the nation. Of particular significance was the lighting. General indirect illumination came from fluorescent bulbs positioned in the grid and reflecting coffers on the ceilings of all of the galleries, while adjustable spotlights with incandescent bulbs provided warmer light on the individual pieces (fig. 8).

As the Library and Art Museum was being built, the Academy matured into its present form.

In 1942 the Academy, which until then had operated as a division of The Cranbrook Foundation, was incorporated as a separate non-profit trustee institution under the educational laws of Michigan and now was authorized to grant degrees. The new by-laws detailed the organization of "The Academy Museum," with a "Director of the Museum Department" notably responsible for both the Art and Library Collections. The director was responsible to both the director of the Academy (for issues "exclusively concerning the Academy") and to the Academy's trustees through a Museum Committee for all other matters (including the maintenance and protection of the Library and Art Collections).[30]

The first curator in charge of the new Museum and Library was Richard Davis, who had graduated from Harvard University, where he studied art history and museum studies at the Fogg Museum of Art. Toward the end of his brief tenure, when he was about to become director, Davis wrote a carefully thought-out fourteen-page report to the Academy of Art's Executive Committee detailing his proposed policies and procedures in preparation for the suggested November opening of the Museum. He argued for a reversal of the library/museum relationship, asserting that the proportions of the new operation dictated that the Museum no longer be defined as a "part of the library"; rather the Library now needed to be part of the Museum. He further called for a more precise definition of the Museum audiences as Academy students, the Cranbrook community and the general public. As far as the scope of the collections were concerned, he felt the strong "Oriental" and "Primitive" collections should continue to be strengthened with a few carefully selected acquisitions while the modern and contemporary collections (in 1942 this meant both nineteenth and twentieth centuries) should be the primary focus of future acquisitions. Davis also proposed a temporary exhibition program that stressed a limited number of "important" contemporary exhibitions (rather than many

small ones), relying almost exclusively on traveling exhibitions offered by other museums. His other recommendations included the establishment of both the equivalent of a museum committee (comprised of the curator and Academy trustees) and a Visiting Committee of outside professionals, as well as public hours of two to five every day of the week.[31] It all was sound advice for the fledgling museum. Unfortunately Davis had to leave abruptly in September 1942 to join the war effort, less than a month after being promoted to director.

The new Museum operated on a limited basis during World War II with George Booth serving as interim director after Davis's departure. It was not until 1945, when Albert Christ-Janer became director, that a full series of temporary exhibitions opened to the public. The inaugural exhibitions in the lower level of the new building included "Modern Dutch Architecture," "What is Modern Painting" from the Museum of Modern Art, "Modern Art in Advertising" and "European Artists in the United States." But no sooner did the new museum fully open than the Academy trustees began to view it as a "drain" on the budget. At the Third Annual Meeting of the Academy's trustees in June 1945, the treasurer called the trustees' attention to the fact that the $21,000 deficit in the proposed 1945-1946 budget was approximately the cost of operating the Museum and Library. It was recalled "that at times in the past consideration had been given to the idea that the Museum and Library should both be taken over and operated by The Cranbrook Foundation, as the Art Museum particularly serves the public even more than it does the Academy." Since the Museum and Library and their collections had been legally deeded to the Academy and it was deemed too difficult to separate them, the Academy's trustees decided to ask The Cranbrook Foundation for additional funds to operate these two facilities and received an appropriation for $20,000.[32]

While George Booth in his dual role as a trustee of both the Academy and The Cranbrook Foundation

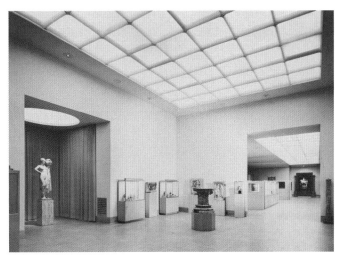

Figure 8: Cranbrook Art Museum, Center and South Galleries, December 1944. Photograph Collection of Cranbrook Archives (AA485).

was quick to continue directing additional appropriations to the Academy, it was clear that the existing endowment and tuition revenues were not enough to operate the Museum on the scale envisioned in the early 1940s. At their January 1947 meeting the Academy trustees voted to eliminate the position of museum director (which they also codified in a revision to the by-laws in 1950), placing a curator in charge "under the active supervision of the Director of the Academy."[33] By the time of Christ-Janer's departure that summer, it was clear that the scope of Davis's vision for the Museum had been drastically narrowed.

The Museum's mission and the goal of its exhibitions and collection programs in the late 1940s is perhaps best summarized in a letter written in 1948 by the Art Museum's new curator, Esther Sperry, to Eugene Kingman, Director of the Joslyn Memorial Art Museum in Omaha.[34] Following a visit Kingman made to Cranbrook, Sperry summarized the four primary aims and objectives:

1. The art of the past as a "Library" for our art students
2. Contemporary art – for the same purpose
3. Circulating exhibitions to keep them [Academy students] au courant
4. Student and faculty accessions and/or exhibitions for work of quality done at Cranbrook

The Museum's new focus on Academy students as the only audience for the Museum was disrupted when Sperry discovered that "the success of these four has attracted an increasing local, even itinerant national public, so that we really at this time find ourselves with an unsought but nor unwelcome fifth aim of serving this public." Although this four-part mission, which Sperry attributed to the Academy's president Eliel Saarinen, echoed to a great extent the mission George Booth outlined in 1930, she failed to realize that the "unsought" fifth goal—serving the public—was in fact also part of Booth's original mission.

While Sperry was optimistically recounting the Museum's mission, it nevertheless continued to be questioned by Cranbrook's trustees. Like many organizations, Cranbrook, and in particular its Art Museum, had a difficult time surviving the deaths of its founders George and Ellen Booth (1949 and 1948, respectively). Without their vision—and all-important financial support—the Museum's mission was caught between the sometimes conflicting goals of meeting the needs of the Academy and the Museum's expanding public audiences. By the fall of 1948, when the museum estimated that it would serve a record high of nearly 50,000 visitors that fiscal year, Sperry described the museum as having reached a "state of emergency," with inadequate staffing and insufficient funds to support its rapid transition from a small museum to a large one.[35]

The history of the Museum in the first half of the 1950s is recorded through the official records of the next curator in charge, Eva Ingersoll Gatling, in the form of minutes from meetings of the Museum Committee (established in 1946) and formal Annual Reports prepared for the Academy's Board of Trustees after her arrival in August 1950. Meanwhile, a more personal account of the era was recorded by Henry Scripps Booth and his fellow trustees. Henry Booth, the founders' youngest son and an architect himself, always had taken a leading role in the oversight of the Art Museum. He was a founding trustee of The

Cranbrook Foundation and as early as 1932 was designated as the link between the Academy of Art and the Foundation. With the Trust Indenture that established the Academy as a separate entity from the Foundation in 1942, Henry Booth served as a trustee of the Academy while his father served as vice-chairman. Two years later Henry Booth became the chairman of the Academy Board of Trustees and, in 1946, he succeeded his father as chairman of The Cranbrook Foundation. By the early 1950s he also was serving as the chair of the Museum Committee. In contrast to Gatling's attempts to record a more objective history, Henry Booth's correspondence and informal assessments of the next three decades provide us with an impassioned account of the era.

In Gatling's first report to the Museum Committee, the Annual Report for 1949-1950, she took stock of both the Museum's program and collections and reflected on its future development.[36] Like Sperry, she outlined a robust program, not dissimilar from the Museum program today. Then, as today, the Museum had an aggressive temporary exhibition program, with no less than twenty-three exhibitions that year, drawing heavily on exhibitions circulated by other museums (such as "New Directions in Intaglio" from the Walker Art Center) and national agencies such as the American Federation of Arts (including "Modern Jewelry Under Fifty Dollars" and "New Directions in Modern Painting"). The season also included four "Work in Progress" exhibitions, three of which featured Academy students with the fourth featuring the work of Michigan artists. Although the Museum always had hosted a student exhibition at the time of graduation, that year the Museum inaugurated an annual summer-long "Student Exhibition," citing the fact that the summer brought to Cranbrook visitors from a wider geographical area who had made many requests to see student work.[37] The Museum also mounted an exhibition and catalogue of the work of Zoltan Sepeshy, inaugurating an annual one-person faculty exhibition.

While the public experienced a dynamic exhibition schedule, the curator, Museum Committee and Academy trustees were wrestling with the Museum's urgent need for increased financial support which, as often is the case, forced a reexamination of the mission of the museum itself, including its audience and collection policy. In her 1952 Annual Report, Gatling described the financial concerns under the heading: "The Relations between the Museum, Its Public and the Academy." She noted the challenge of creating an exhibition program that met the needs of the students first, acknowledging that these same exhibitions might, in some instances, lack public appeal.[38] While "public appeal" was not an issue while George Booth was alive and offering financial support to both the Academy and Museum, by the early 1950s it was a reality that created a tension as the Museum argued for the support it needed, and did not feel it was receiving, as a department of the Academy.

To address the problem, Gatling proposed the creation of a membership program as a way of soliciting outside support for the Museum, a suggestion that the Museum Committee and Academy trustees were reluctant to adopt because of the issues of outside control that a support organization raised. In a memo to Henry Booth in January 1953, Gatling wrote: "I believe the scope of this organization should be confined to the Museum. I have always felt that the Museum's position was precarious because it was so closely tied to the Academy. If it grows it will obviously be a greater drain upon the Academy's finances and I believe that it should be permitted to seek some separate support now. I think also that the Museum must seek this support from friends in the neighborhood while the Academy may secure help from other sources such as Alumni or various organizations which provide scholarships and loans to deserving students."[39]

Warren Booth, Henry Booth's brother, the president of *The Detroit News* and a trustee of The Cranbrook Foundation, offered a more drastic and perhaps cynical option. He felt the solution to the Museum's financial problems was to close the Museum, putting both it and Cranbrook House in "mothballs."[40] While Warren Booth's solution was rejected, the Museum underwent a reexamination of its policies beginning with the nature of the permanent collection. At the beginning of her tenure in 1950, Gatling described a new arrangement of the collection in the galleries that in turn reflected a new collecting emphasis on contemporary art, which had been initiated by the previous curator, Esther Sperry. The collection of Western painting from the Renaissance to "modern times" had been moved from the South Gallery to the smaller North Gallery, with the larger South Gallery now devoted to "the expanding collection of contemporary art." Gatling, who seemed to be ambivalent about this new focus on contemporary art, argued that the Chinese, Pre-Columbian and contemporary American collections (in that order) should be developed in preference to others, thereby building upon the existing high quality of these collections at Cranbrook, collections which were not duplicated at The Detroit Institute of Arts. Gatling concluded her report by citing several additional needs, most importantly the need for air conditioning and the control of humidity in both the Museum and the Library.[41]

Always one to register his own opinion, Henry Booth wrote a "Suggested Collection Policy" in 1953 in which he reaffirmed both public and student audiences as well as an encyclopedic collection, a position he shared with Gatling, with an emphasis on applied and contemporary art. Although it is not known whether or not it officially was adopted, it was filed with other official policies of the period:

Whereas the Museum of Cranbrook Academy of Art was designed to serve the public and the students and faculty of the Cranbrook community, it is the policy of the Museum to develop and maintain, in so far as finances and generosity of donors will permit, a relatively small and well-proportioned collection of fine and applied arts having high quality and historical and geographical breadth, said collection to include contemporary works which appear to have enduring merit.

Booth's description of the Museum's audiences, which expanded beyond the public and the students and faculty of the Academy to include the other schools at Cranbrook, was emphasized in the original typed version where "Academy" was crossed out and "Cranbrook community" written above it in Booth's script.[42]

While both Booth and Gatling felt the needs of the Academy and its students would be served best by a Museum with an encyclopedic collection, the Foundation trustees now felt there was an opportunity for "an entirely new approach" that could prevent mothballing or closing the Museum. In a memo from the Academy's Board of Trustees (under the initials of trustee Marc T. Patten) to the Museum Committee dated February 10, 1954, a plan for the "Cranbrook Museum of Contemporary Art" was outlined. It was believed that this approach would better reflect the philosophy of the Academy of Art, and, once again, would complement rather than compete with the Detroit Institute of Arts "in the same way as the New York Museum of Modern Art complements the Metropolitan Art Museum." The trustees apparently were prepared to fund this plan for a three-year period, including maintaining the museum staff and the buildings and grounds. At the same time, the memo notes that it may be necessary "to move the permanent collection" and "dispose of those items of its collection which are found undesirable."[43]

In spite of some remarkable contemporary acquisitions, including Henry Moore's wood sculpture, *Reclining Figure*, in 1952, the plan does not seem to have gone very far. By the summer of 1954 the Board of Trustees was hesitant to even commit to a three-year program of development for a new Museum membership organization[44] and by September, Booth had reported to the Museum Committee that "the Academy's financial situation was such that unless additional funds were secured for the Museum, the activities would have to be seriously curtailed." Booth's comments were no doubt

based on the views toward the Art Museum expressed by the Academy's president, Zoltan Sepeshy. In his own report delivered to the trustees in October, Sepeshy felt that the "present scale and function [of the Museum] jeopardizes the financial stability of the Academy" and even threatened the Academy's attempt to seek accreditation through the National Association of Schools of Design. Sepeshy ended his report by proposing "utilizing the Museum at a lesser cost for instructional purposes for the students, to a much greater extent than is done at the present."[45] The year ended with the resignation of Gatling at the request of Sepeshy.[46]

FISCAL CRISIS AND THE 1972 AUCTIONS
Cranbrook Academy of Art Galleries, 1955-1977

In January of 1955 a new era was launched with great fanfare. Local and national media, including *The Museum News*, the national newsletter of the American Association of Museums, announced the Museum's new name, "Cranbrook Academy of Art Galleries," and the promotion of Wallace Mitchell to the position of Director of the Galleries. At the same time, the article detailed a new mission: "Under new policy the galleries will continue to show art of the past, but will stress the program of activities especially in contemporary decorative and practical art, sculpture and painting."[47] The change from "Museum" to "Galleries" was significant. It clearly represented a shift from an encyclopedic collection to one that would focus on contemporary art, like the commercial galleries devoted to contemporary art that were rapidly forming in New York City as the center of the postwar art world shifted from Europe to the United States. In a letter to Edgar Richardson, Director of The Detroit Institute of Arts and a member of Cranbrook's Museum Committee, Henry Booth enthusiastically described the plan as taking the Museum "out of the 'curatorial' field into one which holds far greater promise in this area—an institution more actively interested in the broad

aspects of art in human life than the historical (…)."[48] But as the Museum moved more and more of its collection into storage, it also narrowed its audiences as it lost its ability to make contemporary art more accessible to audiences beyond the Academy by introducing it in the context of its historic works of art.

The new policies also included by-law amendments that effectively weakened the responsibility of the head of the Galleries. Whereas the original 1942 by-laws provided greater autonomy for the Museum and direct access to the trustees through a Museum Committee chaired by the Museum curator or director, the 1957 by-laws made the head of the Galleries responsible to the director of the Academy in all matters, including the care and protection of the art collection. While it also delineated a "Collections Committee" (replacing the previous Museum Committee) that included the head of the Galleries, it noted that the director of the Academy would chair the committee.[49] It is clear in both name and policy that the new solution to financial concerns was not to pursue new sources of outside support but rather to have the Academy exert more control over the Museum. Even a substantial portion of the Museum's real estate was turned over to Academy use, with most of the Museum's large South Gallery converted to a lecture hall between 1958 and 1959. Mitchell's initial exhibitions relied on traveling exhibitions, including two circulated by the Museum of Modern Art: "Recent Works by Young Americans" (1955), an exhibition of paintings and drawings, and "Built in U.S.A." (1956), a photographic version of MoMA's important 1944 exhibition curated by Henry-Russell Hitchcock that documented architecture in the United States since 1945, including several projects by Eliel and Eero Saarinen, and Charles Eames.

Institutional records for the next decade are limited to the concise minutes of the meetings of the Academy trustees. Although there appears to have been a functioning Collections Committee,

the equivalent of Gatling's detailed minutes and Museum Annual Reports either were not produced or do not survive. A history of the exhibitions and new acquisitions can be traced through the files still held by the Art Museum, but little survives that illuminates the decisions made by Mitchell and the Academy trustees. Clearly, however, the Academy's financial problems did not diminish and by the early 1970s the Galleries were again at the center of a heated controversy.

In the Galleries Committee Report presented to the Academy trustees on November 18, 1971, the committee detailed their recommendations regarding "the proposed selling of numerous art possessions," a plan that the Academy of Art Board of Trustees first raised in 1970 when it asked the Galleries Committee to "investigate the judicial sale of several Academy art possessions."[50] The immediate goal was to supplement the Academy's endowment funds, "the first expansion of which must total at least two million dollars within the next four years." The Committee's report indicates that the sale of the art collection was a measure of last resort to solve a looming crisis, noting that they "surely cannot be accused of having failed to go to our constituents for direct financial support, to the very limit that all factors combined would allow." The records of the Academy trustees make clear that they had become increasingly dependent on appropriations and matching gifts from The Cranbrook Foundation, which by this time was struggling with its own budget concerns resulting from inflation and the rising costs of the institutions it was supporting. By 1970 the Academy was receiving $300,000 from the Foundation, roughly half of the Foundation's annual endowment earnings.[51]

While there seemed to be general agreement by many people at Cranbrook, including Henry Booth, that the sale of selected objects was perhaps permissible, if not necessary at this time, the extent of the sale was contested. As in the early 1950s, the best records of the era were

preserved by Henry Booth. It seems that Booth alone carried a sense of his parents' mission for Cranbrook and his response to the proposed sale shifted from initial resigned acceptance to one of growing indignation at the scope of the sale. In a letter to Henry Booth from Ernest Jones, then chairman of the Academy's Board of Trustees, dated December 7, 1971, Jones described his perspective on Booth's initial reaction to the proposed sale:

Through the months in which we have been working out the system by which to carry out our decision to sell works of art, we, the Academy's trustees, have been inspired by the munificent understanding which you expressed in April when Wallace Mitchell and Sue Thurman [Academy vice president] discussed in some detail with you this particular aspect of stabilizing the Academy's future. The unhesitating support you expressed for the long-deliberated step was truly indicative of the Booth insight which spans the generations. The full confirmation of our overall priorities, which you reiterated in the second paragraph of your recent letter to me, was noted with much appreciation.[52]

The letter to which Jones refers is dated December 2, 1971. In the second paragraph, Booth had written:

The founders, of course, would be very disappointed at the present turn of events—especially after years of having their collection ignored, neglected or misused. Being flexible, realistic people, however, they would today prefer having the Academy so solidly financed it will be perpetuated rather than seeing it fail because the vaults are left full of valuable art objects benefiting no one.[53]

However, after noting his reluctant acceptance of the sale, Booth went on to detail his view of the central role the Academy's art collection played in defining the identity of all of Cranbrook, not just the Academy, and expressed his concern about the works on display in Cranbrook House and those located elsewhere on the campus, including all of the bronzes by Carl Milles for which the Academy served as the custodian. Assurances had, in fact, been made by the Academy to preserve these and other aspects of the collection. The Galleries Committee Report in November detailed four areas of the collection that they did not recommend selling:

1. Items owned by the Academy but located at Cranbrook House.
2. Works which are installed as integral and familiar components of architecture and grounds. These vary from the Milles fountains to some choice fragments from ancient ruins—given Academy prominence by Saarinen.
3. Works of all types created by Academy faculty and alumni.
4. Works which the faculty consider vital to the reinforcement of their teaching.[54]

These recommendations, however, did little to assuage Booth's concerns. On December 28, 1971, he began a letter to Jones, "In spite of assurances that Cranbrook House will retain top-quality objects in sufficient numbers to truly represent the Booth Collection, it should be no surprise that the more I discuss the Academy's forthcoming art auction the more disgusted I get."[55] He went on to explain his disenchantment: "It is not the fact an agreement has been signed relative to an auction. It is that the auction is intended to cover the bulk of the collection (much to my surprise) rather than a few major works (...)." In his impassioned letter, Booth restated his father's mission for the Museum and the role of an encyclopedic collection: "(...) it is a fact thoroughly evidenced by Academy history that the Founders believed solidly based artists and craftsmen know the past and that, if possible, an art library and an art museum should be available to them. Those were provided by the Academy from the start. Working hand in hand, art objects help interpret books; books help interpret objects of art." Finally, he readdressed the audience of the Museum, returning to George Booth's dual mission: "But it is obvious Mr. and Mrs. Booth didn't build such an important library-museum building for the exclusive benefit of Academy students. Do we have to remind ourselves there are three Cranbrook schools? And beyond them an ever-growing community having many citizens who seldom if ever go to Detroit?" He concludes by arguing for a less extensive sale than planned, while acknowledging that increasing the Academy's endowment would benefit both Cranbrook's students and the surrounding community.[56]

Although the decision to hold the auctions, which ultimately were conducted by Sotheby, Parke-Bernet in New York City in 1972, remains a controversial decision, the museum profession did not have formal guidelines at the time which forbade this practice.[57] In fact, at the same time that the auctions were conceived and planned, Cranbrook Academy of Art Galleries began the accreditation process that the American Association of Museums had just implemented in 1970.[58] At no point during the extensive review process (which began in December 1971 and concluded with formal notification of Museum Accreditation in August 1977) did the widely publicized auctions send up any red flags. The only time that they were even indirectly mentioned was in the AAM Visiting Committee's evaluation in which they noted that sales of the collection had been appropriately initiated by staff and cleared through the Museum Committee.[59] Indeed, although it is easy for us to look back on this era and feel that there must have been another solution, the leaders that made this very difficult decision insist that they had only two options at the time: sell the Art Museum's collection or substantially reduce the scale of both the Academy and Art Museum.

And Cranbrook was not alone. It was a difficult period for many of the region's cultural organizations, including The Detroit Institute of Arts. In the wake of the 1967 riots and high unemployment in the early 1970s that particularly hurt Michigan's automobile industry, the Institute of Arts faced its own financial crisis that culminated in the summer of 1975 with a brief (but much publicized) closure of the museum and furlough of many of its employees. When the Institute reopened, only 25 to 40 per cent of the galleries were open to the public on a rotating basis. The Institute of Arts ultimately was able to solve its financial crisis only through a bailout by the State of Michigan, resulting in allocations that grew to $7.1 million by the 1978-1979 fiscal year.[60]

A CELEBRATION OF THE ACADEMY
Cranbrook Academy of Art Museum, 1977-1994

The Academy's financial crisis and resulting auctions paralleled The Cranbrook Foundation's own financial problems in the early 1970s due to inflation and the escalating costs of the institutions it was supporting.[61] These concerns, coupled with the new tax regulations imposed on private foundations by the Tax Reform Act of 1969, demonstrated the need for greater centralization and a restructuring of Cranbrook. In 1973 Cranbrook Educational Community was formed, merging five autonomous institutions (Cranbrook School, Kingswood School Cranbrook, Brookside School, Cranbrook Institute of Science and Cranbrook Academy of Art) into one centralized non-profit institution under the administration of a Board of Trustees.[62] The three Boards of Governors (no longer trustees) for what became Cranbrook Schools, the Institute of Science and the Academy of Art and Art Museum remained as leading forces for the development of what now are Cranbrook's three programmatic divisions.

In 1977 the Academy's Board of Governors invited Roy Slade to succeed Wallace Mitchell as the fifth head of the Academy of Art. Having come to Cranbrook from the Corcoran in Washington, D.C., where he was both dean of the school and director of the art museum, Slade became both the president of the Academy and the director of what had become "Cranbrook Academy of Art Museum." Like the name change in 1955, the return to a "Museum" (which was reflected in amendments to the by-laws in 1977) carried symbolic weight. When it was first proposed in 1972 immediately following the auctions, the name change was no doubt an attempt to start anew and reclaim a sense of history that was lost through the auctions, a strategy that Slade also followed.[63] In his Statement of Intent, which he delivered at Cranbrook before officially becoming

president in July, Slade stressed that the Art Museum in particular had the potential to bring "greater support from the community and renewed recognition throughout the country."[64] He outlined three primary functions for the Museum, which remained the focus of the Museum during his seventeen-year tenure:

(…) A permanent installation showing the history and development of the Cranbrook Educational Community in all aspects including the Kingswood, Brookside and Cranbrook Schools, the Institute of Science, Christ Church and Academy of Art. Work from the collection relative to the founders of Cranbrook will be presented along with work by distinguished alumni. The emphasis will be on the works of art and design that have emerged from the Cranbrook Academy of Art and influenced international design and vision.

The Museum should devote a gallery to on-going exhibitions from the Academy of Art, students and faculty. As far as student work is concerned, the process of art, rather than the product, should be emphasized. The exhibition of students' work is a sensitive issue and should be regarded as an educational experience, not an early and wrongful presumption of achievement as an artist.

Exhibitions from throughout the world, showing the best of contemporary art and design, should be presented both from traveling shows and exhibitions originated by Cranbrook.

Given the legacy of the auctions earlier in the decade, Slade arrived at Cranbrook and astutely began to focus on the history, faculty and students of the Academy of Art. The permanent collection, which he named "The Cranbrook Collection" and launched with a new permanent installation in the Lower Galleries in 1978, was redefined as representing artists, architects and designers who had studied or taught at the Academy. The upper galleries were used for temporary exhibitions such as Slade's successful "Viewpoint" series (1977, 1981 and 1986) that explored themes in contemporary painting, and several surveys of Detroit-based artists beginning with "At Cranbrook, Downtown Detroit, Twenty One Artists" in 1979. Although the role of the Art Museum had changed, it nevertheless developed a national reputation for its collection that provided a unique and important history of twentieth-century art, crafts, architecture and design through the lens of Cranbrook Academy of Art.

The history of the Academy and the Art Museum's collection was celebrated through the exhibition "Design in America: The Cranbrook Vision, 1925-1950," which was organized by and presented in 1983 and 1984 at The Detroit Institute of Arts and The Metropolitan Museum of Art with a third venue in Helsinki, Finland. In 1985, with the completion of the Albert and Peggy deSalle Auditorium, the permanent collection was moved to the upper Main Gallery of the Art Museum. The South Gallery that previously had been remodeled for use as an auditorium was returned to its original use as a gallery for the Art Museum's primary temporary exhibitions, including surveys of the work of Duane Hanson (1985 and 1990) and Yoko Ono (1989 and 1993), and a project initiated by Museum Administrator Michele Rowe-Shields in which Keith Haring painted his graffiti-inspired drawings on the four walls of the North Gallery titled "Keith Haring at Cranbrook: Detroit Notes" (1987) (fig. 9).

REMEMBERING THE PAST WHILE PLANNING FOR THE FUTURE
Cranbrook Art Museum, 1995-Present

Renamed "Cranbrook Art Museum" in 1995 to signal its greater independence, the Museum now is in the midst of a significant period of growth, building on its former role as a more autonomous public museum that still is part of the Academy of Art. This evolution continues the Art Museum's history as a forum for contemporary art, but one that now serves increasingly diverse constituencies. While the mission during Slade's tenure did not exclude an audience beyond Cranbrook, it emphasized the Art Museum's role in educating and enriching Academy students. At the same time the permanent collection was defined exclusively in terms of work by artists who had studied or taught at the Academy. In 1994, with Slade's retirement, a separate position of Art Museum director was re-established, and in 1998 a new mission and Collections Management

Policy was adopted by the Board of Trustees of Cranbrook Educational Community. The new collection policy included clearly defined accessioning and deaccessioning procedures— including the stipulation that proceeds derived from the sale of objects "shall not be used as operating funds" but only for the "replenishment of the Art Museum's Permanent Collection"— putting the legacy of the auctions behind the Art Museum once and for all. In addition, the new mission more emphatically than at any time in the Art Museum's history defined its audience in a regional, national and international context, including "the artists and students of both Cranbrook Academy of Art and Cranbrook Schools as well as the widest possible public audiences."

The goal was not to replace the students at Cranbrook with a public audience, but rather to adopt a dual mission in which the Art Museum supports the graduate program of the Academy while also educating diverse public audiences. Most major cities in the United States have both a large encyclopedic art museum and a second museum that focuses on contemporary art. While The Detroit Institute of Arts is the nation's fifth largest encyclopedic museum, Detroit did not have a contemporary art museum. This is the niche that Cranbrook Art Museum aggressively claimed with an exhibition program that included shows with substantial catalogues organized and produced by the Art Museum including "Beautiful Scenes: Selections from the Cranbrook Archives by Buzz Spector" (1998), "Weird Science: A Conflation of Art and Science"(1999), the traveling exhibition "Iñigo Manglano-Ovalle" (2001), and "Post-Digital Painting" (2002).

For many people, however, the weak link in this vision was the permanent collection which remained focused on the Academy's own history. Although the Art Museum was able to build a strong collection during the 1980s and early 1990s by focusing on Academy faculty and

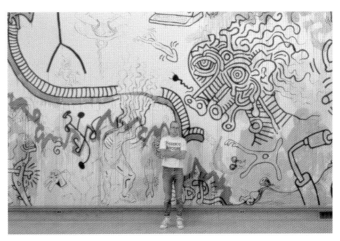

Figure 9: **"Keith Haring at Cranbrook: Detroit Notes."** installation view with the artist, September 1987. Photograph Collection of Cranbrook Art Museum.

graduates, to many the collection policy was parochial and prevented the Art Museum from truly extending its vision once again into a national and international context. The opportunity to address this problem came in 2001 when Rose M. Shuey offered to donate her world-class collection of postwar American and European painting and sculpture (forty-six works altogether) to the Art Museum. The problem was that Willem de Kooning, Donald Judd, Roy Lichtenstein, Agnes Martin, Joan Mitchell, Robert Rauschenburg, Bridget Riley, Frank Stella, Andy Warhol and Tom Wesselmann—to name just ten of the artists— did not study or teach at Cranbrook Academy of Art and therefore their works could not be considered for the permanent collection. The opportunity initiated a year of discussions by the Museum Committee, Academy governors and Cranbrook trustees that ended in the acceptance of the collection, the presentation of the exhibition "Three Decades of Contemporary Art: The Dr. John & Rose M. Shuey Collection," and the publication of an accompanying catalogue. It also precipitated the adoption of the Art Museum's current mission statement, which broadens the goals of the Museum:

Cranbrook Art Museum is a dynamic forum for contemporary art, craft, architecture and design, and an integral component of Cranbrook Academy of Art. Through its broad-based educational programs, permanent and changing exhibitions, collections and research, the Museum engages diverse public audiences in emerging artistic forms and ideas of visual culture. The Museum's collections document outstanding examples of art, architecture and design from the 20th and 21st centuries, with a special interest in recognizing the history and innovations of Cranbrook and the achievements of its artists.

Rather than a radical new mission, in many respects it is a return to the spirit of the mission that George Booth outlined for his Art Museum almost seventy-five years ago—emphasizing contemporary art, architecture, craft and design, but also having the ability to present this work in a historic context, one that serves both Cranbrook's students and a broader public. As the first presentation since the 1950s of the entire breadth of the Museum's collection, the exhibition and catalogue *Cranbrook Art Museum: 100 Treasures* reaffirm the historic importance, social and cultural impact, and continuing influence of the collection as well as the unique legacy and enlargement of the mission (fig. 10). We like to think that George and Ellen Booth are beaming with approval.

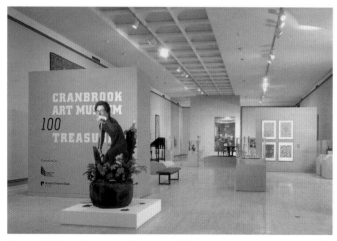

Figure 10: "Cranbrook Art Museum: 100 Treasures," installation view of the Main Gallery, February 2004. Photograph Courtesy of Cranbrook Art Museum and Balthazar Korab.

PRESIDENTS, DIRECTORS AND CURATORS-IN-CHARGE

CRANBROOK EDUCATIONAL COMMUNITY PRESIDENTS

Rick Nahm (President, 2001-Present)
Robert Gavin (President, 1997-2001)
Robert Larson (Acting President, 1996-1997)
Lillian Bauder (President, 1984-1996)
Dan Martin (President, 1980-1984)
Edward Lerchen (President, 1978-1980)
Arthur Kiendl (President, 1973-1978)

CRANBROOK ACADEMY OF ART PRESIDENTS AND DIRECTORS

Gerhardt Knodel (Acting Director, 1995-1997, and Director, 1997-Present; Vice President, Cranbrook Education Community, 1997-Present)
Susanna Torre (Director, 1994-1995)
Roy Slade (President, 1977-1994)
Wallace Mitchell (Acting President, 1970-1971, and President, 1971-1977)
Glen Paulsen (President, 1966-1970)
Zoltan Sepeshy (Director, 1946-1959, and President, 1959-1966)
Eliel Saarinen (President, 1932-1946)

CRANBROOK ART MUSEUM DIRECTORS AND CURATORS-IN-CHARGE*

Gregory Wittkopp (Director, 1994-Present)
Roy Slade (Director, 1977-1994)
John D. Peterson (Director of Galleries, 1971-1977)
Wallace Mitchell (Head of Galleries, 1955-1964, and Director of Galleries, 1964-1971)
Eva Ingersoll Gatling (Curator, 1950-1954)
Esther S. Sperry (Curator, 1948-1949)
Harriet Dyer Adams (Museum Curator and Lecturer, 1947-1948)
Albert Christ-Janer (Director of the Museum and Library, 1945-1947)
Mary I. De Wolf (Custodian of the Museum and Library, 1943-1944; Museum Custodian, 1944)
George G. Booth (Acting Director, 1942-1944)
Richard S. Davis (Curator of the Museum and Library, 1941-1942; Director of the Museum and Library, 1942)
Mary I. De Wolf (Museum Curator, 1940-1941)
Richard Raseman (Executive Secretary, Cranbrook Academy of Art, 1932-1940)
Henry P. Macomber (Secretary, Art Department, Cranbrook Foundation, 1928-1930)

*Dates reflect the years the person held the senior staff position for the Art Museum, and not necessarily the total years the person worked at Cranbrook or in this position.

ARTISTS AT WORK

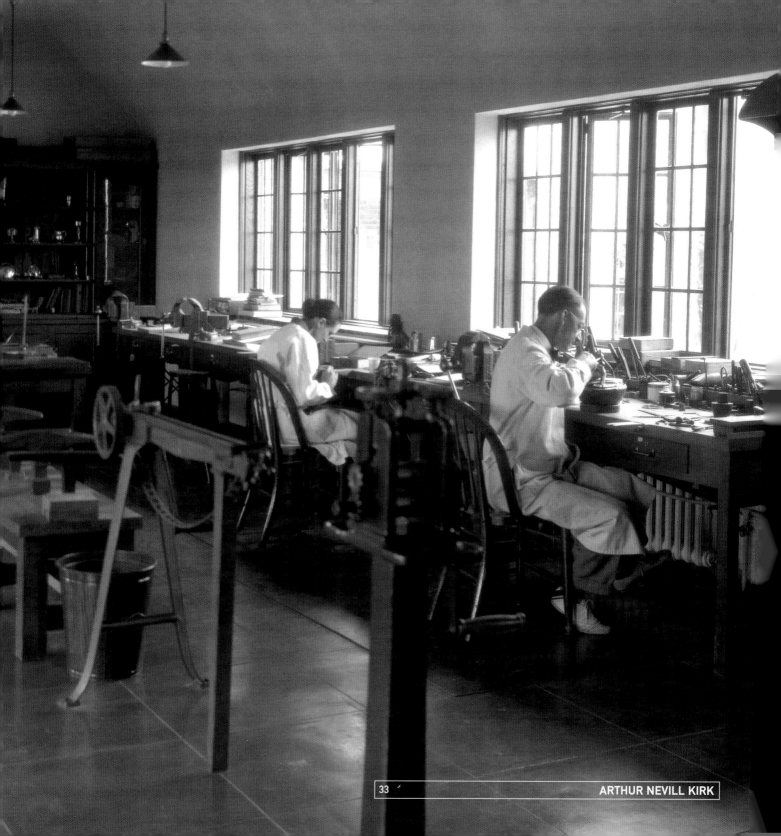

ARTHUR NEVILL KIRK

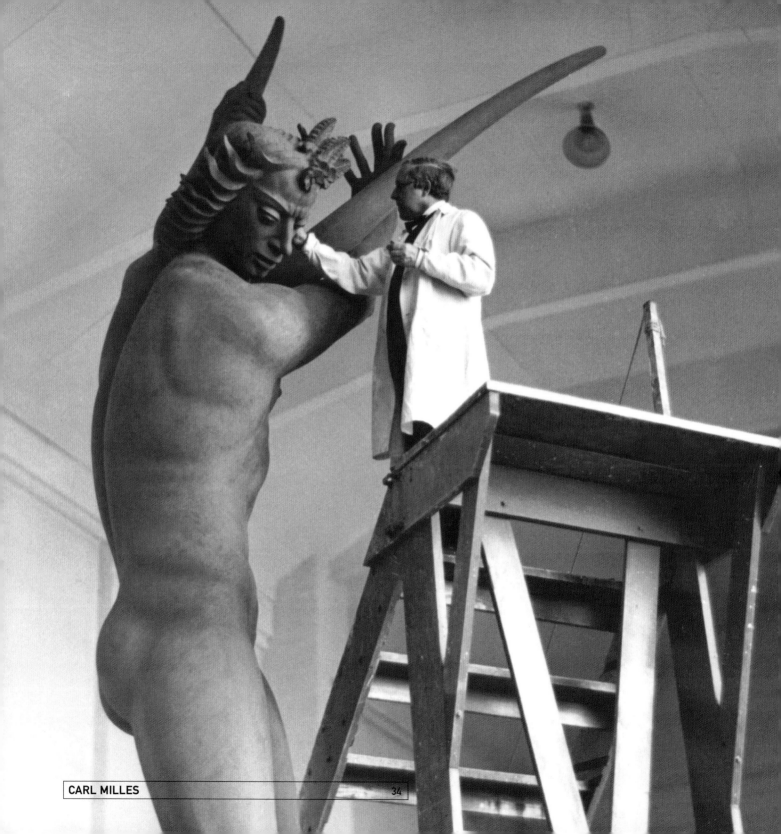

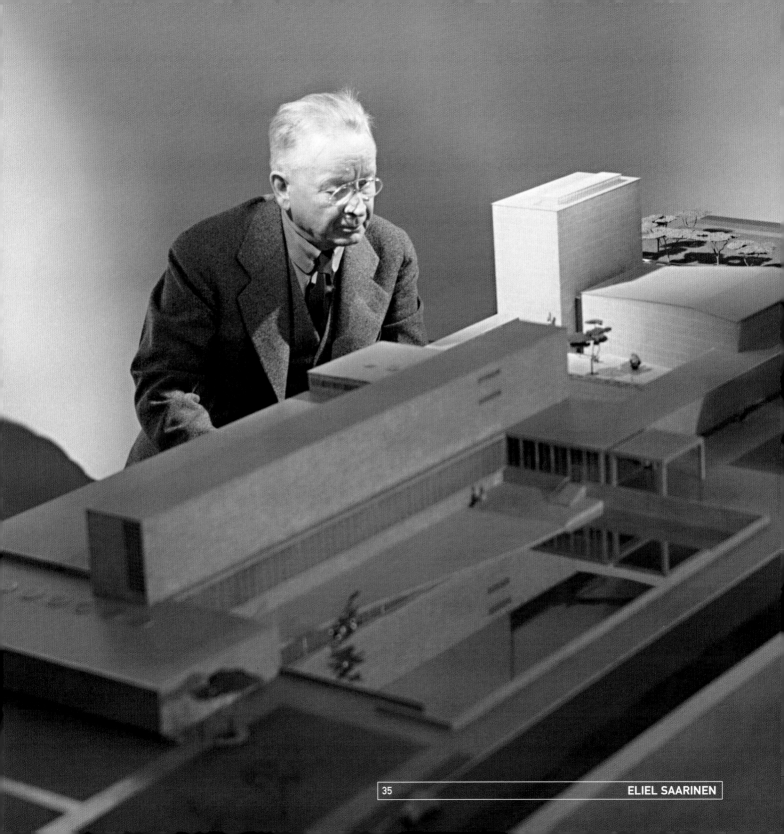

ELIEL SAARINEN

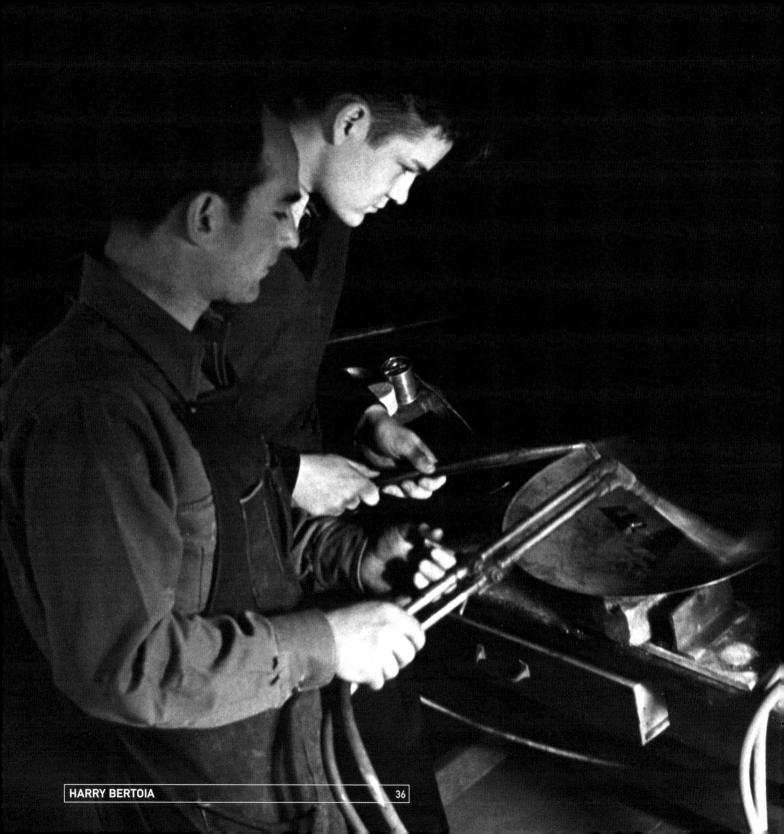

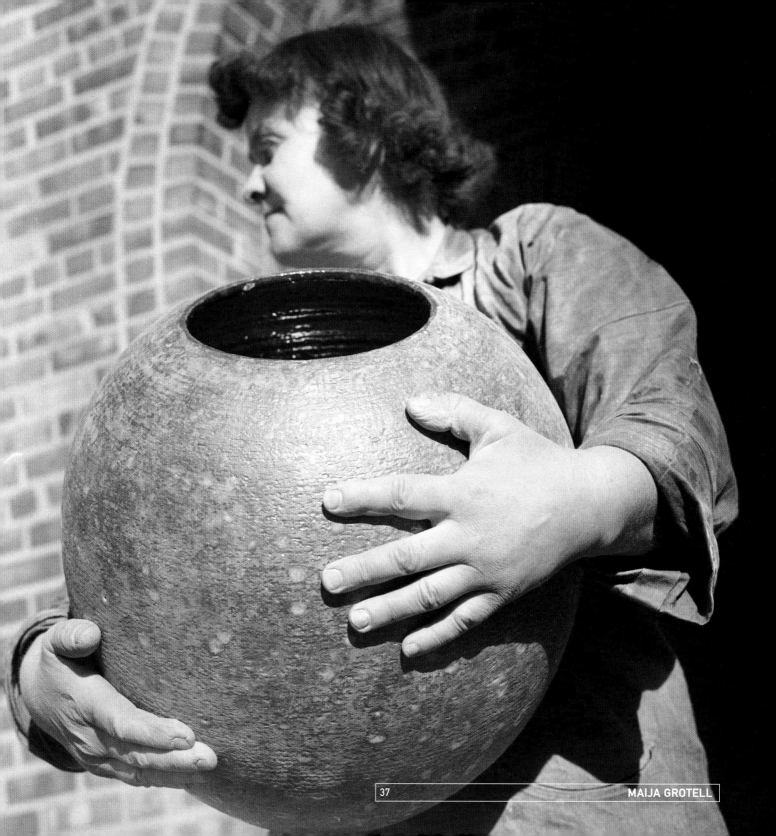

MAIJA GROTELL

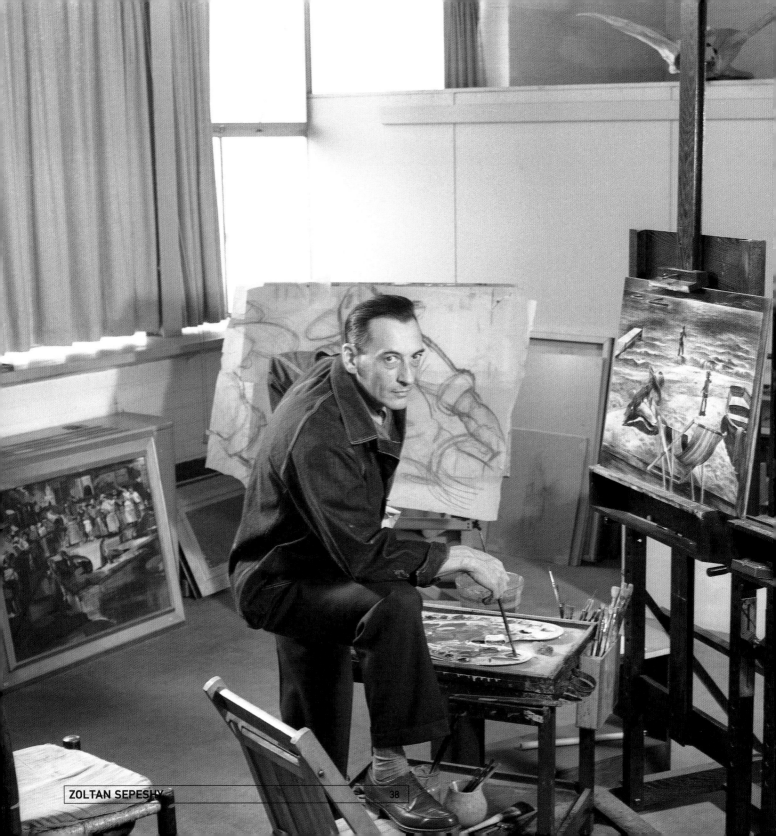

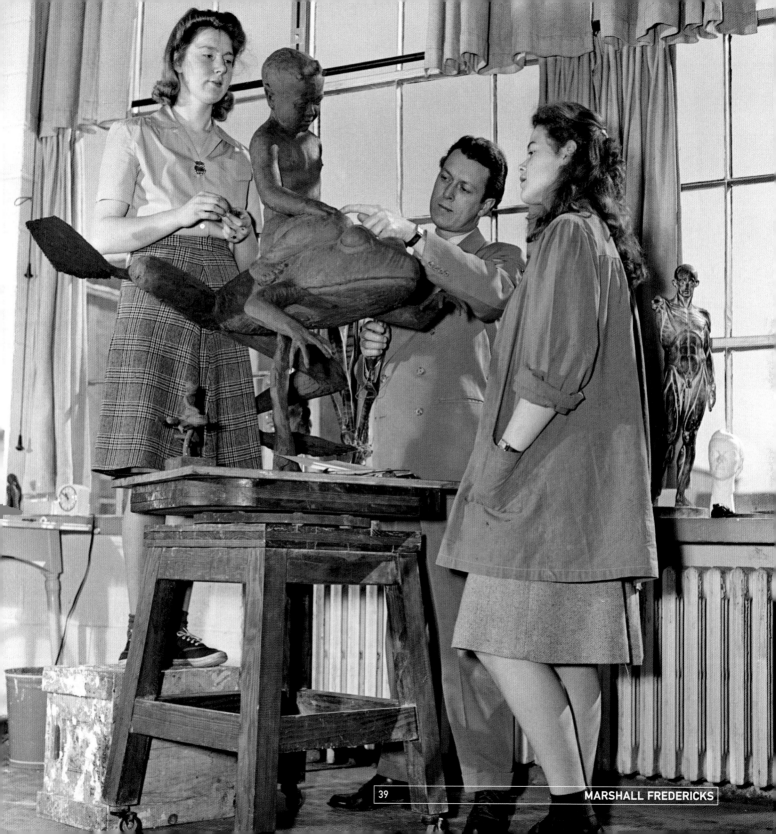

MARSHALL FREDERICKS

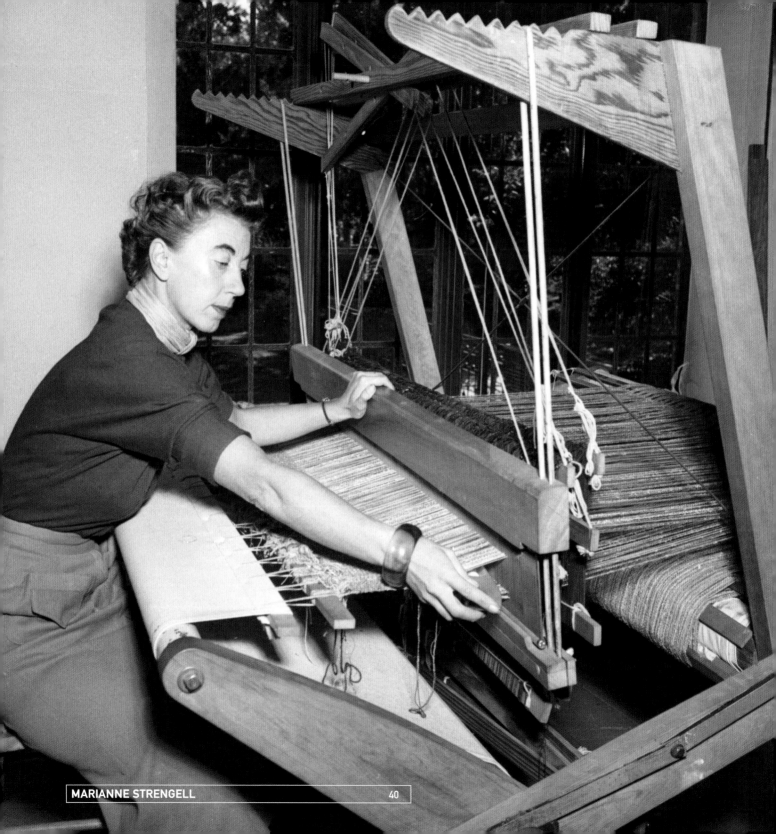

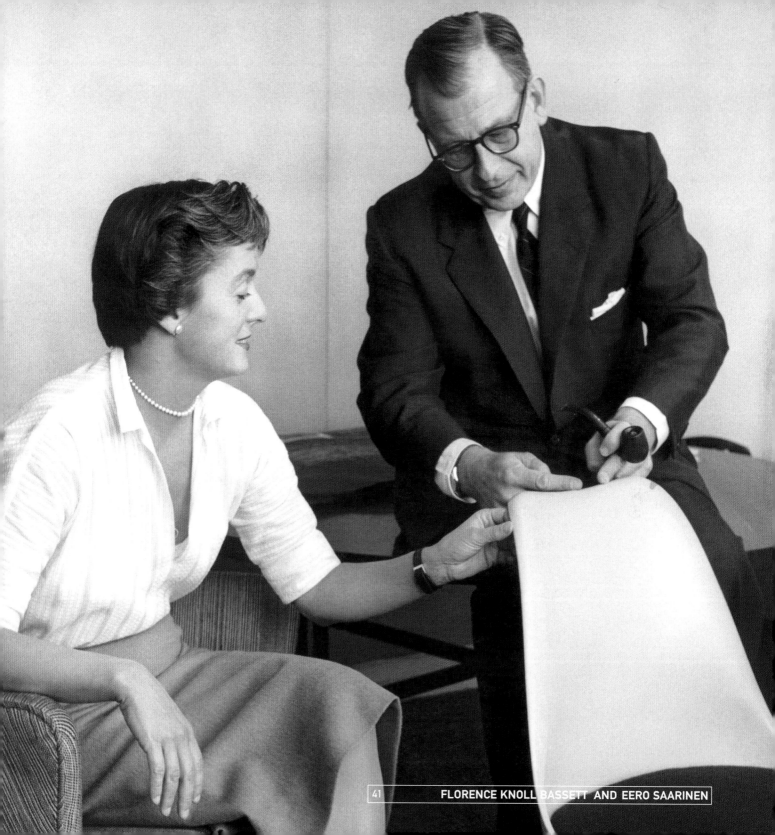

FLORENCE KNOLL BASSETT AND EERO SAARINEN

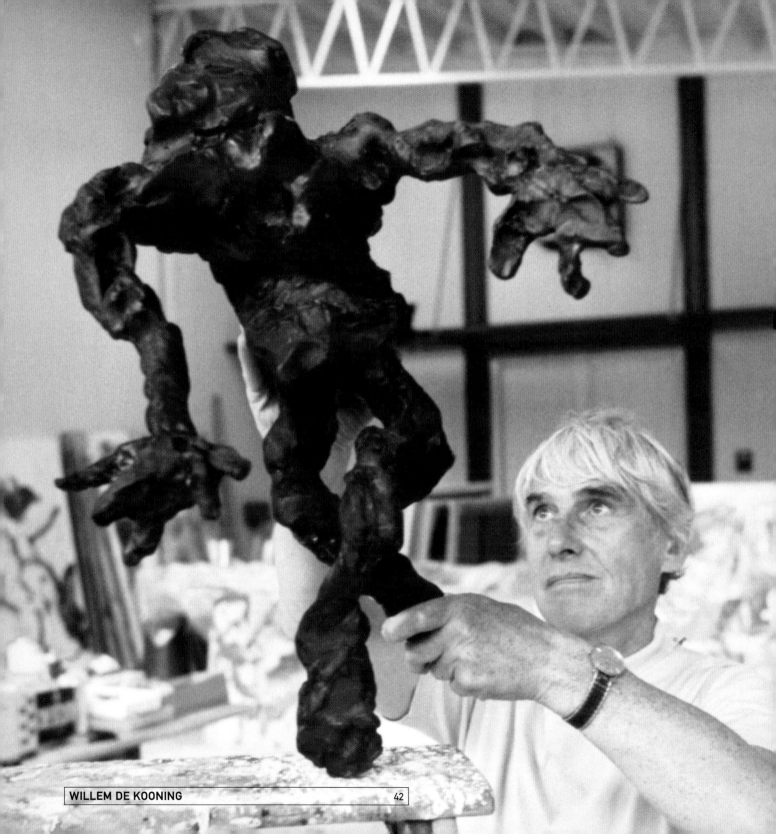

WILLEM DE KOONING 42

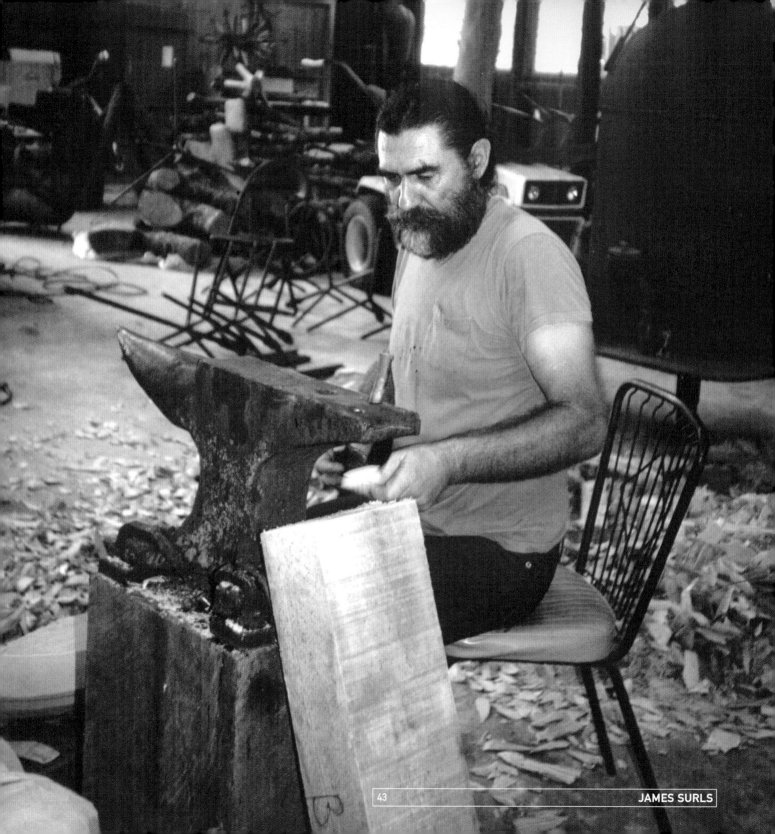

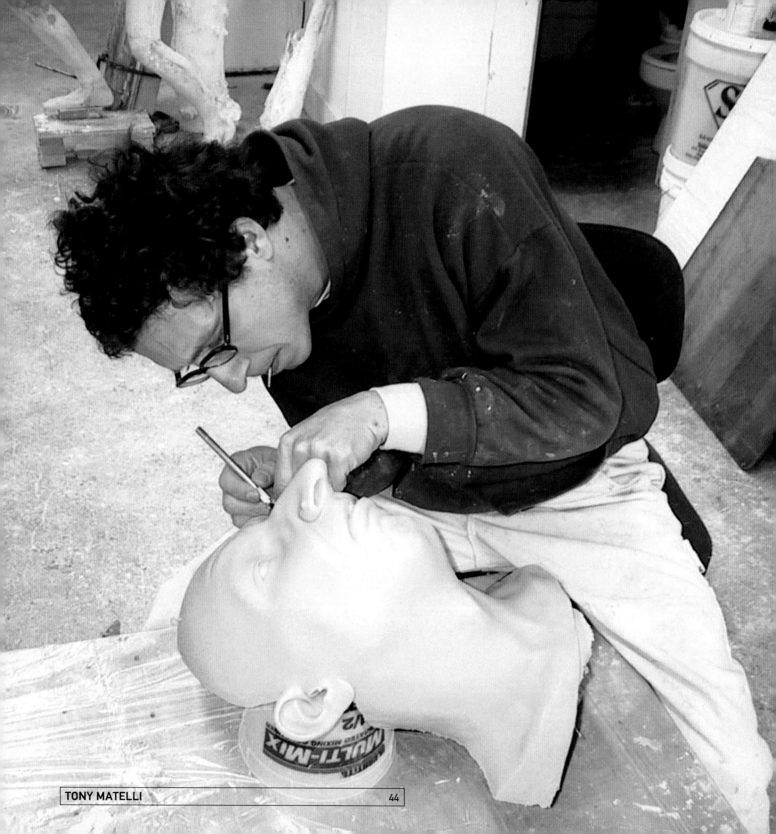

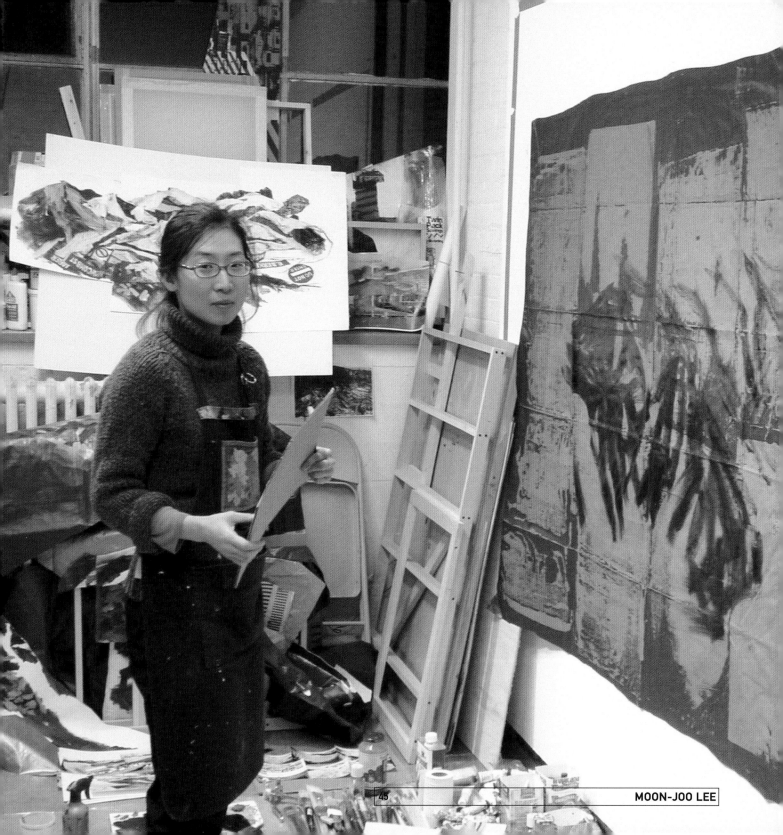

MOON-JOO LEE

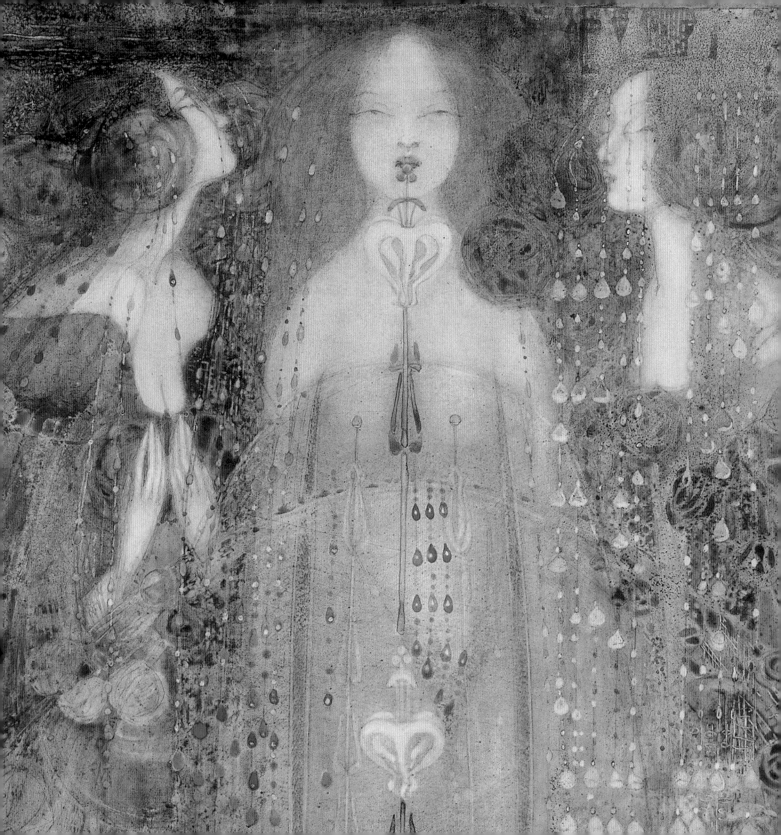

A LIFE WITH BEAUTY
The Arts and Crafts Movement
1904-1940

A revival in aesthetics and handicraft emerged in the nineteenth century in reaction to industrialization and its deleterious social effects. With its epicenter in Great Britain, the Arts and Crafts movement flowered internationally by the dawn of the new century, privileging handmade objects of utility and beauty over those of mass production. In Detroit, birthplace of the factory assembly line, successful newspaper publisher George Gough Booth and his wife Ellen Scripps Booth embraced this aesthetic revival for the benefit of their growing family and the greater good of the community.

An Anglophile and coppersmith in his youth, George Booth helped to found the Detroit Society of Arts and Crafts in 1906 and acquired works by masters of the movement from the Society's annual exhibitions. He also commissioned leading artisans such as silversmith Arthur Stone and woodworker John Kirchmayer to create extraordinary interiors, furniture and decorative objects for his properties, including Cranbrook House, the family's Tudor-style home completed in 1908, and the Neo-Gothic Christ Church Cranbrook, consecrated two decades later. More than a patron, Booth actively collaborated on many projects, leaving his imprimatur throughout the collection.

The Booths were guided by the tenets of British designer William Morris, the spiritual leader of the Arts and Crafts phenomenon, in their creation of an educational community which valued artistry as a means to personal and social transformation. Some of the artists invited to work in the original Craft Studios in the late 1920s became the first teachers at the Academy of Art when it opened on the estate in 1932. The Booths' personal collection of Arts and Crafts textiles, woodwork and metalwork formed a significant part of Cranbrook Art Museum, which opened to the public in its original location in 1930. On a prominent archway on campus, Booth inscribed the inspirational philosophy that shaped Cranbrook: "A life without beauty is only half lived."

Joe Houston

1 Eli Harvey (Sculptor)
Recumbent Lioness, 1904

Born 1860, Ogden, Ohio; died 1957, Alhambra, California

Foundry: Pompeian Bronze Works, New York
Bronze
7 1/2 x 5 x 21 1/2 inches
Gift of George Gough Booth and Ellen Scripps Booth
CAM 1909.1

George Booth purchased this resting lioness in
1909 from Tiffany & Company in New York and
prominently displayed it in the Sunset Room of
his newly completed home north of Detroit,
Cranbrook House. Although not the oldest work
in his art collection, which became the
permanent collection of Cranbrook Art Museum,
it was assigned the first accession number: 1909.1.
At the time, Eli Harvey was widely recognized as
a leading American animal sculptor, known in
particular for the moods of his lions—majestic,
shy, frolicsome, fierce. Among his most
celebrated commissions were the four seated
lions he carved in stone for the Lion House at the
Bronx Zoo (1901-1903). Initially trained as both a
painter and a sculptor in Cincinnati, Harvey
devoted himself almost exclusively to animal
sculpture following his studies in Paris with the
French *animalier* sculptor Emmanuel Frémiet at
the Paris Zoo. In this work, Harvey demonstrates
his subtle understanding of feline behavior.
With her ears pinned back slightly and tail
curled warily, his *Recumbent Lioness* remains
pensive but alert.
 Gregory Wittkopp

Albert Kahn (Architect), 1869-1942
Cranbrook House, Sunset Room,
with **Recumbent Lioness**,
photographed in 1920
Photograph Collection of Cranbrook
Archives (E480)

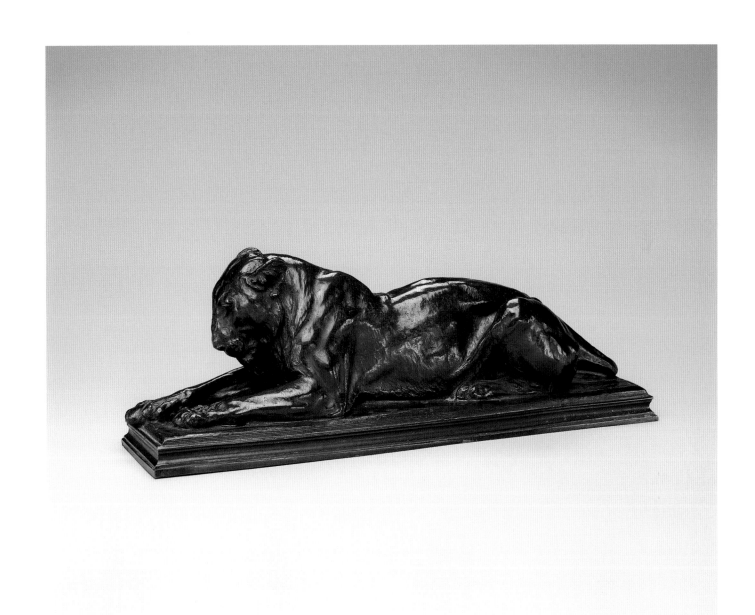

2 Margaret Macdonald Mackintosh
The Three Perfumes, 1912

Born 1864, Newcastle-under-Lyme, England; died 1933,
Pont Vendres, France

Watercolor and pencil on vellum
19 3/4 x 18 3/4 inches
Gift of George Gough Booth and Ellen Scripps Booth
CAM 1955.275

William B. Stratton and
H. J. Maxwell Grylls (Architects),
Stratton: 1865-1938, Grylls: 1865-1942
Detroit Society of Arts and Crafts
on Watson Street, photographed
circa 1916
Photograph Collection of Cranbrook
Archives (FD192)

As ephemeral as fragrance, this image of
The Three Perfumes comes into focus like an
ethereal vision. Dressed in flowing, heavily
patterned jewel-tone mantels exquisitely adorned
with roses and lotus-like blossoms, three maidens
cluster around a fragrant white lily as blue and
pink droplets of perfume rain down from them.
This rhapsody of fleeting beauty was produced
by Margaret Macdonald Mackintosh, the wife and
creative partner of Charles Rennie Mackintosh,
the great Scottish architect and designer.
Working together, they were pioneers of the
"Glasgow Style," a unique blending of ancient
Celtic design and symbolism with Art Nouveau,
an elegant stylization of foliate forms derived
from nature. Mackintosh was accomplished in the
fields of repoussé metalwork, oil and watercolor
painting, stencils, fabrics, and interior design.
This delicate watercolor of *The Three Perfumes*
was purchased by Cranbrook Founder George
Booth from the Detroit Society of Arts and Crafts'
"Exhibition of British Arts & Crafts" in 1920.
David D.J. Rau

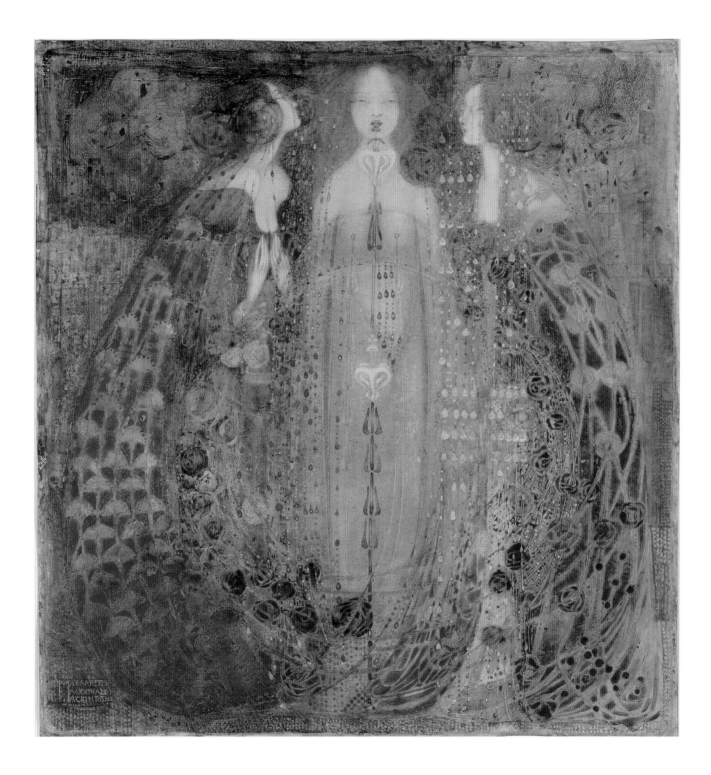

3 William Morris (Designer)
A Collection of Seventy-Two Wallpaper Samples,
designed 1864 to 1890, printed 1932, or earlier
(clockwise, from upper left)
Wild Tulip, designed 1884; printed circa 1932, 28 5/8 x 21 inches
Lily and Pomegranate, designed 1886, 29 x 21 inches
Pimpernel, designed 1876, 26 7/8 x 21 1/8 inches
Fruit or **Pomegranate**, designed 1864, 24 5/8 x 22 1/2 inches

Born 1834, Essex, England; died 1896, Hammersmith, England

Printer: A. Sanderson and Sons, Ltd., London, England
Hand-printed wood block prints in distemper colors on wove paper
Gift of Mrs. William H. Hansen
CAM 1991.17

William Morris
Evenlode (Fabric Sample),
designed 1883
Printed cotton
Gift of Mrs. William H. Hansen
(CAM 1991.16.9.1)

These wallpaper samples are a representative
selection of the seventy-two wallpaper samples
donated to the museum in 1991. This superb collection,
with many of the samples bearing the stamp of
Morris & Co., accompanies the fine Arts and Crafts
collection accumulated by Cranbrook's founder,
George Booth. Booth was a firm believer in William
Morris's philosophy that art and design were not
only important aspects of a healthy life,
but also should be available to everyone.

A poet, typographer, political activist, and
designer of objects ranging from furniture to stained
glass, Morris was undeniably one of the most
influential men in design in the last 150 years.
By emulating medieval production techniques,
Morris successfully redirected late nineteenth- and
early twentieth-century design away from nameless,
mass-produced wares to objects handcrafted and
designed by a named designer. While attempting to
change production methods, Morris also strove to
alter patterning and decoration trends. As these
samples show, Morris favored rhythmic and stylized
patterning based on nature. As such, his work
contrasted sharply with the heavily decorated
Victorian objects common at the time.

Ellen M. Dodington

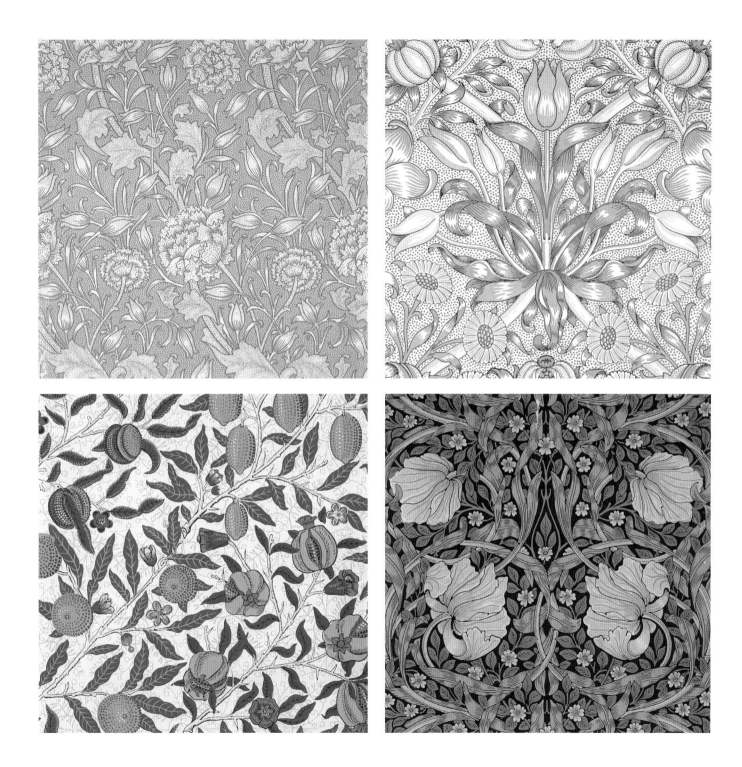

4 May Morris (Designer)
Bed-Hangings (Two Curtains), 1917, or earlier

Born 1862, Bixley Heath, England; died 1938, Lechlade, England

Embroiderers: May Morris and Mary J. Newill
Embroidered wool on linen
Each panel: 76 3/4 x 27 inches
Gift of George Gough Booth and Ellen Scripps Booth
CAM 1955.402.A and .B

May Morris learned textile design from her father, William Morris (1834-1896), and embroidery from her mother, Jane Burden Morris (1839-1914). An astute businesswoman, author and lecturer, May was so accomplished as a designer and embroiderer that she became Morris & Co.'s director of textile production at age twenty-three.

These panels were exhibited at the 1916 "Arts & Crafts Exhibition" in London and were reproduced in *The Studio: Year-Book of Decorative Art* in 1917. In November and December of 1920, the panels were shown in the "Exhibition of British Arts & Crafts" held at the Detroit Society of Arts & Crafts. George Booth, who met Morris during her lecture tour in the United States in 1911, purchased the panels out of this exhibition along with the matching valance and embroidered headboard panel. Booth hung these on his own bed in Cranbrook House where they remained until they were donated to Cranbrook Art Museum in 1955.

Ellen M. Dodington

Albert Kahn (Architect), 1869-1942
Cranbrook House, George Gough Booth's Bedroom, with May Morris's **Bed-Hangings**, photographed in 1923
Photograph Collection of Cranbrook Archives (E490)

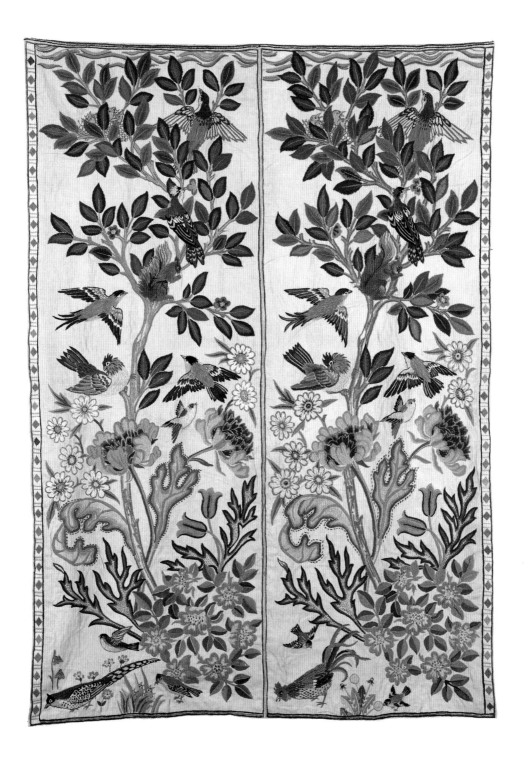

5 Adelaide Alsop Robineau
A Collection of Thirty-Four Vases and Jars, 1909 to 1926

Born 1865, Middletown, Connecticut; died 1929, Syracuse, New York

Porcelain
Heights: 2 to 11 7/8 inches
Gift of George Gough Booth and Ellen Scripps Booth
Accessioned between 1929 and 1975

Adelaide Alsop Robineau
Egg Shell Coupe, 1919, or earlier
High fire porcelain
Gift of George Gough Booth and Ellen
Scripps Booth (CAM 1944.154)

Pushing beyond the limitations of her craft, china painter Adelaide Robineau decided to try her hand at high fire porcelain production in 1903. Armed with only a few weeks' instruction at a pottery school and information gleaned from published articles on Sèvres porcelain, Robineau began a slow and laborious process of mastering the techniques that would eventually make her one of the best-known ceramists of her day. Through experimentation, she developed many glazes and a range of novel techniques—such as carving designs in the fresh clay before glazing—that resulted in exquisitely fashioned pieces renowned for their intricate detail and beautiful finishes. To ensure the highest quality of her art, Robineau destroyed all work that did not measure up to her exacting standards.

George Booth was captivated by Robineau's artistry and helped to promote her work to public audiences. Cranbrook's collection of Robineau porcelains is the second largest in the country. Among the Art Museum's holdings is a rare *Egg Shell Coupe*, one of only two in existence.
Mark A. Coir

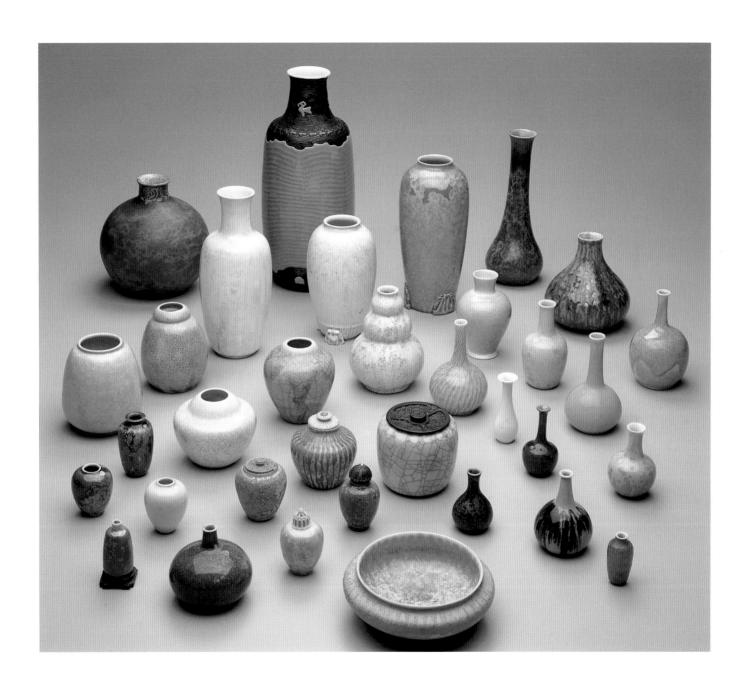

6 Arthur J. Stone
Coffee and Tea Service, 1916-1918

Born 1847, Sheffield, England; died 1938, Gardner, Massachusetts

Sterling silver
Coffee Pot height: 10 7/16 inches
Tray width: 30 3/8 inches
Gift of George Gough Booth and Ellen Scripps Booth
CAM 1944.9 through 1944.16

Underside of **Tea Caddy** showing
George Gough Booth's initials and
Arthur J. Stone's maker's mark
Gift of George Gough Booth and Ellen
Scripps Booth (CAM 1944.15)

A close relationship between patron and craftsman was already well-formed when George Booth commissioned Arthur Stone to begin this coffee and tea service in May 1916. Supported through precise technical execution of Arts and Crafts iconography, this extraordinary sterling silver and gold service was two years in production. Booth's intimate role in the development of the tea caddy is accurately relayed in Stone's written remarks to Booth: "You are right in assuming that I took pleasure in making this small piece. . . . The only way I could acknowledge your design [a rough sketch Booth had made while in Stone's workshop] was to put your initials with my name at the bottom." Additionally, the tea strainer, delicately wrought with inlaid gold grapes and pierced silver leaves encircling the bowl, caused Mrs. Stone to write, "I seldom covet anything going out from the shop as I do that [tea strainer]. It is such a perfect specimen of Mr. Stone's work, both in design and execution" (Booth Papers, Cranbrook Archives).
 Gary S. Griffin

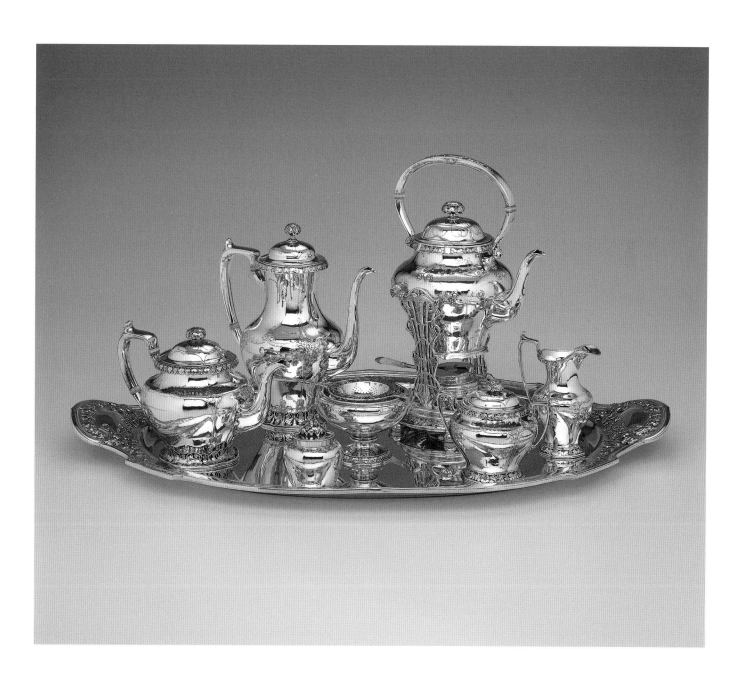

ABCDEFGH
IJKLMNO
PQRSTU
VWX
YZ
&

Eric Gill
Alphabet (I) for St. Dominic's Press,
1918
Woodcut
From **Eric Gill: The Engravings** by
Christopher Skelton; David R. Godine,
Publisher, 1990

7 Eric Gill (Designer)
Alms Dish, 1930, or earlier

Born 1882, Brighton, England; died 1940, London, England

Metalsmith: H.G. Murphy
Engraver: G.T. Friend
Silver
2 3/4 x 14 1/2 (diameter) inches
Gift of George Gough Booth and Ellen Scripps Booth through
The Cranbrook Foundation
CAM 1930.74

Eric Gill, active in the British Arts and Crafts
movement, trained in architecture before
realizing his true passion lay in lettering.
He studied writing and illumination at the
Central School for Arts & Crafts, London, and
worked as a sculptor, typographer, illustrator and
stone carver. Gill designed many fonts still in use
today, most notably Gill Sans (1927-1930) and
Perpetua (1929). He influenced the next
generation of British stone carvers and letter
cutters through his work and teachings, and
established an informal Arts and Crafts
community in Ditchling Common, England.

A Catholic convert in 1913, Gill imbued this
Alms Dish with his strong faith. As the plate
attests, his later work became increasingly
involved with religious themes. Although a
traditional object, the plate's design exhibits a
modern sensibility with flattened forms
represented by a minimal amount of modeling
and line while depicting scenes from the
Old and New Testament. George Booth
purchased this work for the Museum's collection
from the American Federation of
the Arts' "Third International Exhibition of
Contemporary Industrial Arts" in 1930.

Ellen M. Dodington

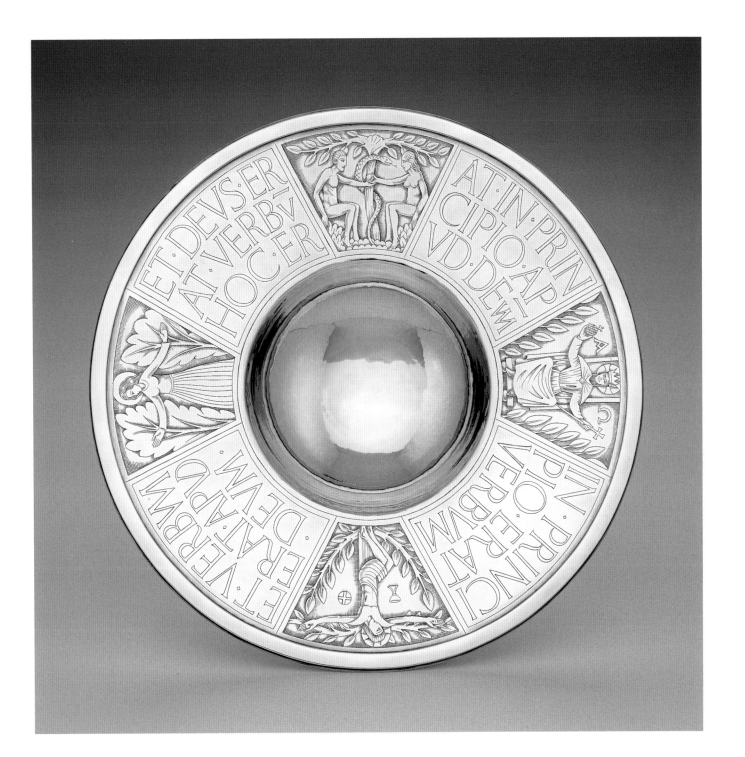

8 Wilhelm Rupprecht (Designer)
Twenty-Four Scenes from the Book of Genesis,
designed 1921, executed 1923, installed at Cranbrook
Art Museum 1942

Born 1886, Stadtprozelten, Germany; date and location of death
unknown

Manufacturer: Zettler Royal Bavarian Glass Staining Company,
Munich, Germany
Stained glass
Each panel: 11 3/4 x 8 3/8 inches
Gift of Mrs. Ralph H. Booth
CAM 1955.376.1 through .24

Wilhelm Rupprecht
Untitled from the portfolio **Passion**,
1922
Woodblock print
Collection of Cranbrook Art Museum
(CAM 1955.44)

German artist Wilhelm Rupprecht tells the
Biblical story of creation by merging medievalist
conventions with modernist style in this stained
glass work. In the panel of God admonishing
Adam and Eve for eating from the tree of
knowledge, for example, Rupprecht represents a
larger God (to show his greater importance)
towering over the modern figures of Adam and
Eve, whose more closely observed bodies are
modeled with paint. Rupprecht also produced a
series of woodcuts on Christ's Passion, in the
collection of Cranbrook Art Museum, which
includes a scene of Palm Sunday set in a
modern metropolis.

Designed in Munich in 1921 and installed in
the Art Museum foyer in 1942, the twenty-four
panels, placed in random order, are part of a
larger series of twenty-seven panels depicting
the story of Genesis. They capture the light in a
rich palette of lapis lazuli blue, emerald green,
turquoise, red and ochre. Well known for his
religious devotion, George Booth must have felt
the installation of this work sanctified the Art
Museum as a temple for art.

Dora Apel

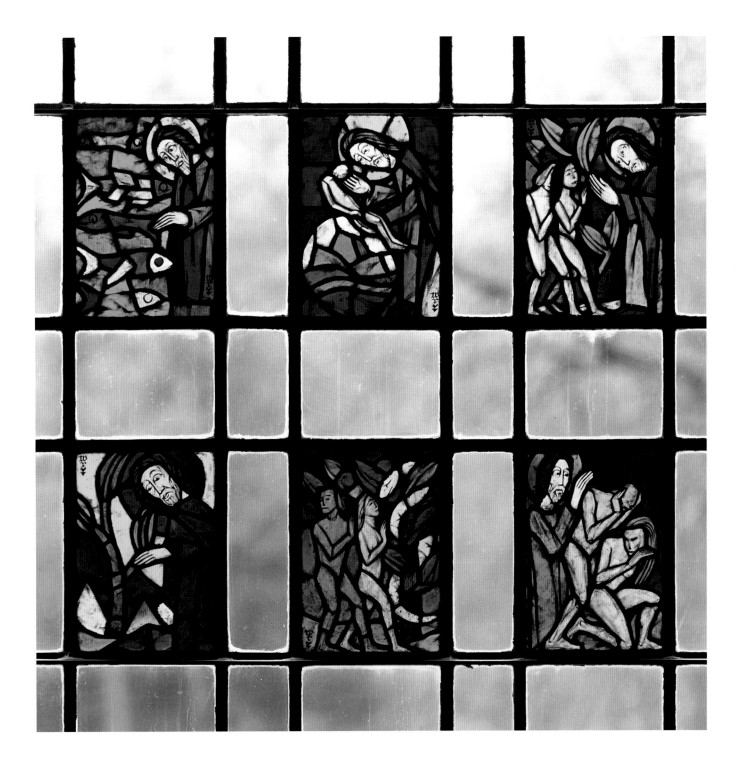

9 Albert Herter
The Great Crusade, 1920

Born 1871, New York, New York; died 1950, Santa Barbara, California

Manufacturer: The Herter Looms, Inc., New York, New York
Cotton, wool and silk tapestry
156 x 120 inches
Gift of George Gough Booth and Ellen Scripps Booth
CAM 1944.83

George Gough Booth,
1864-1949
**Sketch for The Great
Crusade**, 1918
Pencil on paper
Collection of Cranbrook
Archives (ACC 1981-01)

George Booth was inspired to mark the end of World War I in 1918 with a commemorative tapestry designed in the European tradition. His pen and ink sketch was submitted to renowned designer Albert Herter in New York City, who developed Booth's concept and oversaw the work's production by the Herter Looms in 1920. The resulting tapestry is beautiful, unique and dense with political symbolism.

Since the Middle Ages, tapestries functioned as a means to document and glorify the "progress" of civilization. *The Great Crusade* presents America, whose involvement in the battlefields brought the war to an end, as the savior of European culture. The tapestry depicts the great political and religious leaders of Europe's cultural past standing on the ground (Henry VIII, Francis I, Joan of Arc, among others) welcoming the triumphant victor, General Pershing on horseback, leading his troops. A Renaissance-style angel of victory is suspended in the sky above the crowd, accompanied by American bi-planes, the first ever used in warfare. The tapestry is a "red-carpet" homage to the victors.

Gerhardt Knodel

10 John Kirchmayer
Reading Desk and Bench, 1919, or earlier

Born 1860, Oberammergau, Germany; died 1930, Boston, Massachusetts

Carved wood
Desk: 44 1/4 x 43 1/4 x 21 1/2 inches
Bench: 20 x 41 7/8 x 12 1/8 inches
Gift of George Gough Booth and Ellen Scripps Booth
CAM 1919.10.A and .B

John Kirchmayer
Music (detail), 1917,
or earlier
Carved wood with gold
Gift of George Gough Booth
and Ellen Scripps Booth by
exchange (CAM 1944.102.A)

Trained in the famous workshops of his native Oberammergau, Bavaria, master carver John Kirchmayer immigrated to the United States in the 1880s and settled in Cambridge, Massachusetts. There, in the view of many, he developed into the finest woodcarver in the land, turning out hundreds of sculptures, decorative panels and other works of art for churches, businesses, institutions and private homes. Kirchmayer had close working relations with a number of prominent architects and artisans and was a founding member of the Society of Arts and Crafts, Boston.

George Booth made Kirchmayer's acquaintance through his Arts and Crafts activities and soon became one of his most ardent patrons, commissioning him to produce many carvings for Christ Church Cranbrook, Cranbrook House and the Booth Collection of decorative arts at the Detroit Museum of Art. Booth particularly enjoyed this reading desk and bench, which Kirchmayer crafted for the Booths' library in 1919 from a sketch that Booth supplied. At Booth's request, Kirchmayer finished the Gothic-styled work in a dark stain to contrast it with the lighter woodwork of the room.

Mark A. Coir

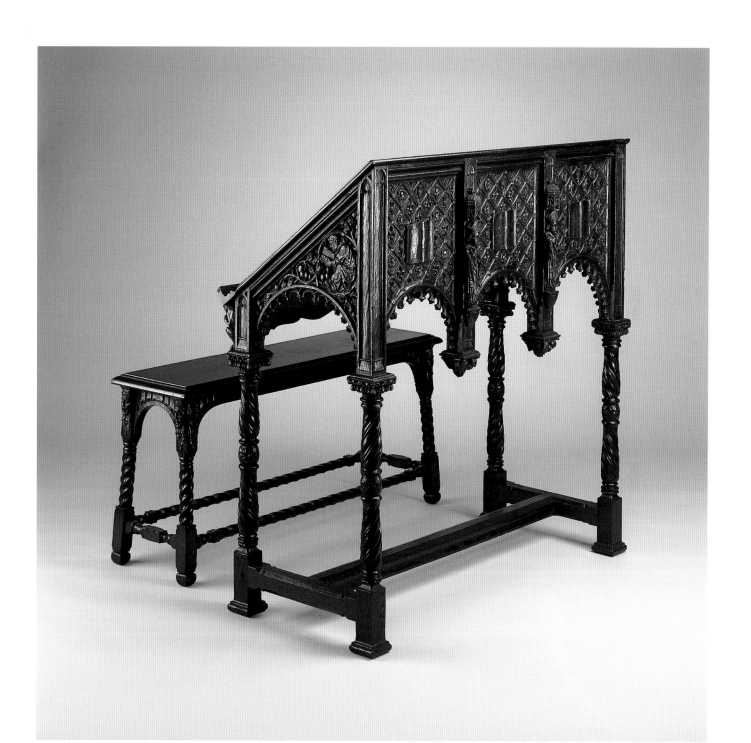

11 Paul Manship
Pair of Candelabra (Venus and Vulcan and Adam and Eve), 1916

Born 1886, St. Paul, Minnesota; died 1966, St. Paul, Minnesota

Foundry: Roman Bronze Works, Brooklyn, New York
Bronze
Each candelabrum: 58 1/2 x 12 1/2 x 12 1/2 inches
Gift of George Gough Booth and Ellen Scripps Booth
CAM 1942.24 and 1942.25

Paul Manship
Armillary Sphere, circa 1924
Bronze
Cranbrook Cultural Properties
Collection, Cranbrook Schools,
Cranbrook Campus, Gift of
George Gough Booth and
Ellen Scripps Booth (CS 58)
Photograph Collection of
Cranbrook Archives (CEC1954)

At the age of twenty-three, Paul Howard Manship became the youngest sculptor ever to receive the prestigious Prix de Rome fellowship. While in Europe, he acquired a love of Classical and Renaissance art and became fascinated with Greek and Roman mythology. After returning to the United States, he created several works for his Manhattan home in 1916, including the original pair of these candelabra in gilt-bronze. *Adam and Eve* and *Venus and Vulcan*, which personify Manship's love of the juxtaposition of human and animal forms, were exhibited at the Detroit Society for Arts and Crafts in 1919.
The candelabra exemplify the style Manship became known for—sensitivity to forms, polished contours, and symmetrical compositions.
The detail of the low reliefs (as shown on the candle collars) was achieved by his skillful carving of the plaster mold. This pair of cast bronze candelabra was purchased by George Booth for the Still Room in Cranbrook House which features a painted Pompeian motif.

 Leslie S. Edwards

12 H. Van Buren Magonigle (Designer)
Samuel Yellin (Maker)
Flower Basket, 1918, or earlier, Detail of the
Door Grille for the McNair Residence, New York,
New York, circa 1915

Van Buren Magonigle: Born 1867, Bergen Heights, New Jersey;
died 1935, Bain Harbor, Vermont
Yellin: Born 1885, Galicia, Poland; died 1940, Philadelphia,
Pennsylvania

Iron Company: Arch Street Metalworkers' Studio, Philadelphia,
Pennsylvania
Wrought iron
37 1/2 x 20 7/8 inches
Gift of George Gough Booth and Ellen Scripps Booth
CAM 1944.158

One of America's most renowned blacksmiths,
Samuel Yellin ran his own firm in Philadelphia
from 1910 until his death in 1940. In 1918, George
Booth acquired *Flower Basket* for his metals
collection as a superb example of Yellin's artistry
and craftsmanship. The motif was designed by
architect H. Van Buren Magonigle and was
originally used at the McNair Residence in
Manhattan in 1915 as part of an elaborate door
grille (now in the permanent collection of The
Metropolitan Museum of Art). Beautifully forge-
welded on both sides, the ornamental flower
basket exemplifies Yellin's mastery in
blacksmithing and his commitment to Arts and
Crafts style. In a letter to Booth dated December
11, 1922, Yellin observed, "It is so important that
any craft which is put into a museum should first
be designed for its proper material and then
executed in its proper material." Booth, an avid
admirer of Yellin's work, also commissioned him
to design and fabricate much of the interior
hardware and two of the main exterior entrance
gates of his own residence, Cranbrook House.
 Sarah Schleuning

Samuel Yellin
**Door Grille for the
McNair Residence**.
Wrought iron
Collection of The
Metropolitan Museum of Art

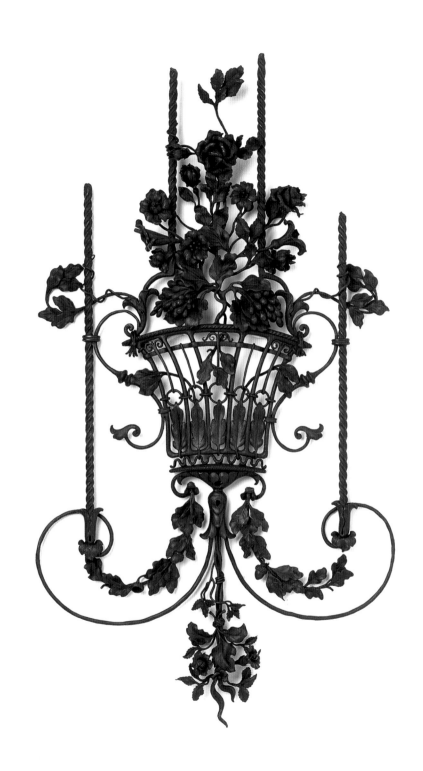

13 Emile Lenoble
Vase, 1928, or earlier

Born 1875, Paris, France; died 1939, Choisy le Roi, France

Stoneware
10 1/4 x 8 1/4 (diameter) inches
Gift of George Gough Booth and Ellen Scripps Booth
CAM 1929.134

Emile Decoeur, 1876-1953
Vase, circa 1925
Stoneware
Gift of George Gough Booth and Ellen
Scripps Booth (CAM 1926.28)

Emile Lenoble studied at the École des Arts Décoratifs in Paris before working for his father-in-law, the famed late nineteenth-century French ceramist, Ernest Chaplet. Through experimentation, Chaplet's guidance, and exposure to Pre-Columbian, Asian and Greek ceramics at various exhibitions, Lenoble developed a personalized vocabulary of expression. Traditional shapes decorated with precise geometric incisions characterize his work and reflect the influence of ancient cultures on his vessels. Lenoble often complemented his stylized and abstracted patterns with white, beige and black glazes, reinforcing his ties to ceramists of antiquity while also appealing to graphic Art Deco sensibilities. Notable Art Deco designers such as Jacques-Emile Ruhlmann recognized Lenoble's talent and often commissioned pottery from him.

George Booth purchased this vase from the "International Ceramic Exhibition" organized by the American Federation of the Arts. This traveling exhibition came to the Detroit Society of Arts and Crafts in 1929. Booth, a founding member and past-president of the Society, purchased several works from the exhibition in order to represent the finest achievements in contemporary art at his newly formed educational community, Cranbrook.

Ellen M. Dodington

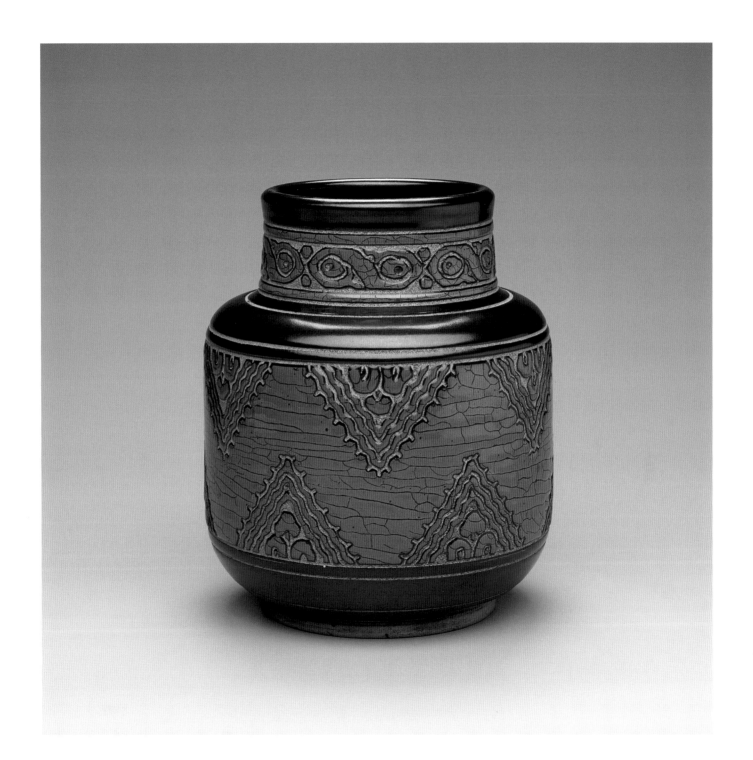

14 Mary Chase Stratton for Pewabic Pottery (Maker)
Jar, 1932, or earlier

Born 1867, Hancock, Michigan; died 1961, Detroit, Michigan

Pottery: Pewabic Pottery, Detroit, Michigan
Cast stoneware clay
9 1/2 x 7 (diameter) inches
Gift of George Gough Booth and Ellen Scripps Booth through
The Cranbrook Foundation
CAM 1932.13

Eliel Saarinen (Designer)
Mary Chase Stratton and Pewabic
Pottery (Maker)
**Saarinen House Living Room
Fireplace Mantel**, 1928-1929
Gift of Mary Chase Perry Stratton
(CAM 1992.25)

Mary Chase Stratton's interest in ceramics began
as a teen when she studied china painting in
Detroit with Bohemian artist Franz Bischoff.
After studying at the Art Academy of Cincinnati,
Stratton helped establish the Detroit Keramic
Club and later studied with Charles F. Binns in
New York. At the turn of the century, Stratton
began experimenting with various glaze formulas
and firing techniques with Horace J. Caulkins,
inventor of the Revelation China Kiln. Together
they founded Pewabic Pottery in 1903. At the
request of Pewabic enthusiast Charles Lang
Freer, Stratton began experimenting with
iridescent glaze effects and her interest shifted
from form to color.

This classic Arts and Crafts vase was first
decorated with a fritted (fused glass powder)
glaze over which Stratton applied an iridescent
glaze. The effect is suggestive of a landscape
that shifts in varying light. Two cascading vertical
lines of spar-copper glaze connect the earth tones
of beige, sienna and umber on the upper portion
of the cylinder with the smoky silvery grays that
slide into the blues and purples (Stratton's
favorites) on the lower portion of the vase.

Leslie S. Edwards

74

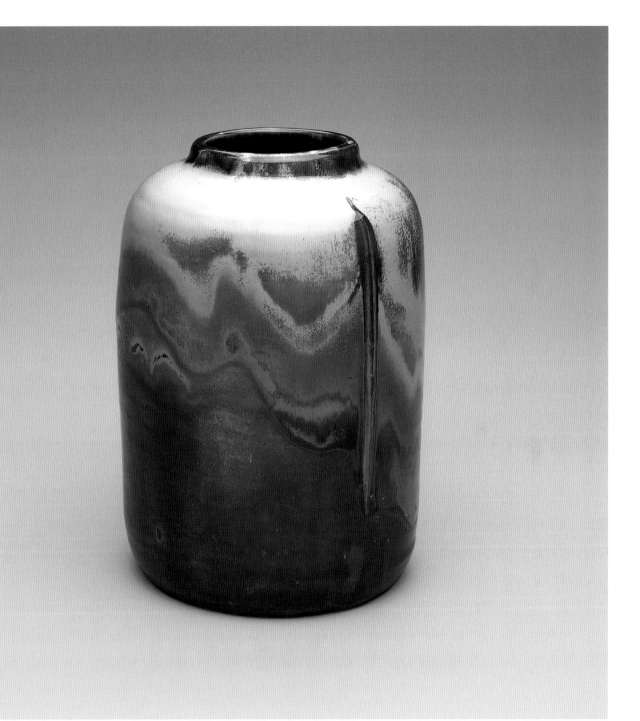

Frank L. Koralewsky
Detail of **Lock with Hinges and Key** revealing hidden keyhole compartment

15 Frank L. Koralewsky
Lock with Hinges and Key, 1932, or earlier

Born 1872, Straalsund, Germany; died 1941, Boston, Massachusetts

Iron Company: F. Krasser & Company, Boston, Massachusetts
Carved steel inlaid with brass and silver
Lock: 13 1/2 x 15 x 3 1/2 inches
Hinges: 9 1/4 x 6 1/2 x 1 inches
Key: 3/8 x 6 3/8 x 1 5/8 inches
Gift of George Gough Booth and Ellen Scripps Booth through
The Cranbrook Foundation
CAM 1932.3

Frank Koralewsky, chief designer for the Frederick Krasser Iron Company of Boston, followed in the German metalcrafting tradition of the Middle Ages. Pragmatic as well as literary, this *Lock with Hinges and Key* stands as a tour de force of Arts and Crafts sensibilities in metalwork. In the case of the literary, a craftsman stands ready to open the door to the lock's keyhole, a fictional doorway to knowledge. Within the lever handle a young boy whittles, projecting an inclination towards craft. In an adjacent relief, several figures present painting, basket- and pottery-making, and a student of art, fresh with his hard-earned diploma. Pragmatically, the lock is a shrewd mechanical device. To the right of the lockbox, a lever is concealed beneath a leaf. By pulling this lever to the right with a forefinger, the door within the lock opens to reveal the keyhole. The key, in turn, locks the latch. Over the door, an overtly moralistic motto—"When you do – Do it"—suggests that a craftsman should put his utmost efforts into his work.
Gary S. Griffin

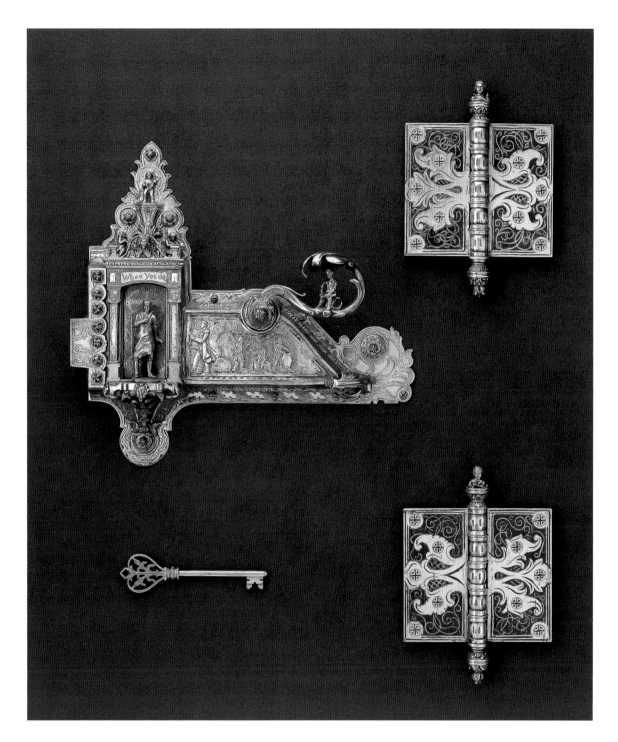

16 Arthur Nevill Kirk
Triptych, 1940, or earlier

Born 1881, Lewes, Sussex, England; Cranbrook School,
Instructor, 1927-1929; Cranbrook Academy of Art, Director of
Silver Shop, 1929-1933; died 1958, Birmingham, Michigan

Silver and enamel
9 5/8 x 6 x 3 inches
Gift of George Gough Booth and Ellen Scripps Booth through
The Cranbrook Foundation
CAM 1940.69

Arthur Nevill Kirk
Hand Mirror, circa 1931
Silver, ivory, enamel and
semiprecious stones
Gift of Henry Scripps Booth (CAM
1987.61)

Arthur Nevill Kirk was a renowned metalworking
instructor at the Central School of Arts and
Crafts in London when George Booth invited him
to relocate to Detroit in 1927. Kirk assumed a
postion at the Detroit Society of Arts and Crafts
and was commissioned to produce an
ecclesiastical plate for Christ Church Cranbrook.
The following year, Kirk moved his family to
Cranbrook, where he turned out a variety of
works while overseeing the Silver Shop associated
with the early Academy of Art operations.

This triptych in gold and silver and translucent
enamels was executed in 1940 while Kirk taught
metalwork and jewelry at Wayne University in
Detroit. The delicately rendered cloissonné
enameling depicts the Magi's gifts to the Christ
child. Kirk's remarkable technical skills as a
silversmith and his predilection for traditional
design is apparent in the crafting of the triptych's
casing, support and base. In spirit, it echoes an
earlier triptych that won Kirk a gold medal at the
famous 1925 Art Deco exposition in Paris.

Mark A. Coir

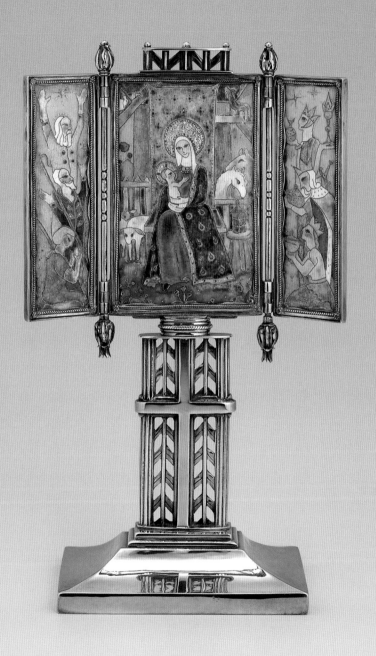

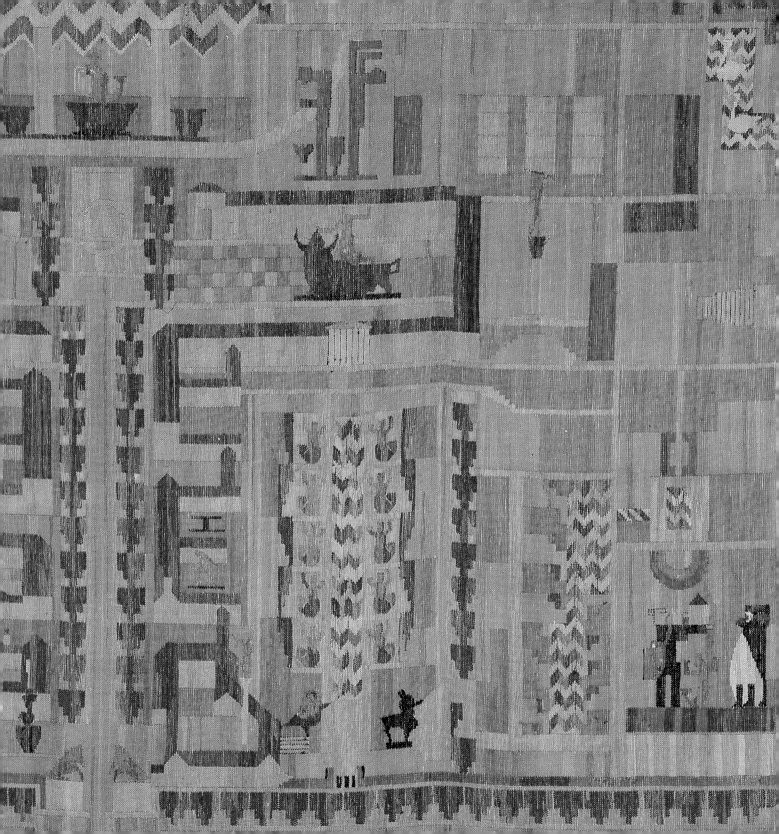

AN ENCHANTED PLACE
Creating the Cranbrook Community
1923-1946

George and Ellen Booth made their considerable fortune in publishing as owners of the **Detroit News** and a chain of regional papers. As a refuge from urban society, the couple purchased rambling property on the outskirts of Detroit in 1904, naming it Cranbrook after George Booth's ancestral English home. In 1908 the family moved into their new house designed by local architect Albert Kahn, adorning it with work by well-known artisans from America and Europe, some of whom were invited to work in studios on the property for an extended period.

By the early 1920s, the Booths conceived of a greater potential for their estate, envisioning an educational community that included craft workshops and schools for children. This idea quickly proliferated to encompass Christ Church Cranbrook, Brookside School, Cranbrook School for boys, Kingswood School Cranbrook, Cranbrook Academy of Art, Cranbrook Art Museum, and Cranbrook Institute of Science. George Booth guided the master plan and collaborated on many details of its design. Each building, pathway, fountain and garden added to an inspiring environment for education and creativity, integrating art, design and nature.

Finnish architect Eliel Saarinen was commissioned in 1925 to begin designing many of the buildings that unfolded throughout the property, with Swedish artist Carl Milles arriving in 1931 to grace the grounds with fanciful sculptures and fountains. Taking up long-term residence at Cranbrook, Saarinen, Milles and Hungarian painter Zoltan Sepeshy guided the Academy of Art when it opened in 1932. The Art Museum, which reopened at its current site in 1942, represents the crowning jewel in Booth's plan and Eliel Saarinen's final masterwork at Cranbrook. The imprint of the extended Saarinen family of designers, including Eliel's wife Loja, their children Pipsan and Eero, and son-in-law J. Robert F. Swanson, is found in the progressive modernist furnishings and interiors throughout the campus, now recognized as a National Historic Landmark.

Joe Houston

17 Zoltan Sepeshy
Industrial Detroit (Plant No. II), 1929

Born 1898, Kassa, Hungary (now Kosice, Czech Republic);
Cranbrook Academy of Art (CAA), Instructor, Department of
Painting, beginning 1931; CAA Director, Department of Painting,
beginning 1936; CAA Educational Director, 1944-1946; CAA
Director, 1946-1959; CAA President, 1959-1966; died 1974,
Bloomfield Hills, Michigan

Oil on canvas
42 1/4 x 49 1/8 inches
Gift of the Artist
CAM 1933.32

Maija Grotell, 1899-1973
The City, 1930
Earthenware
Cranbrook Academy of Art
Purchase for the Museum
(CAM 1935.2)

In the late 1920s, Zoltan Sepeshy began to paint canvases inspired by the factories and smelting plants built by the Ford Motor Company along the Rouge River south of Detroit. Recognized as one of Detroit's most experimental and talented modernists, Sepeshy became head of the painting department at Cranbrook Academy of Art in 1931, eventually succeeding Eliel Saarinen as president of the Academy.

Industrial Detroit presents a composite view of factories and worker houses along the Rouge River. The large cranes used for loading and unloading lake freighters at the mouth of the river are seen in the background. Interested in Cubism, Sepeshy orchestrated the buildings into a complex arrangement of abstract, geometric shapes and rendered his composition in a tight, tonalist palette favoring earth tones and grays— colors well suited to the depiction of the smoke- and soot-darkened landscape along the Rouge River. As one of the more innovative and sophisticated paintings from the Upper Midwest in the 1920s, *Industrial Detroit* expresses the explosive energy of a Great Lakes city enthralled with the drama of the unfolding industrial age.

Michael D. Hall

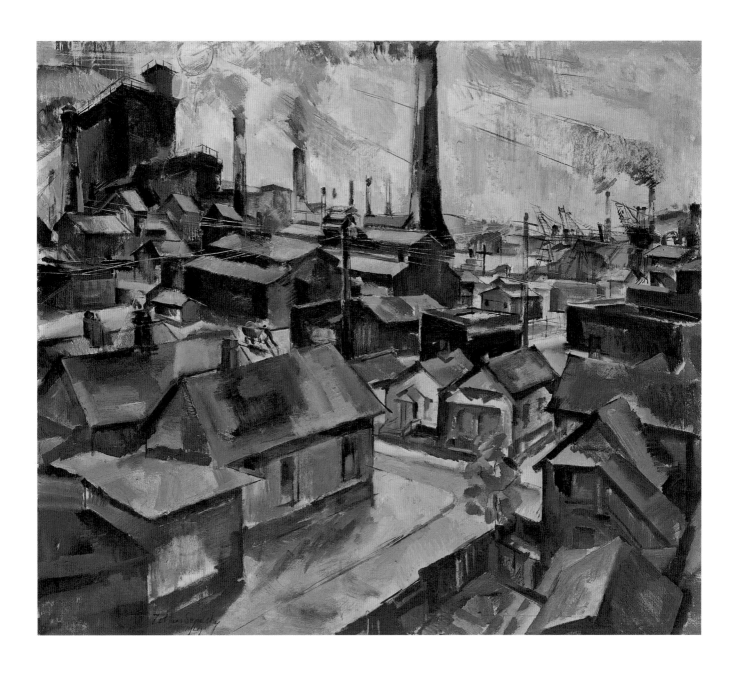

18 Hugh Ferriss
Detroit News Building, 1927, or earlier

Born 1889, St. Louis, Missouri; died 1962, New York, New York

Charcoal with ink on drawing board
21 1/2 x 27 7/8 inches
Gift of George Gough Booth and Ellen Scripps Booth
CAM 1955.400

George Gough Booth on opening day
of the Detroit News building, 1917
Photograph Collection of Cranbrook
Archives (Estate Album 3)

Considered by many to be the most gifted
architectural draftsman of the early twentieth
century, Hugh Ferriss excelled at depicting
buildings and structures as grand, dramatic
spaces invoking mystery, grandeur and private
ambition. A master of light and shadow, Ferriss's
renderings manage to subtly convey properties of
scale, detail and material without resorting to
overt delineation. His prodigious abilities made
him a favorite of the architectural trade, and
many well-known professionals, including the
Saarinens, made use of his free-lance talents.

The origins of this particular drawing are
unknown but it seems likely to have been
commissioned by George Booth, an amateur
architect who teamed with Albert Kahn to design
the Detroit News building on Lafayette Avenue in
Detroit. Erected between 1915 and 1917 at a cost
of nearly two million dollars, the building set
new industry standards for operations and
functionality when it opened. Ferriss's rendering
deftly evokes Booth's hopes that the handsome,
well-crafted building would bustle with activity
around the clock.

Mark A. Coir

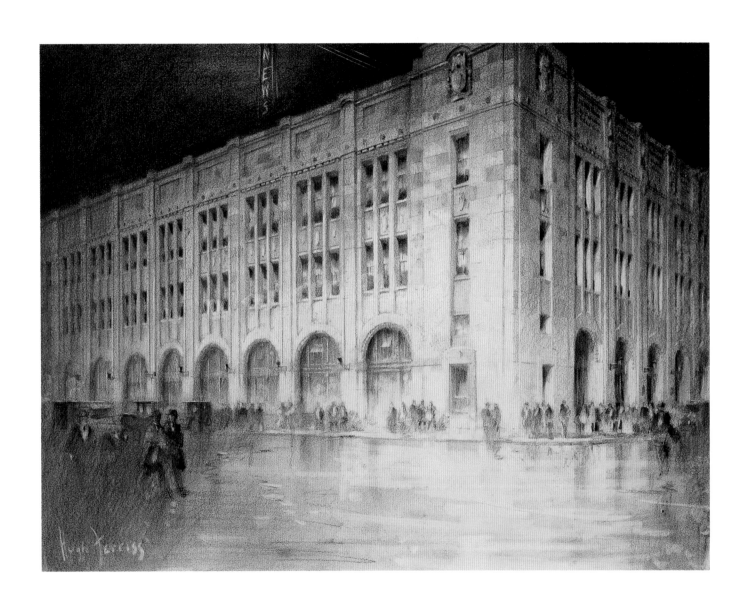

19 Eliel Saarinen
**Study for the Chicago Lakefront Project:
Perspective of the Chicago Tower**, 1923

Born 1873, Rantasalmi, Finland; Cranbrook, Resident Architect,
1925-1950; Cranbrook Academy of Art (CAA), President, 1932-
1946; CAA Director of Department of Architecture and Urban
Design, 1946-1950; died 1950, Bloomfield Hills, Michigan

Pencil on tracing paper
23 1/2 x 17 inches
Collection of Cranbrook Art Museum
CAM 1955.389

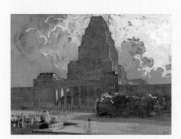

Eliel Saarinen
A Tower Sketch (Study for the
Parliament House, Helsinki), 1908
Watercolor
Gift of Robert Saarinen Swanson
(CAM 1979.9)

With the $20,000 award he received for his
second-place entry in the 1922 Chicago Tribune
Tower Competition, the fifty-year-old Eliel
Saarinen set sail for the United States in 1923
where he first settled with his family in Chicago.
Although he did not have a client in mind, he
occupied himself by creating a plan for the
development of Chicago's lakefront. Saarinen—
who believed architecture encompassed all
aspects of design, from flatware to city plans—
was well known in Europe as a town planner and
for his proposals for Helsinki, Tallinn, Budapest
and Canberra, the new capital of Australia.
His plan for Chicago was a detailed proposal
focused on Grant Park and its surroundings,
including bold solutions to traffic problems in the
loop and an innovative underground parking lot
for 47,000 automobiles. At either end of the park
he situated two elegant towers, with the Chicago
Tower at the southern end. The design's soaring
verticality was softened by a series of subtle
setbacks, recalling both his proposal for the
Chicago Tribune Tower and his earlier studies
for the Parliament House in Helsinki.
 Gregory Wittkopp

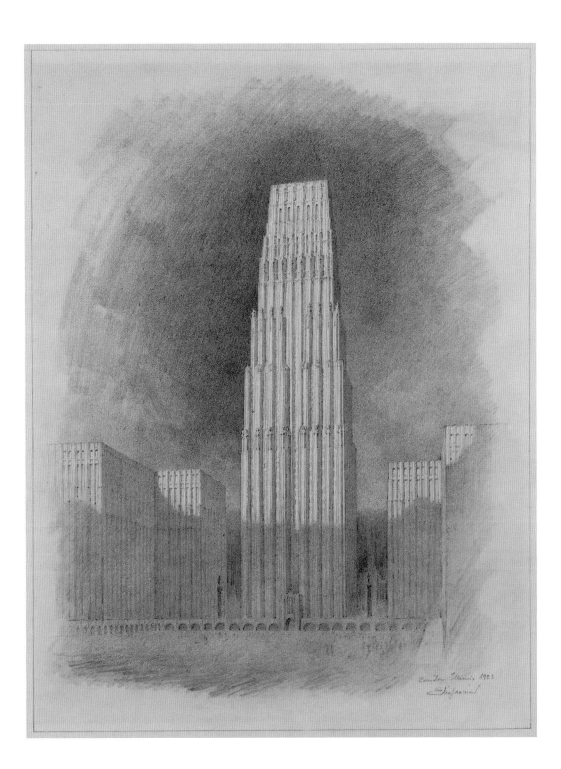

Eveston, Illinois 1923
Saarinen

20 Eliel Saarinen
Cranbrook School for Boys, Aerial Perspective,
1926

Born 1873, Rantasalmi, Finland; Cranbrook, Resident Architect,
1925-1950; Cranbrook Academy of Art (CAA), President, 1932-
1946; CAA Director of Department of Architecture and Urban
Design, 1946-1950; died 1950, Bloomfield Hills, Michigan

Pencil on drawing board
26 1/4 x 29 1/2 inches
Gift of Cranbrook School
CAM 1954.5

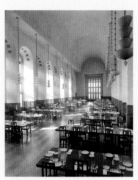

Eliel Saarinen (Architect)
**Cranbrook School for
Boys, Dining Hall,**
photographed in 1936
Photograph Collection of
Cranbrook Archives (3744)

This exquisite drawing of the Cranbrook School
Quadrangle captures in delightful detail Eliel
Saarinen's almost completed plan for the new
boys' boarding school complex. Saarinen had
given George Booth a simple footprint for the
school buildings in the spring of 1925 and
returned to the project in the fall eager to develop
his designs for the high school. By the time he
made this drawing Saarinen had fully visualized
the final arrangement of the buildings.

The working ideas here include a raised track
around the football oval (the track was later
lowered to field level), a greenhouse (not
realized) along the south wing of the academic
building, a meeting space in the quadrangle
itself (later embellished with a superb fountain),
and a colonnaded walkway for a pedestrian
entrance from Lone Pine Road at the upper right
(which was not built). Apart from some further
changes in the architectural detail of the
buildings, the drawing presents the Cranbrook
quadrangle buildings almost exactly as they
appear today.

Jeffrey Welch

Cranbrook 1926
Eliel Saarinen

21 Eliel Saarinen (Designer)
Cranbrook Map Tapestry, 1935

Born 1873, Rantasalmi, Finland; Cranbrook, Resident Architect,
1925-1950; Cranbrook Academy of Art (CAA), President, 1932-
1946; CAA Director of Department of Architecture and Urban
Design, 1946-1950; died 1950, Bloomfield Hills, Michigan

Weaver: Studio Loja Saarinen; attributed to Lilian Holm and
Ruth Ingvarson
Linen warp; linen, silk and wool weft; plain weave with
discontinuous wefts
103 1/2 x 123 1/2 inches
Gift of George Gough Booth and Ellen Scripps Booth through
The Cranbrook Foundation
CAM 1935.7

Eliel Saarinen
Cranbrook Academy of Art,
Proposed Site Plan, 1925
Pencil and ink on paper
Gift of the Architect (CAM 1928.39)

Studio Loja Saarinen, under the direction of
Loja Saarinen, frequently collaborated with
Eliel Saarinen to translate his designs into fiber.
This large-scale *Cranbrook Map Tapestry* was
designed by Eliel and is based on one of his
proposed plans for Cranbrook. It includes
Cranbrook Academy of Art and the Art Museum,
Cranbrook School for boys, Cranbrook Institute of
Science, Kingswood School Cranbrook, and the
Cranbrook Pavilion and Greek Theatre.

The buildings, sculpture and landscaping in
this lively schema ignore all rules of perspective
and scale. Buildings are presented in plan,
elevation or from a bird's-eye view. Natural
elements such as bodies of water and trees are
geometrically stylized. The sculptures, mostly by
Carl Milles, take on enormous proportions as do
the two fanciful figures at the bottom right,
possibly Eliel as the architect and painter
sending a clever message to patron George Booth
that his proposed expanded Institute of Science,
represented by the penguin, should be located at
Eliel's preferred location, the site of the Cranbrook
Pavilion depicted just below the figures.
Not surprisingly, Booth won the debate and the
existing Institute was expanded in its current
location.

Diane VanderBeke Mager

90

Sketch for Orpheus, circa 1926

Born 1875, Lagga, Sweden; Cranbrook Academy of Art, Director
of Department of Sculpture, 1931-1951; died 1955, Lidingö, Sweden

Foundry: Herman Bergman, Stockholm, Sweden
Bronze
87 x 21 x 16 inches
Gift of George Gough Booth and Ellen Scripps Booth through
The Cranbrook Foundation
CAM 1931.8

Carl Milles
Orpheus Fountain, 1926-
1936, in front of the Concert
Hall, Stockholm, Sweden
Photograph Collection of
Millesgàrden Archives,
Lidingö, Sweden

With the grace of a dancer, a youthful Orpheus
descends into Hades to retrieve his dead wife
Eurydice, charming the guardian of the
underworld with his poet-musician's lyre.
Enlivened by Carl Milles's characteristic dark
green patina and rugged surface, this "sketch" of
Orpheus in bronze remembers the softer clay that
formed its boyish locks and sinewy muscles.

Milles studied sculpture in Paris and was
accepted into his first Salon exhibition in 1899.
Shortly thereafter he worked in the studio of
Auguste Rodin. Milles won a sculptural
competition for the Stockholm Concert Hall with
this exhuberant interpretation of the Orpheus
myth. The completed monument includes eight
figures, their heads slightly cocked as they strain
to hear his music. Another casting of the eight
figures was installed as the *Orpheus Fountain* at
Cranbrook in 1938 where the harmonious sounds
of splashing water evoke the songs of the absent
Orpheus.

Milles came to Cranbrook to head the
sculpture department in 1931 and remained until
1951. He sculpted the final Stockholm Orpheus in
his Cranbrook studio.

David D.J. Rau

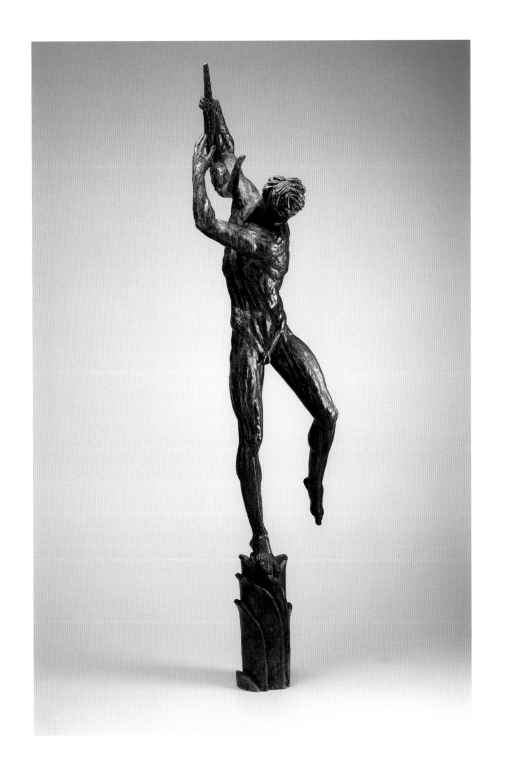

Carl Milles
Sketch for Jonah and the Whale, designed 1931
Bronze
Promised Gift of the Estate
of Elizabeth Laverack White
(T 2000.19)

23 Carl Milles
Jonah and the Whale Fountain, designed 1931,
cast 1931-1932, installed on Academy Way, 1932-1934

Born 1875, Lagga, Sweden; Cranbrook Academy of Art, Director of
Department of Sculpture, 1931-1951; died 1955, Lidingö, Sweden

Foundry: Herman Bergman, Stockholm, Sweden
Bronze
108 x 148 inches
Gift of George Gough Booth and Ellen Scripps Booth through
The Cranbrook Foundation
CAM 1934.67

This delightful fountain reflects Carl Milles's
elation upon becoming the first Director of the
Department of Sculpture at the new Cranbrook
Academy of Art in 1931. His first commission from
The Cranbrook Foundation, *Jonah and the Whale*,
was designed the same year he arrived at
Cranbrook and installed in 1932 at a total cost
of $29,000.

Though he started small, thinking of a
fountain for the inner courtyard at the new
Kingswood School Cranbrook (where his *Diana*
now presides), Milles's love of water seemed
unquenchable. With its eighty pipes splashing
streams of water on both the whale and the
Buddha-like Jonah, Milles blithely succeeded in
his initial intent to make his fountain "a joke for
the children." Jonah, the Biblical fugitive
swallowed by a whale, is spewed high into the
air after three days in darkness. The look of utter
surprise on his face gives the fountain its
extraordinary charm. "There is no other like it,"
said Milles. "I like it, and would like to make
another Jonah—more amusing."

Jeffrey Welch

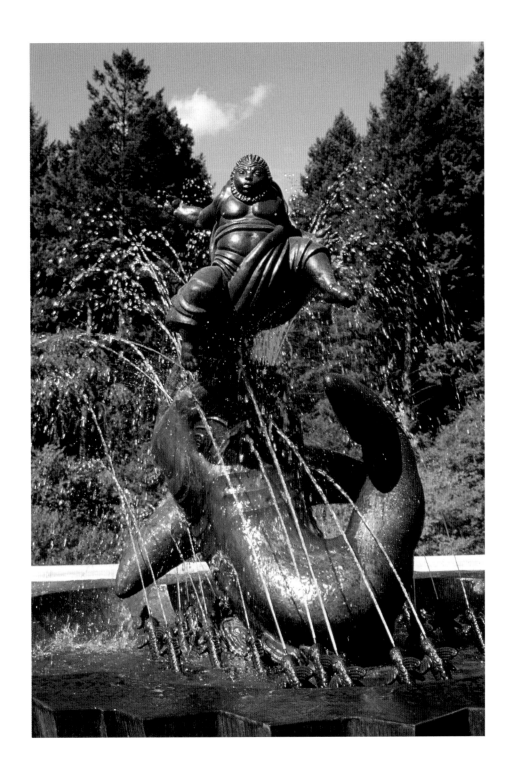

24 Loja Saarinen and Eliel Saarinen (Designers)
Rug No. 2, November 1928 - February 1929

Loja: Born Louise Gesellius, 1879, Helsinki, Finland; operated Studio Loja Saarinen at Cranbrook, 1928-1942; Cranbrook Academy of Art, Head of Department of Weaving and Textile Design, 1929-1942; died 1968, Bloomfield Hills, Michigan
Eliel: Born 1873, Rantasalmi, Finland; Cranbrook, Resident Architect, 1925-1950; Cranbrook Academy of Art (CAA), President, 1932-1946; CAA Director of Department of Architecture and Urban Design, 1946-1950; died 1950, Bloomfield Hills, Michigan

Weaver: Studio Loja Saarinen; Loja Saarinen and Walborg Nordquist Smalley
Cotton warp; wool pile; plain weave with ten picks of weft between each row of knots
110 1/2 x 39 inches
Collection of Cranbrook Art Museum
CAM 1955.3

Studio Loja Saarinen Logo

In 1928 Loja Saarinen, Eliel Saarinen's wife, established Studio Loja Saarinen, a commercial weaving studio she operated at Cranbrook until 1942. Her studio created textiles for special commissions, the bulk of which were for Cranbrook and included rugs, window treatments, and upholstery fabrics for Kingswood School Cranbrook (founded as a school for girls in 1931) and Saarinen House (1930, the Saarinens' Cranbrook residence). Studio Loja Saarinen employed primarily Swedish weavers who worked in a traditional Scandinavian *ryijy* technique, hand knotting tufts as they wove. These new *ryijy* rugs complemented the Saarinens' interest in and collection of historical examples.

Loja and Eliel Saarinen designed this second rug woven by Studio Loja Saarinen, in which Eliel's initials appear in one corner and Cranbrook Academy of Art's "CA" monogram in another. The peacock motif, which occurs repeatedly in the Saarinens' designs for Cranbrook, emphasizes that this rug, though destined for use in Loja's studio in front of a bench of equal width, belonged to a larger scheme for the campus.

Ashley Callahan

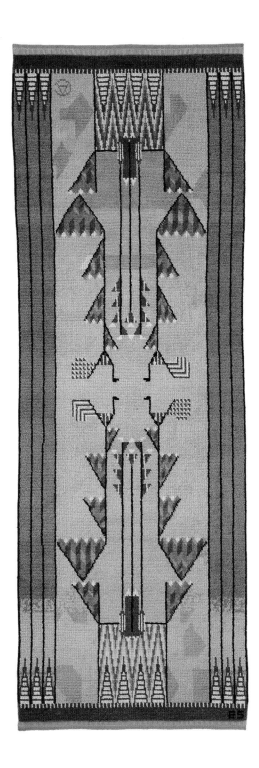

25 Eliel Saarinen (Designer)
Saarinen House Dining Room, designed 1928, constructed 1929-1930

Born 1873, Rantasalmi, Finland; Cranbrook, Resident Architect, 1925-1950; Cranbrook Academy of Art (CAA), President, 1932-1946; CAA Director of Department of Architecture and Urban Design, 1946-1950; died 1950, Bloomfield Hills, Michigan

Collection of Cranbrook Art Museum
Saarinen House accession number: CAM 1992.25

Eliel Saarinen (Designer)
Dining Room installation in "The Architect and the Industrial Arts" exhibition at The Metropolitan Museum of Art, 1929
Photograph Collection of The Metropolitan Museum of Art (L11268B)

Saarinen House has been hailed as one of the most significant residential projects in America—a *Gesamtkunstwerk*, or total work of art.
Both an architect and a painter, Eliel Saarinen planned each detail of his personal environment from the design of the house and gardens to the interior furnishings.

The dining room at Saarinen House represents his masterful use of geometry and color. The square rug, with its octagonal pattern, establishes the geometry of the space and allows for a subtle transformation of shapes throughout the room, terminating in the concentric circles of the gilded domed ceiling. This rug and the Pewabic tiled fireplace mantel in the adjacent living room were both originally designed by Saarinen for another dining room which appeared in "The Architect and the Industrial Arts: An Exhibition of Contemporary American Design" at The Metropolitan Museum of Art in 1929. Chinese red corner niches and dramatic orange and gold textiles provide vivid bursts of color, offsetting the warm golden hues of the paneled walls, veneered dining table with side chairs, and the brass chandelier and serving pieces favored by Saarinen.

Diane VanderBeke Mager

26 Eero Saarinen
Drawings for Furniture Designs for Kingswood School Cranbrook, 1930-1931

Born 1910, Kirkkonummi, Finland; Cranbrook Academy of Art,
Instructor, 1939-1942; died 1961, Bloomfield Hills, Michigan

Pencil on paper (nine pages in a book)
Each page: 9 1/8 x 6 1/8 inches
Gift of Ronald S. and Heather R. Swanson
CAM 2003.4

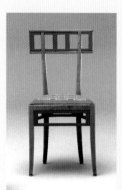

Eero Saarinen (Designer)
Kingswood School Cranbrook, Dining Hall Side Chair, 1930-1931
Birch with paint and reproduction linen upholstery
Gift of Kingswood School Cranbrook (CAM 1983.20)

Eero Saarinen is well-known for "talking with a pencil," evident in impromptu drawings and expressive sketches produced on the closest material at hand. Seminal drawings for his mature architectural projects survive on the backs of menus, as insertions into letters he wrote to friends and relatives, and in the margins of his desk calendar. The earliest known document of Eero's creative process as a designer is this series of pencil sketches he clustered on the end and back pages of this book, *Henry of Navarre* by Henry Dwight Sedgwick, published in 1930. It is not hard to imagine the precocious twenty-year-old designer randomly pulling this novel off his shelf to quickly record these studies for the furniture that his father, Eliel Saarinen, asked him to design for Kingswood School Cranbrook, the school for girls completed in 1931. The studies on the two pages illustrated here capture his initial ideas for the *Dining Hall Side Chair*, an Art Deco design that undoubtedly drew inspiration from the nineteenth-century Scandinavian furniture he remembered from his childhood and recent summers spent in Finland.
 Gregory Wittkopp

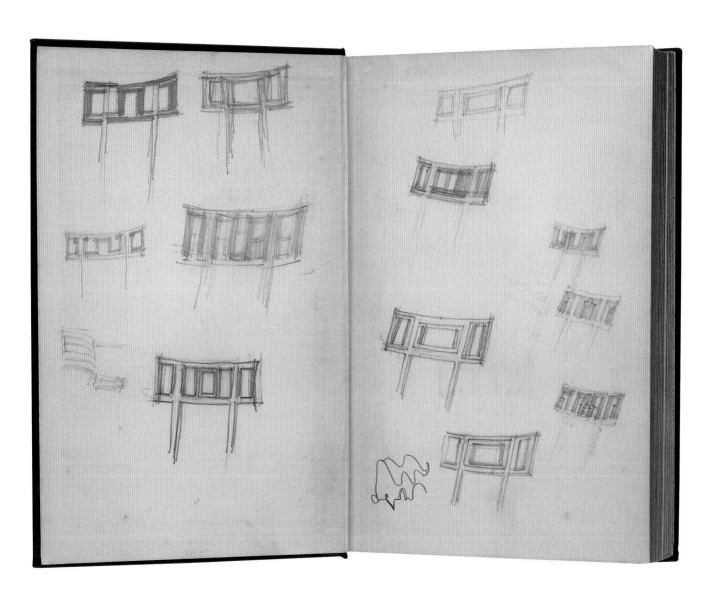

27 Loja Saarinen (Designer) and Eliel Saarinen (Designer and Draftsman)
Study for the Festival of the May Queen Tapestry, 1932

Loja: Born Louise Gesellius, 1879, Helsinki, Finland; operated Studio Loja Saarinen at Cranbrook, 1928-1942; Cranbrook Academy of Art, Head of Department of Weaving and Textile Design, 1929-1942; died 1968, Bloomfield Hills, Michigan

Eliel: Born 1873, Rantasalmi, Finland; Cranbrook, Resident Architect, 1925-1950; Cranbrook Academy of Art (CAA), President, 1932-1946; CAA Director of Department of Architecture and Urban Design, 1946-1950; died 1950, Bloomfield Hills, Michigan

Watercolor and gouache with pencil underdrawing on tracing paper
28 1/2 x 26 1/2 inches
Gift of Kingswood School Cranbrook
CAM 1981.12

Loja Saarinen and Eliel Saarinen (Designers)
Sample Weaving of a Young Maiden for the Festival of the May Queen Tapestry, 1932
Linen warp; linen, wool and rayon weft
Gift of Mrs. Adolf Hornblad
(CAM 1979.20)

The Festival of the May Queen Tapestry celebrates a revered rite of spring at Cranbrook. The May Queen stands beneath a highly stylized tree filled with white birds and receives edible tribute from a handmaid while the Queen's attendants wrap her in a red garland. Designed by Loja and Eliel Saarinen together, it emphasizes the harmonious relationship between human social activity and burgeoning nature in this season of renewal. The elements of queen, court, pet, fauna and flora provide a charming and apt decoration for Eliel's splendid dining hall in the original girls' school at Cranbrook.

This watercolor study, prepared in 1932 by Eliel, displays the fully realized content of the richly woven Kingswood Dining Hall tapestry but with a twist: the figures in the watercolor have been reversed in the tapestry—the handmaid with platter serves from the Queen's right side. Initially, Loja used this watercolor to weave a panel of the girl in pantaloons for a preliminary study. The full tapestry, completed in 1934, still adorns the Kingswood Dining Hall today.

Jeffrey Welch

28 Eliel Saarinen and Walter von Nessen (Designers)
Kingswood School Cranbrook Dining Hall
Torchère, designed circa 1928, manufactured 1932

Saarinen: Born 1873, Rantasalmi, Finland; Cranbrook, Resident Architect, 1925-1950; Cranbrook Academy of Art (CAA), President, 1932-1946; CAA Director of Department of Architecture and Urban Design, 1946-1950; died 1950, Bloomfield Hills, Michigan
Von Nessen: Born 1889, Berlin, Germany; died 1943, New York, New York

Manufacturer: Nessen Studio, Inc., New York, New York
Assembler: Leonard Electrical Company, Birmingham, Michigan
Polished aluminum shades with chrome-plated stem
Height: 67 inches
Gift of Kingswood School Cranbrook
CAM 1972.23

Eliel Saarinen (Architect)
Kingswood School Cranbrook, Dining Hall,
photographed circa 1931
Photograph Collection of
Cranbrook Archives (4672)

Torchères were popular fixtures in most Art Deco interiors, including many spaces at Cranbrook. One of twelve originally ordered for the dining hall at Kingswood School Cranbrook, torchères like this one are still used today at Kingswood. The design allows the room to be lit indirectly, as light is aimed towards the ceiling, while the machine-age layered and inverted funnel forms further reflect light on the underside of the polished funnels. While serving as excellent light sources, they also add an element of Art Deco glamour.

Walter von Nessen came to the United States from Germany in the 1920s and quickly became the most innovative designer of modern residential lighting. Von Nessen used non-traditional materials to create lamps and light fixtures that diffused light in accordance with his exacting standards while creating a decidedly modern sensibility. Eliel Saarinen was aware of von Nessen's progressive pieces and often approached von Nessen to manufacture his own designs for metalwork, including this torchère. Nessen Studio retained the rights to the lamp and manufactured it for other projects in the late 1920s and early 1930s.

Ellen M. Dodington

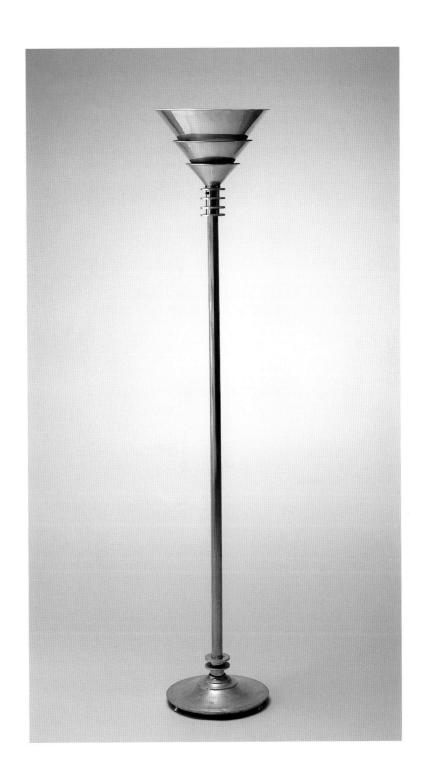

29 Eliel Saarinen (Designer)
Tea Urn and Tray, 1934, or earlier

Born 1873, Rantasalmi, Finland; Cranbrook, Resident Architect, 1925-1950; Cranbrook Academy of Art (CAA), President, 1932-1946; CAA Director of Department of Architecture and Urban Design, 1946-1950; died 1950, Bloomfield Hills, Michigan

Manufacturer: International Silver Company, Wilcox Silver Plate Division, Meriden, Connecticut
Silverplate
Urn: 14 5/8 x 10 7/8 (diameter) inches
Tray: 1/2 x 17 1/2 (diameter) inches
Gift of George Gough Booth and Ellen Scripps Booth through The Cranbrook Foundation
CAM 1935.8.A and .B

Eliel Saarinen (Designer)
Room for a Lady installation at the Cranbrook Pavilion, 1935, with
Tea Urn and Tray
Photograph Collection of Cranbrook Archives (2757)

From his broad city plans and architecture to his detailed furniture and silverware designs, Eliel Saarinen sought balance between geometry and nature. His spherical tea urn with flat handles and round tray embodies futuristic design elements that helped define the Machine Age while its spire finial and linear spout reference nature.

The urn is unique within a limited series manufactured for use at Cranbrook. This series includes two documented examples with ebony handles and lid inserts (still in the collection of Cranbrook Schools) and Saarinen's personal urn, matching creamer and sugar bowl, plated in brass with Bakelite inserts (now in the collection of The Metropolitan Museum of Art). Another version designed for mass production with wider slats and no bun feet appeared in *Room for a Lady*, "Contemporary American Industrial Arts" at The Metropolitan Museum of Art in 1934, and again in the "Exhibition of Home Furnishings" at the Cranbrook Pavilion in 1935. Retailing at $80 for the urn and $30 for the tray, few were manufactured. It nonetheless appeared in numerous subsequent exhibitions and publications and inspired many prominent industrial designers.

Diane VanderBeke Mager

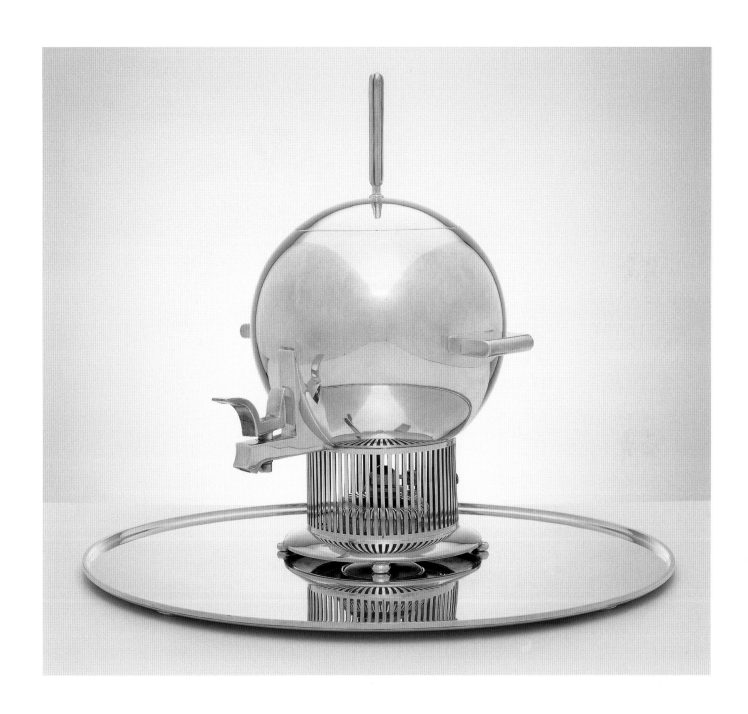

30 J. Robert F. Swanson (Designer)
Candelabrum, designed 1935, manufactured 1947

Born 1900, Menominee, Michigan; died 1981, Bloomfield Hills, Michigan

Manufacturer: Cray, Boston, Massachusetts
Brass with chrome satin finish
25 1/4 x 18 1/4 x 6 inches
Gift of the Estate of Mr. And Mrs. Alfred C. Wermuth
ZO 1979.4

Saarinen Swanson Group
home furnishings
reproduced in "Saarinen-
Swanson modern" article
in **House & Garden
Magazine**, October 1947

Architect J. Robert F. Swanson and his wife,
Pipsan Saarinen Swanson, encountered difficulty
when they sought contemporary furnishings
appropriate to his modern buildings. To meet
this need they worked with Pipsan's father Eliel
Saarinen to develop the Flexible Home
Arrangements line of furniture in 1939. After
World War II they expanded this line to create the
Saarinen Swanson Group, a collection of
coordinated furniture, fabrics, lamps, metalwork,
glassware and pottery. Because of the line's
versatility, affordability and modern design,
it met postwar desires for convenience, order,
comfort, simplicity and economy. J. Robert F.
Swanson's contributions to the group included
designs for furniture, metal fire tools and this
boldly simple candelabrum.

Swanson originally designed the
candelabrum in 1935 for the dining room of the
Gordon Mendelssohn home that he designed in
Bloomfield Hills. Composed of rectilinear
branches forming a horizontal row of supports
joined by diminutive arches, the candelabrum
was appropriate both for the custom design of the
Mendelssohn home and the varied interiors of
later owners of Saarinen Swanson Group
furnishings.

Ashley Callahan

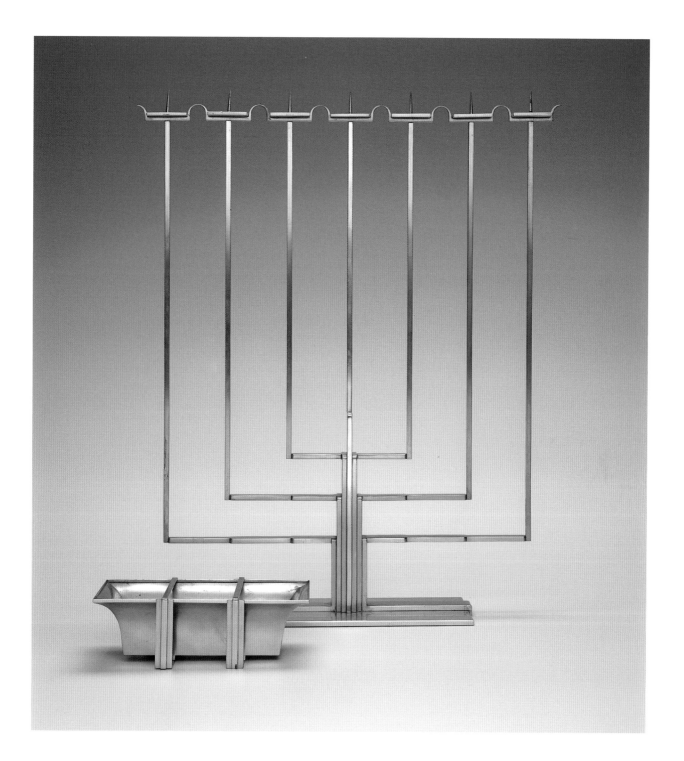

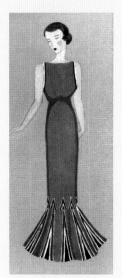

Pipsan Saarinen Swanson
Costume Design,
circa 1933
Watercolor with pencil
underdrawing on paper
Gift of Robert Saarinen
Swanson and Ronald
Saarinen Swanson
(CAM 1979.8.E)

31 Pipsan Saarinen Swanson (Designer)
Four Glasses: Champagne Glass, Water Goblet, Sherbet Glass and Wine Glass, designed 1946

Born Eva Lisa Saarinen, 1905, Kirkkonummi, Finland; Cranbrook Academy of Art, Instructor of Weaving and Textile Design, 1932-1933, 1935; died 1979, Bloomfield Hills, Michigan

Manufacturer: US Glass Company, Tiffin, Ohio
Glass
Water: 5 3/8 x 3 3/4 (diameter) inches
Champagne: 3 3/4 x 4 (diameter) inches
Wine: 4 x 2 7/8 (diameter) inches
Sherbet: 3 1/8 x 3 1/4 (diameter) inches
Gift of Robert Saarinen Swanson and Ronald Saarinen Swanson
CAM 1981.70.A through .D

Pipsan Saarinen Swanson, daughter of Loja and Eliel Saarinen, readily accepted her parents' all-encompassing approach to art, and during her long and successful career designed furniture, woven and printed textiles, clothing, metalwork, glass and interiors. She participated in Cranbrook's early history both as an artist and an instructor, contributing decorative details to Cranbrook School for boys (1926), Saarinen House (1930), and Kingswood School Cranbrook (1931), and offering several courses at Cranbrook Academy of Art in costume design and interior design in the mid-1930s.

By the late 1930s Swanson directed her talents toward creating affordable modern home furnishings. She developed designs that could be mass produced, in a sense offering the Cranbrook model to the general public. One of the manufacturers with which she worked was the United States Glass Company in Tiffin, Ohio, for which she designed these drinking glasses in 1946. Tiffin engaged her as a designer from 1948-1950, and she created free-form vases, ashtrays, candleholders and flower floaters, as well as more traditional pressed glass dinnerware patterns.

Ashley Callahan

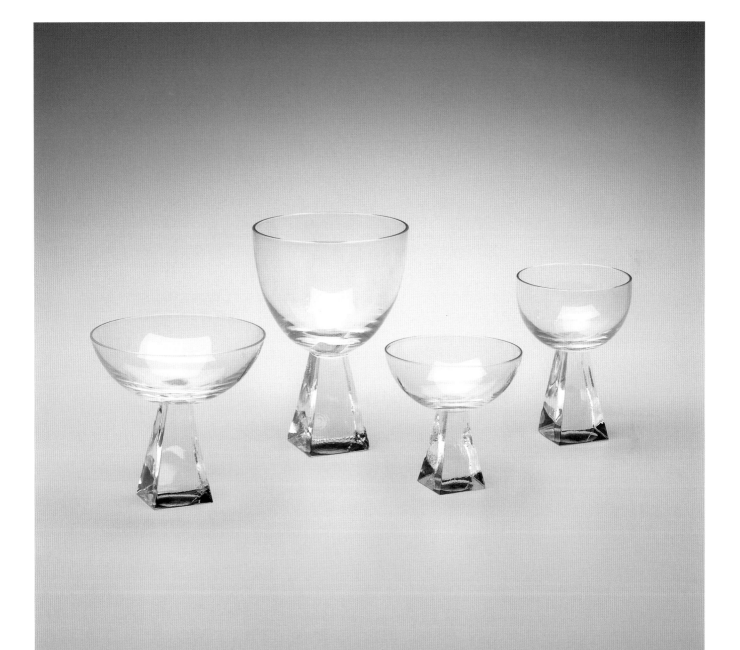

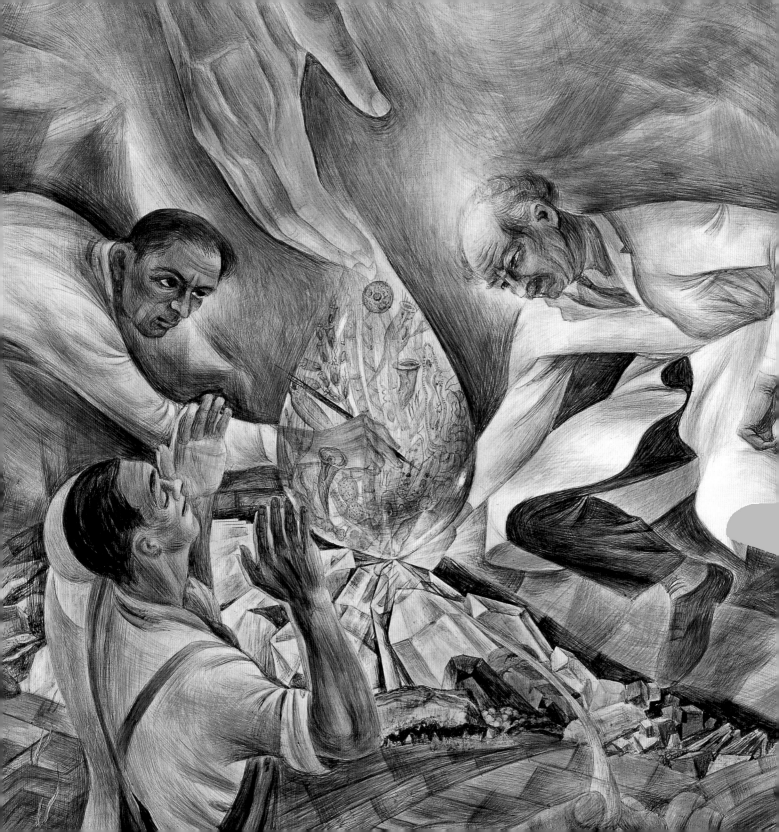

REFLECTING LIFE
Struggle and Progress Between the Wars
1923-1944

The years between the wars gave rise to social dissent and political reform on an international scale. Artists on both sides of the Atlantic sought to express growing humanist concerns through dramatic representations of the figure. This activist spirit spawned a modern renaissance in the medium of printmaking. Created in editions and sold inexpensively, prints allowed artists to communicate their timely messages to a wider audience. German artists such as Käthe Kollwitz and George Grosz summed up the toll of warfare in their graphic images, while American artists like Raphael Soyer gave voice to the downtrodden in their Depression-era lithographs.

In stark contrast to the modernist avant garde gaining momentum in the art centers of Paris and New York during the 1930s and 1940s, narrative imagery predominated in the American heartland. Missourian Thomas Hart Benton typified the American Scene artists whose illustrative images elevated the humble farmer and factory worker as heroic subjects. Doris Lee and Zoltan Sepeshy, head of the painting department at Cranbrook Academy of Art, were among the midwestern painters who helped to define this purely American aesthetic with vernacular images extolling the virtues of labor, family and community. These sentiments were doubly encouraged by government and corporate patronage of public murals and sculptures designed to stimulate national unity and inspire productivity necessary for economic recovery.

As the Depression waned, public faith in scientific progress burgeoned. Among the forward-thinking exhibits at the 1939 New York World's Fair, the Hall of the Atom introduced the new symbol of a brighter future offered by human ingenuity. However, by the end of World War II, the atom gained a more ominous meaning and the folksy regionalist style proved less relevant for a new generation of artists coming to grips with private conflict and global uncertainty in the postwar era.

Joe Houston

32 Käthe Kollwitz
The Mothers (Die Mütter), 1922-1923
From the portfolio **War (Sieben Holzschnitte zum Krieg)**, 1923

Born 1867, Königsberg, Germany (now Kaliningrad, Russia);
died 1945, Dresden, Germany

Lithograph (Edition: 1/100)
20 1/2 x 29 5/8 inches
Gift of Peggy deSalle
CAM 1984.48

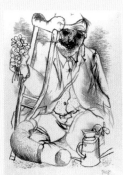

George Grosz, 1893-1959
The Hero, circa 1933, from
American Scene, Series 1
Lithograph
Museum Purchase
(CAM 1955.328.H)

Following the catastrophe of World War I, German artist Käthe Kollwitz produced a portfolio of seven woodcuts entitled *War* in 1923 at the height of the pacifist movement in Germany. Using generalized figures of mothers, widows, young soldier volunteers and grieving parents, the prints focused on the pain and sorrow of those left behind. Kollwitz was particularly sensitive to the grief of mothers, having lost her own son Peter in the early months of the war.

The Mothers, part of the *War* portfolio, shows a group of women locked into a solid sculptural mass that forms a protective barrier for the infant held by one and the two children who peer out between their mothers' skirts. Though implying that mothers will stand together to prevent their children from marching off to future wars, the women are defensive and anxious. The woodcut evokes the sacrifice and suffering of German mothers who sent their sons off to war for their country's honor and now fear losing the flower of the next generation to future militarist adventures.

Dora Apel

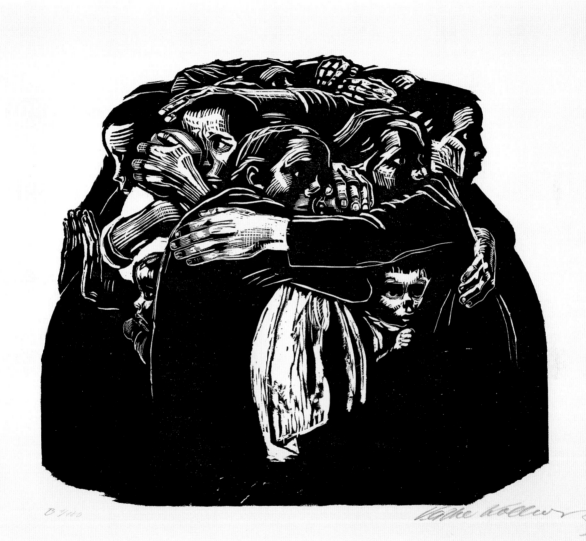

33 Carl Milles
Buddha of the Sea, 1926-1927

Born 1875, Lagga, Sweden; Cranbrook Academy of Art, Director,
Department of Sculpture, 1931-1951; died 1955, Lidingö, Sweden

Rosso Antico marble
32 x 31 1/2 x 17 inches
Gift of George Gough Booth and Ellen Scripps Booth through
The Cranbrook Foundation
CAM 1934.6

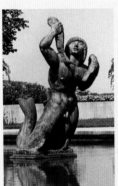

Carl Milles
Triton with Fishes,
designed circa 1923-1926,
installed in the **Triton Pool**
at Cranbrook Art Museum,
1938
Bronze
Gift of George Gough Booth
and Ellen Scripps Booth
through The Cranbrook
Foundation (CAM 1934.22)

Carl Milles's *Buddha of the Sea* is a sculptural
tour de force of pure fantasy. The Buddha's
muscular, athletic body sits atop two large fins
unlike the usual single fin of a merman or the
crossed-legs of a traditional Buddha. The Buddha
looks upward with outstretched arms in an
almost divine manner as if giving thanks or
receiving praise. This hybrid form characterizes
much of Milles's sculpture at Cranbrook which
deals with myths by placing fantastical creatures
within our daily lives. Stories heard as a boy
from the seamen around the harbor in Lagga,
Sweden, influenced Milles's work throughout his
life with visions of mythological beings,
imaginative aquatic creatures and foreign lands.

Milles found the stone for *Buddha of the Sea* in
London about 1926 while preparing for his 1927
exhibition at the Tate Gallery. He carved the
massive form single-handedly. The sculpture
came to Cranbrook in 1934 with approximately
sixty other Milles sculptures purchased by
George Booth. Additions throughout the years
have made Cranbrook's collection second only to
Millesgården, Milles's home outside Stockholm.

Ellen M. Dodington

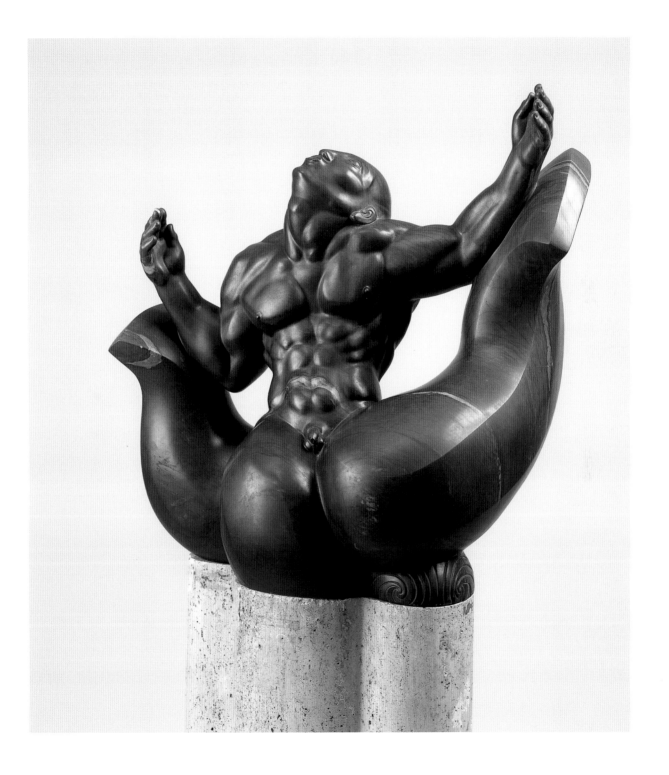

34 Marshall Fredericks
Torso of a Dancer, 1938-1939

Born 1908, Rock Island, Illinois; Cranbrook Academy of Art (CAA), Student, Department of Sculpture, 1933; Cranbrook Schools, Instructor, 1933; CAA Instructor of Ceramics and Modeling, 1934-1938; CAA Instructor in Department of Sculpture, 1938-1942; died 1998, Birmingham, Michigan

Belgian black marble
38 x 18 3/4 x 13 7/8 inches
Gift of George Gough Booth and Ellen Scripps Booth through The Cranbrook Foundation
CAM 1939.42

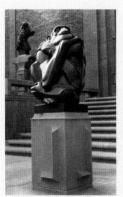

Marshall Fredericks
The Thinker, 1940, installed on the Peristyle steps at Cranbrook Art Museum
Granite
Gift of George Gough Booth and Ellen Scripps Booth through The Cranbrook Foundation (CAM 1941.34)

Marshall Fredericks arrived at Cranbrook in 1932 to assist Carl Milles and eventually remained to teach courses in ceramics and sculptural modeling at the Academy of Art, Kingswood and Cranbrook schools. His years at Cranbrook were among the most productive of his entire career. By the time he left to enter military service in 1942, Fredericks was a well-established sculptor with a string of prize-winning works and significant commissions to his credit, including the Levi L. Barbour Memorial on Belle Isle in Detroit and *The Thinker* that graces the steps of Cranbrook Art Museum.

Fredericks modeled *Torso of a Dancer* in clay in his studio at Cranbrook in 1938, then spent the next year and a half carving it in Belgian black marble. The work is unique, inasmuch as all other copies are in bronze. With its elegant, graceful lines, *Torso of a Dancer* demonstrates Fredericks's skill at capturing the fluid curves and taut forms of the idealized human body.

Mark A. Coir

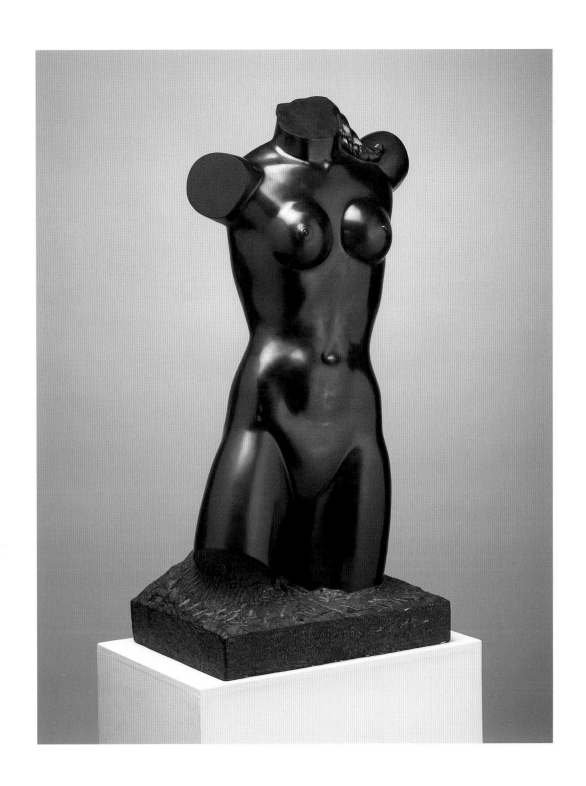

35 Raphael Soyer
The Mission, 1933

Born 1899, Borisoglebsk, Russia; died 1987, New York, New York

Lithograph (Edition of 25)
Image: 12 1/4 x 17 5/8 inches
Gift of George Gough Booth and Ellen Scripps Booth through
The Cranbrook Foundation
CAM 1942.14

Raphael Soyer's paintings and prints created
during the Depression are among the most
evocative representations of that period. In these
works, Soyer, no stranger to poverty himself,
shows his affinity with his subjects, who were
often working-class men or the unemployed.
Soyer based this lithograph on his painting
How Long Since You Wrote to Mother? (private
collection) in which he used homeless men he
had met in the Bowery as models.

In portraying the transients in *The Mission* in
attitudes ranging from resignation to defiance,
Soyer also displays his skills as a lithographer.
The rich darkness of the clothing of the men
huddled around the table emphasizes the
glowing highlights on their faces and hands,
and on the tin cups of coffee and the bread they
are consuming, possibly the only meal they will
have that day. Soyer considered *The Mission* to
be one of his most important lithographs.

Mary Beth Kreiner

Raphael Soyer
Waterfront Scene, 1934
Lithograph
Museum Purchase
(CAM 1955.328.F)

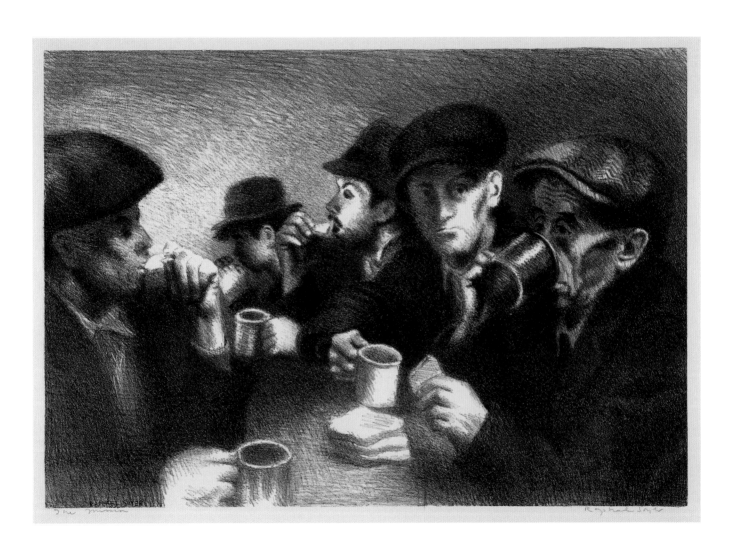

36 The American Scene, Series 1 and 2
1933-1934

Series 1	Series 2
George Biddle (1885-1973)	Thomas Hart Benton (1889-1975)
Jacob Burck (born 1904)	John Steuart Curry (1897-1946)
Adolph Dehn (1895-1968)	William Gropper (1897-1977)
George Grosz (1893-1959)	Russell Limbach (1904-1971)
Reginald Marsh (1898-1954)	Charles Locke (1899-1983)
José Clemente Orozco (1883-1949)	Raphael Soyer (1899-1987)

Publisher: Contemporary Print Group, New York, New York
Printer: George C. Miller
Distributor: Raymond and Raymond, Inc., New York, New York

Represented by:

Thomas Hart Benton, **Mine Strike**, 1933, from **Series 2**, released in 1934

Born 1889, Neosho, Missouri; died 1975, Kansas City, Missouri

Lithograph (Edition: 13/unknown)
Image: 9 3/4 x 10 3/4 inches
Museum Purchase
CAM 1955.328.D

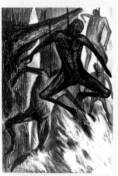

José Clemente Orozco,
1883-1949
**Negros Colgados (Hanged
Negroes)**, 1933 or 1934,
from **American Scene, Series 1**
Lithograph
Museum Purchase
(CAM 1955.328.J)

The Great Depression heightened the political
consciousness of many artists in the 1930s whose
images became powerful tools for revealing social
injustice and inspiring change. To address their
concerns to the greater public, American artists focused
on the common citizen, elevating farmers and factory
workers as heroic subjects in painting and sculpture.
This democratization of art also was reflected in the
widespread revival of printmaking which allowed
artists to distribute their pictures at affordable prices.

The Contemporary Print Group was a progressive
publishing venture formed in 1933 by socially-engaged
artists such as George Grosz, José Clemente Orozco and
Thomas Hart Benton. The Print Group distributed
annual portfolios of six prints each titled *The American
Scene*. Although conceived as a total edition of 300
copies priced at a scant $15 each, it is believed that only
a fraction were actually printed. Benton created *Mine
Strike* for the second portfolio. A stirring allegory of
class conflict, his lithograph depicts the epic struggle
between good and evil, forces dramatized for
contemporary viewers in the guise of labor and the law.

Joe Houston

37 Carroll Barnes
Paul Bunyan, 1938

Born 1906, Des Moines, Iowa; Cranbrook Academy of Art,
Student, Department of Sculpture, 1940; died 1997, Sebastopol,
California

Cherry
40 1/4 x 24 x 12 inches
Gift of the Artist
CAM 1981.58

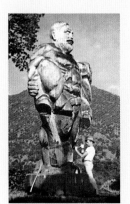

Carroll Barnes with
Paul Bunyan (16 1/2-foot
version), 1941-1947
Giant sequoia
Collection of Three Rivers
Historical Society, Three
Rivers, California

The tall tale of Paul Bunyan and his blue ox
Babe first appeared in the *Detroit News-Tribune*
in 1910, based on stories originating from
Midwestern logging camps. The heroic lumberjack
soon became a nationally recognized icon and a
fitting subject for an artist in search of a new and
typically American subject matter. Carroll Barnes,
who had once worked as a lumber-packer,
sculpted his robust figure of *Paul Bunyan* shortly
before enrolling at Cranbrook Academy of Art to
study with Carl Milles. Although expert at
carving materials as diverse as stone and Lucite,
Barnes's greatest affinity was for wood, a
material particularly appropriate for subjects like
Bunyan and Johnny Appleseed, whom he also
sculpted. After settling into a studio near Sequoia
National Forest in 1941, Barnes embarked on a
16 1/2-foot-tall version of *Paul Bunyan*, a project
which, interrupted by service in the Army,
preoccupied him for seven years. Carved from a
2,000-year-old Redwood tree, the mammoth statue
gained distinction as the world's largest wood
carving and earned Barnes a legendary status
among sculptors.

Joe Houston

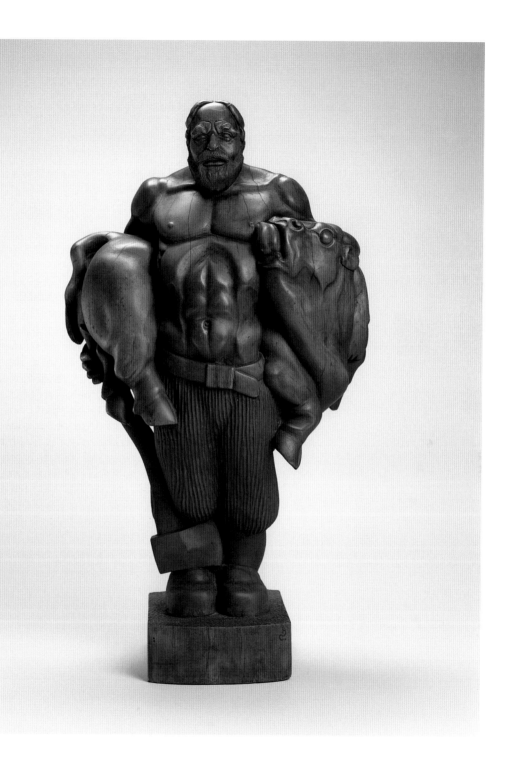

38 Waylande Gregory
Water, 1938, from the **Fountain of the Atom**,
New York World's Fair, 1939

Born 1905, Baxter Springs, Kansas; Cranbrook Academy
of Art, Resident Ceramic Sculptor, 1932-1933; died 1971,
Warren Township, New Jersey

Glazed terra cotta
70 1/4 x 35 x 33 1/4 inches
Collection of Patricia Shaw and Cranbrook Art Museum,
partial gift of Patricia Shaw
T 1999.33

Vintage Postcard featuring
the **Fountain of the Atom**

Waylande Gregory's monumental *Fountain of the Atom*, created for the 1939 New York World's Fair, was a playful symbol of one the twentieth century's most profound scientific developments. Illustrating the fair's general theme, "Building the World of Tomorrow with the Tools of Today," the artist contrasted ancient and modern concepts of science on the two tiers of the fountain. On the bottom tier Gregory personified the atom's electrons as eight exuberant boys and girls dancing with lightning bolts about the nucleus, a central shaft surmounted by a gas flame. Around this shaft on the top tier were four colossal figures, *Fire*, *Earth*, *Air* and *Water*, personifications of the elements as defined by the ancient Greeks. *Water*, a self-portrait of the artist, is depicted as a young swimmer accompanied by smiling maroon fish diving out of a swirling waterfall. Gregory, whose brief tenure at Cranbrook was cut short by the onset of the Depression, ultimately gained recognition in the 1930s and 1940s as one of America's foremost ceramic sculptors.

Gregory Wittkopp

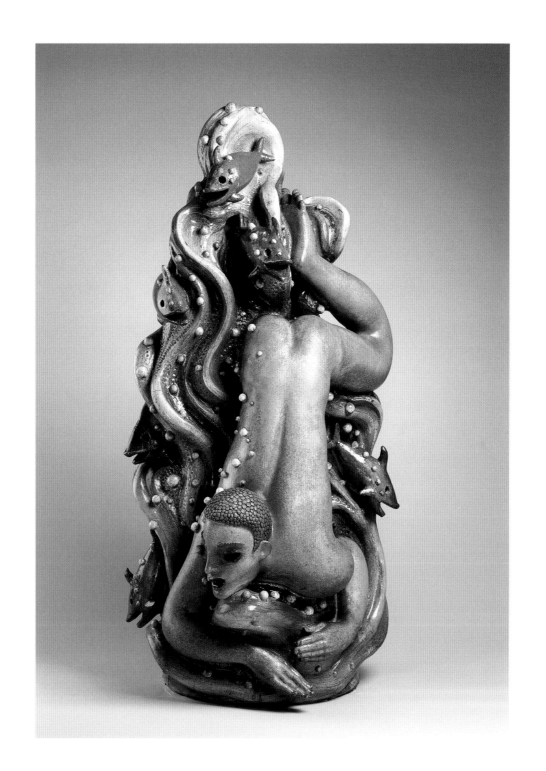

39 Zoltan Sepeshy
Study for The Scientist, Artist and Farmer Mural, Rackham Building, Detroit, Michigan, 1941

Born 1898, Kassa, Hungary (now Kosice, Czech Republic); Cranbrook Academy of Art (CAA), Instructor, Department of Painting, beginning 1931; CAA Director, Department of Painting, beginning 1936; CAA Educational Director, 1944-1946; CAA Director, 1946-1959; CAA President, 1959-1966; died 1974, Bloomfield Hills, Michigan

Tempera on hardboard
27 1/2 x 27 1/2 inches
Transfer from Cranbrook Institute of Science
CAM 1983.60

Zoltan Sepeshy
Untitled (Study for Mural),
not dated
Tempera on hardboard
Gift of Peggy deSalle
(CAM 1984.70)

During the Depression years, government and corporate patronage promoted public artworks designed to inspire civic pride, social unity and job productivity. Like many of his peers, Zoltan Sepeshy was commissioned by the Federal Art Project to create murals for government buildings, including post offices in Michigan and Illinois. Among his most significant private commissions was a mural for the Rackham Engineering Foundation in Detroit. Destined as an overmantle decoration for the Engineers' Lounge, Sepeshy conceived an image that celebrated nature as the inspiration for human endeavors. His design, *The Scientist, Artist and Farmer*, was elaborated in a detailed study, which includes the architectural elements of the ceiling, wood paneling and fireplace that would ultimately frame the panel *in situ*. It illustrates the massive hand of God bestowing the gift of water from above. In a single magnified drop, three men see this natural resource from the diverse viewpoints of scientific inquiry, creative expression and pragmatic application. Sepeshy cleverly represents himself as the artist whose outstretched brush appears to summon the vivid scene to life.
 Joe Houston

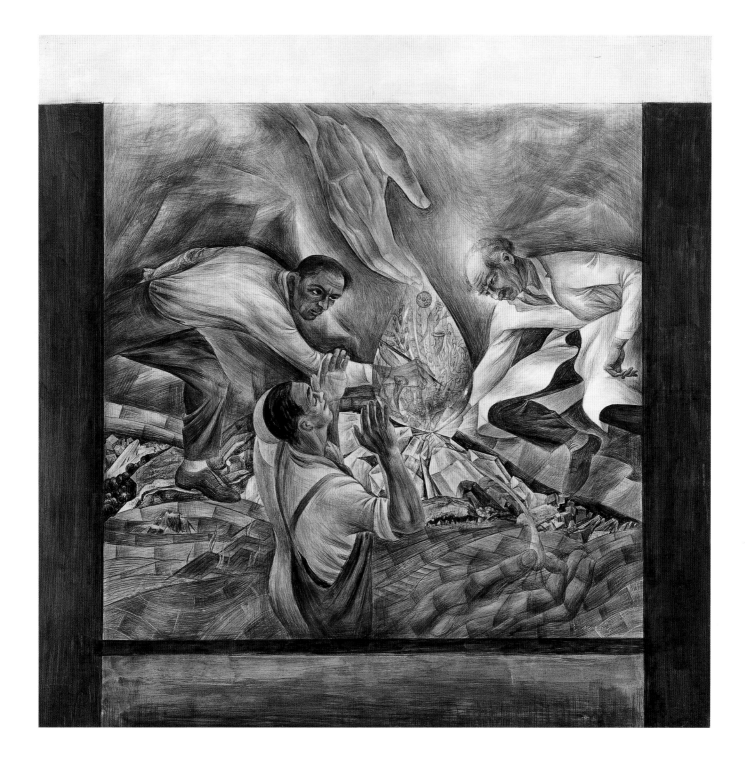

40 Zoltan Sepeshy
Sunday Afternoon—The Family, 1944

Born 1898, Kassa, Hungary (now Kosice, Czech Republic);
Cranbrook Academy of Art (CAA), Instructor, Department of
Painting, beginning 1931; CAA Director, Department of Painting,
beginning 1936; CAA Educational Director, 1944-1946; CAA
Director, 1946-1959; CAA President, 1959-1966; died 1974,
Bloomfield Hills, Michigan

Tempera on hardboard
35 x 45 inches
Gift of George Gough Booth and Ellen Scripps Booth
through The Cranbrook Foundation by exchange
CAM 1950.48

Zoltan Sepeshy
**Study for Painting
(Sunday Afternoon—The Family)**,
1944
Pencil on paper
Gift of the Artist (CAM 1944.174)

Turning to more emotionally expressive works in
the 1940s, Zoltan Sepeshy used his four-year-old
daughter Cecilia and his wife Dorothy as models
for this painting, which employs his painstaking
tempera technique (he later wrote a book on
tempera painting). At first glance *Sunday
Afternoon—The Family* appears to represent a
happy nuclear family in the American Midwest.
But closer examination reveals something
unsettling. Sepeshy places the family atop a hill
with a steep decline that leads to an ominous
landscape in the background. And what is the
cause of the little girl's wide-eyed, transfixed
gaze? Is she frightened by the dark, approaching
storm that has caused the horses to rear, or has
she interrupted an intimate moment between her
parents? The bright primary colors in the
foreground are contrasted with the approaching
darkness of the distant clouds. The discordant
atmosphere of the painting, produced during
World War II, may point to Sepeshy's concern over
the effects of the European war and his hope for
the future, represented by the child whose back is
to the storm.
 Mary Beth Kreiner

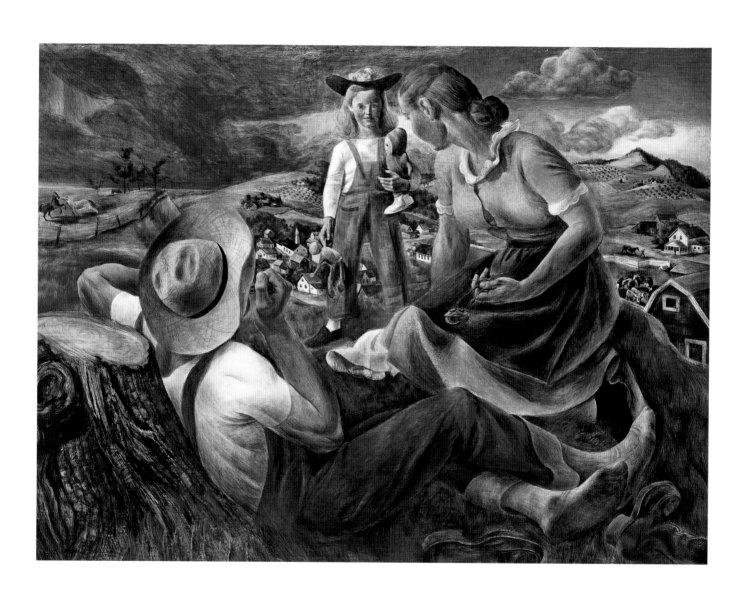

41 Doris Lee
Fisherman's Wife, 1945

Born 1905, Aledo, Illinois; died 1983, Clearwater, Florida

Oil on canvas
22 1/2 x 28 1/2 inches
Gift of George Gough Booth and Ellen Scripps Booth
through The Cranbrook Foundation
CAM 1945.27

Doris Lee was a popular American artist from
the 1930s to the 1950s. Although she is sometimes
taken for a folk artist because of the seemingly
naïve style, Lee studied painting at the Kansas
City Art Institute, in Paris with various artists,
including Cubist André Lhote, and at the
California School of Fine Arts. Early in her career,
her paintings were Regionalist in style and subject
but in the 1940s her style shifted to flattened,
simplified forms.

Fisherman's Wife appears deceptively simple
at first glance, but closer scrutiny reveals a
refined use of shape and pattern with bright,
harmonious colors. The smiling wife on her porch
welcomes the viewer, as well as her husband,
into the painting with its lush garden and
whimsical animals. Lee painted *Fisherman's
Wife* in Michigan, probably while a visiting artist
at Michigan State College (now University).
It reflects her memories of Key West, Florida,
where she had a winter studio.

Mary Beth Kreiner

Zoltan Sepeshy, 1898-1974
Ships that Pass, 1936
Tempera on hardboard
Gift of George Gough Booth and Ellen
Scripps Booth through The
Cranbrook Foundation (CAM 1944.50)

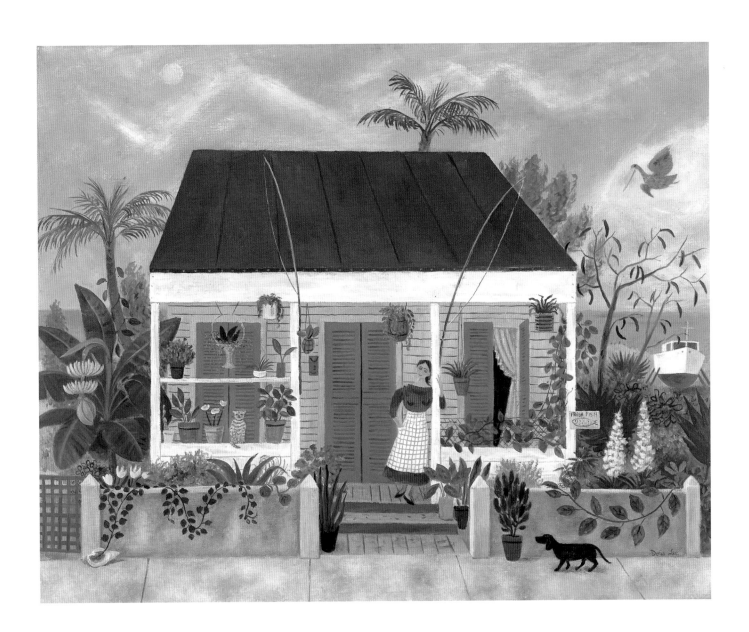

42 The War Collection
1942-1945

Robert T. Barbee (CAA MFA, Department of Painting, 1951)
William A. Bostick (CAA Student, Department of Painting, 1938)
Robert Collins (CAA MFA, Department of Painting, 1948)
John Cornish (CAA Student, Department of Painting, 1936)
David Fredenthal (CAA Student, Department of Painting, 1936-1937)
Edward Frederic James (CAA Student, Department of Painting, 1938-1939)
David A. Mitchell (CAA MFA, Department of Painting, 1947)
Jack Keijo Steele (CAA Student, Department of Painting, 1940-1945)
William K. Whitney (CAA MFA, Department of Painting, 1958)

Represented by:
Jack Keijo Steele, **Soldiers in New Guinea**, 1944

Born 1919, Ironwood, Michigan; Cranbrook Academy of Art (CAA), Student, Department of Painting, 1940-1945; died 2003, Garden City, Michigan

Watercolor on illustration board
31 3/4 x 44 3/4 inches
Gift of the Artist
CAM 1994.55

David Mitchell, 1918-1998
Untitled (Soldier), circa 1943
Ink on paper
Collection of Cranbrook Art
Museum (S 1945.78)

In 1942, the U. S. Navy commissioned the first artists to record the unfolding events of World War II. The Marine Corps Combat Correspondence Program and the Army Art Program, under the auspices of the War Department Art Advisory Committee (WDAAC), soon followed suit. They recruited both enlisted and civilian artists to express the essence of war from a personal point of view. Although the WDAAC lost its federal appropriations in mid-1943, soldier artists continued to document their experience at the front lines through other official channels or as correspondents for the press back home.

The War Collection is a rare repository of sketches and paintings by nine Cranbrook Academy of Art students and alumni who served as combat artists in Europe, North Africa, the South Pacific and Australia. Among this elite group was Jack Keijo Steele whose Soldiers in New Guinea recounts a dramatic scene of troops advancing through the unruly bush. Steele depicts this subject with a painterly vigor that verges on abstraction, relating the emotional impact of war as only the artist can convey it.

Joe Houston

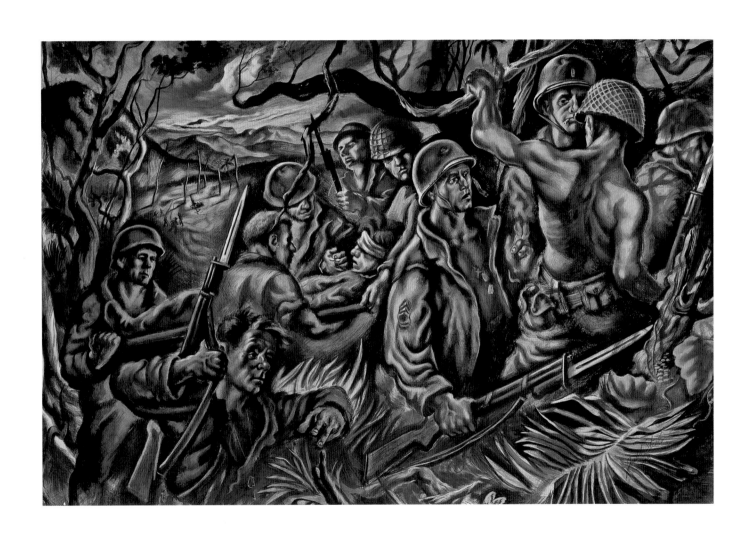

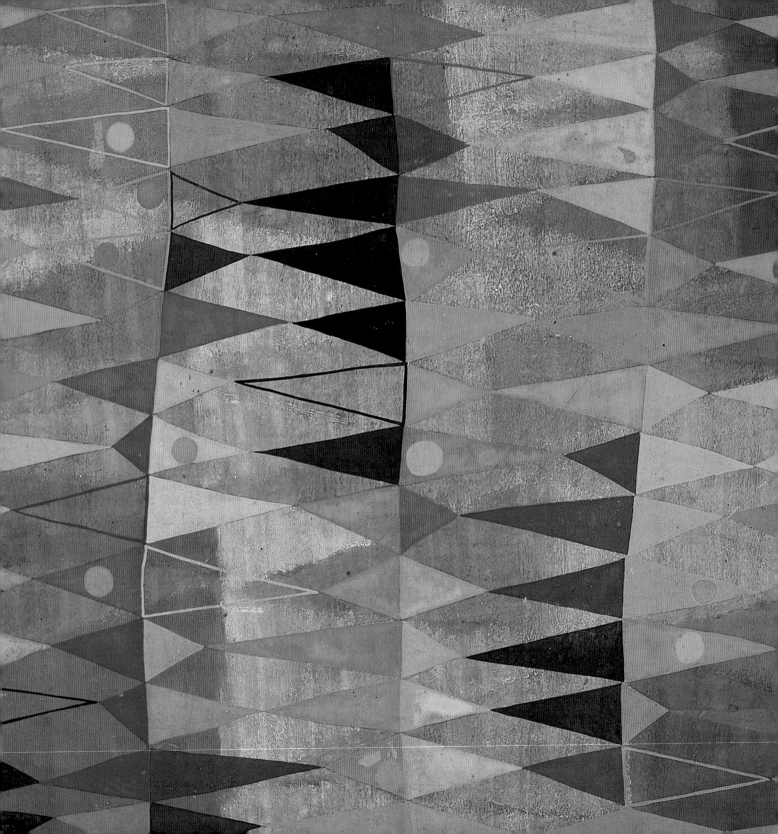

DESIGNING THE MODERN
Cranbrook at Mid-Century
1940-1960

Due in large part to the Saarinen family's presence at Cranbrook, the Academy of Art became a vital center of design and craft by the late 1930s. The unique creative environment attracted innovative architects, ceramists, designers, metalsmiths, painters, sculptors and weavers who together defined a new era in American design. Inspired by natural forms and responsive to industrial manufacturing methods, their modern vision reshaped postwar lifestyle and brought widespread recognition to Cranbrook as a creative force.

This new era in design history was forecast by the Museum of Modern Art's seminal "Organic Design in Home Furnishings" competition and exhibition of 1940 and 1941 which featured ground-breaking furniture by Academy artists Eero Saarinen, Charles Eames and Ralph Rapson. Their focus on design for living was a natural evolution of the Arts and Crafts philosophy upon which Cranbrook was founded. However, the new generation strove to incorporate the aesthetic beauty of the hand-crafted object into mass-produced wares, an inclination given impetus by the proximity of Detroit's industries. Indicative of this changing viewpoint at the Academy, the influential weaver Marianne Strengell channeled her students' efforts almost exclusively into the creation of prototypes for manufacture.

The aspiration to bring good design to the public imagination is exemplified by the work of multi-faceted designers Charles and Ray Eames who met and married at Cranbrook. Their optimistic spirit is echoed in the colorful abstractions of Wallace Mitchell, the sensuous clay vessels of Maija Grotell, and the sculptural furnishings of Harry Bertoia, each of whom taught at the Academy during this pivotal period. The dynamic furniture and architecture of Eero Saarinen are further emblematic of this prosperous era in mid-century design and the space-age aesthetic which has had an enduring impact on our everyday surroundings.

Joe Houston

43 **Eero Saarinen** and **Charles Eames** (Designers)
Side Chair, 1940, for the "Organic Design in Home
Furnishings" Competition, The Museum of Modern Art,
exhibited 1941

Saarinen: Born 1910, Kirkkonummi, Finland; Cranbrook Academy of Art,
Instructor, 1939-1942; died 1961, Bloomfield Hills, Michigan
Eames: Born 1907, St. Louis, Missouri; Cranbrook Academy of Art (CAA),
Student, Architecture, 1938-1939; CAA Instructor of Design, 1939-1941;
died 1978, St. Louis, Missouri

Manufacturers: Haskelite Corporation, Chicago (plywood shells);
Marli Ehrman, Germany (upholstery designer); Heywood-Wakefield
Company, Gardner, Massachusetts (upholsterer)
Molded plywood shell with Honduras mahogany veneers,
maple legs and original wool upholstery
32 1/2 x 18 x 18 inches
Gift of Susan Saarinen with assistance from the Imerman
Acquisition Fund
CAM 2001.1

Eliot F. Noyes (Author)
E. McNight Kauffer (Designer)
**Organic Design in Home
Furnishings**, catalogue for
exhibition organized by the
Museum of Modern Art,
New York, 1941

Eero Saarinen and Charles Eames's *Side Chair* was first
exhibited at New York's Museum of Modern Art in the
1941 "Organic Design in Home Furnishings" competition,
an exhibition often regarded as the formal beginning of
mid-century American modernism. Designers who were
invited to participate in this competition were charged
with creating low-cost furniture and other household
items for the American public. Saarinen and Eames
won first prize for their "Seating and Other Living Room
Furniture" which included a suite of *Side Chairs*, other
chairs, and a variety of modular case units.

All of the Saarinen and Eames chairs featured a
three-dimensional bent plywood shell with foam rubber
padding covered in fabric upholstery. Cranbrook's *Side
Chair*, with its original upholstery, demonstrates the
technological achievement of bent plywood, producing
a chair both lightweight and attractive. While most of
the chairs had visible imperfections caused by the
pieced wood laminate and were completely upholstered,
Side Chair, made with Honduras mahogany veneers,
was successful enough to retain its exposed back.
This chair laid the foundation for further innovations in
modern seating design by Saarinen and Eames as well
as other designers.

Ellen M. Dodington

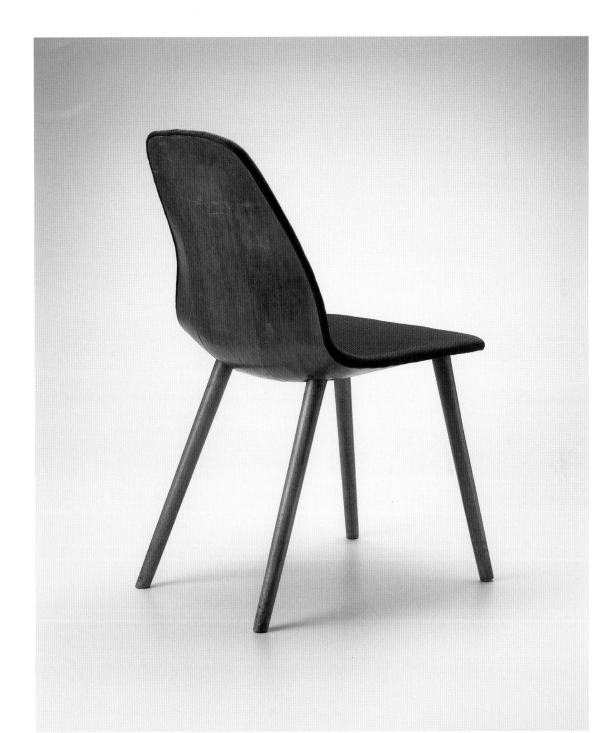

44 Ralph Rapson (Designer)
Rocking Chair, 1940, for the "Organic Design in Home Furnishings" Competition, The Museum of Modern Art, exhibited 1941

Born 1914, Alma, Michigan; Cranbrook Academy of Art, Student, Department of Architecture and City Planning, 1938-1940

Painted wood frame with replacement linen webbing
31 3/4 x 28 3/4 x 38 1/2 inches
Gift of the Designer
CAM 1990.28

Ralph Rapson
Sketch for the Rapson Rapid Rocker (Rapson #12), 1942-1943
Pencil on tracing paper
Gift of the Designer (CAM 1989.82)

Although Ralph Rapson's right arm was amputated in infancy because of a deformity, he fulfilled his dreams of becoming a draughtsman and architect. Between 1938 and 1942, Rapson pursued graduate studies at Cranbrook Academy of Art and worked as a designer in Eliel and Eero Saarinen's private architectural practice. Afterwards, as a principal in his own firm, Rapson established himself as a prominent mid-century modernist architect and also taught at the Illinois Institute of Technology and the Massachusetts Institute of Technology before assuming leadership of the School of Architecture and Landscape Architecture at the University of Minnesota in 1954. Today the school is named in his honor.

Rapson submitted plans for the *Rocking Chair* as a part of his entry to the famous 1940 "Organic Design in Home Furnishings" competition sponsored by the Museum of Modern Art. In 1946, at the instigation of his old Academy friend Florence Knoll, Rapson revived the design for production. He became the first of many Cranbrook-trained designers to work for Knoll. Cranbrook Art Museum also owns an extensive collection of sketches for Rapson's chair designs.
Mark A. Coir

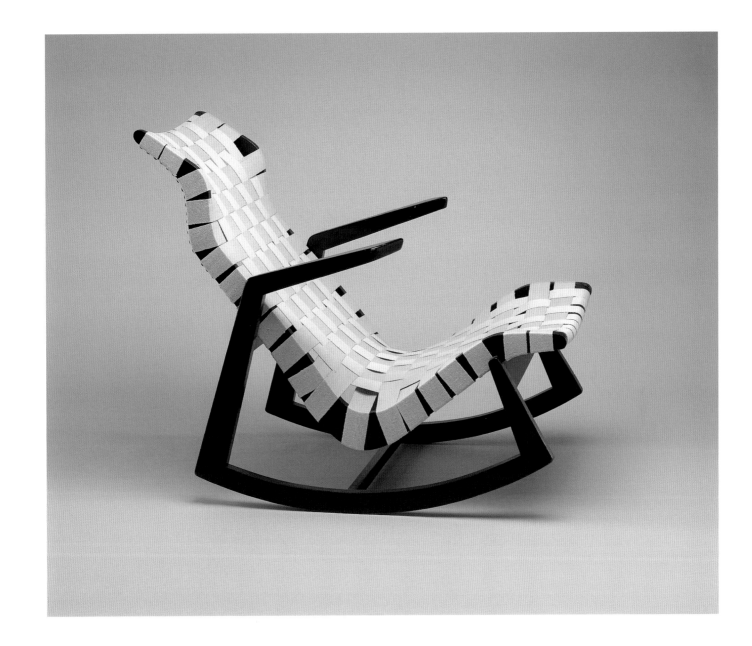

45 Harry Bertoia
Coffee and Tea Service, 1940

Born 1915, San Lorenzo, Udine, Italy; Cranbrook Academy of Art (CAA), Student, Silver and Metalsmithing, 1937; CAA Manager and Instructor in the Metalcraft Shop, 1937-1943; CAA Instructor of Graphic Art, 1942-1943; died 1978, Barto, Pennsylvania

Silver with cherry handles
8 x 15 1/2 x 15 1/2 inches (overall)
Gift of Mrs. Joan R. Graham
CAM 1986.34.A through .F

Harry Bertoia had a prolific and varied career ranging from furniture design to sculpture to graphic design. However different in form, with each medium Bertoia expressed his innovative and unique artistic sensibilities. His design for this *Coffee and Tea Service* captures the streamlining trends in 1930s and 1940s design—a time when everything from vacuum cleaners to car fenders was subject to a curvilinear aesthetic. The form of Bertoia's *Coffee and Tea Service* suggests the nature of the liquids each object was meant to contain, while the play of the silver's arcs and curves, extended through the cherrywood handles and knobs, creates an elegant as well as functional artwork. Although completed fairly soon after coming to Cranbrook, the dynamic forms and sweeping surfaces of the *Coffee and Tea Service* represent Bertoia's independence from Eliel Saarinen's highly geometric designs. This service was privately commissioned by a Bloomfield Hills couple and is accompanied in the Art Museum's collection by a set of maquettes for another coffee and tea service by Bertoia.

Ellen M. Dodington

Harry Bertoia
Maquettes for Coffee and Tea Service,
circa 1940
Transferred from Cranbrook Academy
of Art Department of Metalsmithing
(ZO 1980.1.A through .C)

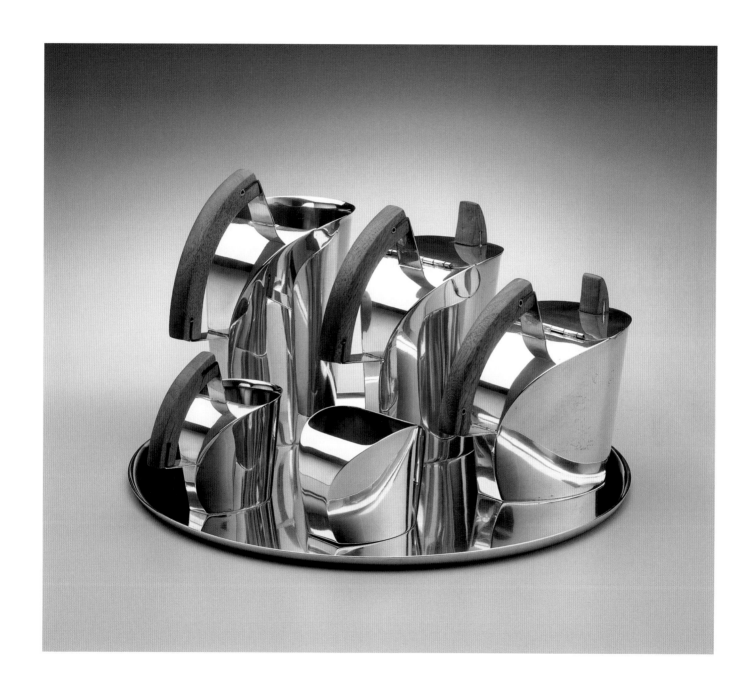

46 Maija Grotell
Vase, circa 1942

Born 1899, Helsinki, Finland: Cranbrook Academy of Art, Head,
Department of Ceramics, 1938-1966; died 1973, Pontiac, Michigan

Stoneware
20 x 11 1/8 (diameter) inches
Gift of Mrs. Benjamin Micou in memory of Maija Grotell
CAM 1978.16

As early as 1927, Maija Grotell was attuned to
contemporary ideas of decorating vessels with
the linear and geometric combinations of Art
Deco motifs. She worked primarily with strong
cylindrical and spherical forms, often leaving the
clay unglazed, textured only with fingers or tools.
Frequently, Grotell made massive vessels when
cleaning up the studio so as not to waste scrap
clay, and later became well-known for using the
large surfaces for glaze experimentation.

While embracing simplicity of form, this
immense vase also exemplifies Grotell's
fascination with the depth of layers and patterns
she found in nature. Hand-thrown on a foot-
operated wheel, the vase was textured with
Albany slip relief in the pâte sur pâte method of
building up layers, creating a geometric relief
pattern which, like Eliel Saarinen's patterns on
the Art Museum's bronze doors, is reminiscent of
tree branches. The glaze treatment is also
layered with the color of the high-fired stoneware
body showing through the blue-gray slip and
the glaze of striking yellow-green.
Leslie S. Edwards

Eliel Saarinen (Designer),
1873-1950
**Cranbrook Art Museum
Front Doors**, designed
1938-1942
Bronze
Photograph Collection of
Cranbrook Archives
(AA3000)

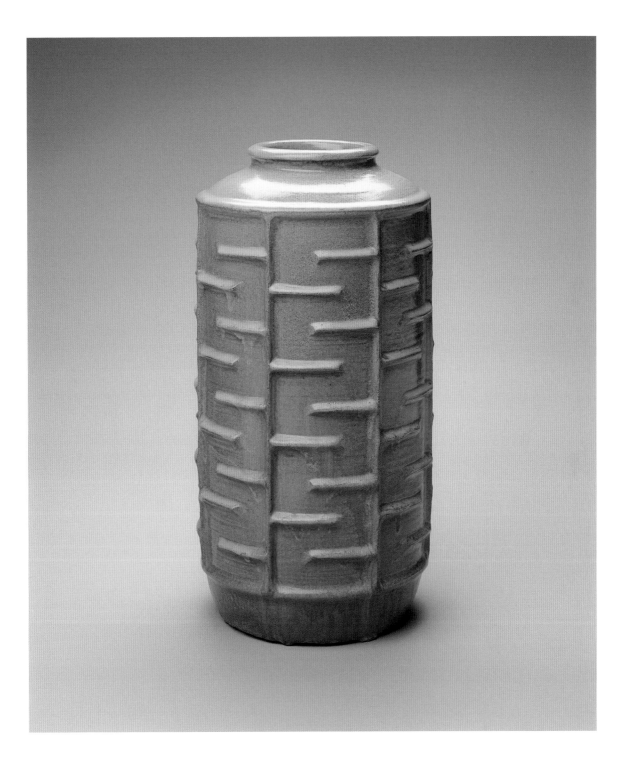

Maija Grotell
Vase, 1943, or earlier

Born 1899, Helsinki, Finland; Cranbrook Academy of Art, Head,
Department of Ceramics, 1938-1966; died 1973, Pontiac, Michigan

Platinum design on unglazed blue stoneware
13 1/2 x 14 (diameter) inches
Gift of George Gough Booth and Ellen Scripps Booth through
The Cranbrook Foundation
CAM 1943.13

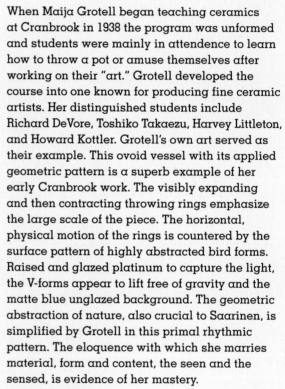

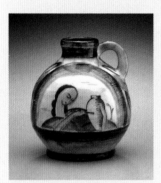

Maija Grotell
Self-Portrait Vase, circa 1937
Earthenware
Gift of Patricia J. Shaw (CAM 1995.9)

When Maija Grotell began teaching ceramics
at Cranbrook in 1938 the program was unformed
and students were mainly in attendence to learn
how to throw a pot or amuse themselves after
working on their "art." Grotell developed the
course into one known for producing fine ceramic
artists. Her distinguished students include
Richard DeVore, Toshiko Takaezu, Harvey Littleton,
and Howard Kottler. Grotell's own art served as
their example. This ovoid vessel with its applied
geometric pattern is a superb example of her
early Cranbrook work. The visibly expanding
and then contracting throwing rings emphasize
the large scale of the piece. The horizontal,
physical motion of the rings is countered by the
surface pattern of highly abstracted bird forms.
Raised and glazed platinum to capture the light,
the V-forms appear to lift free of gravity and the
matte blue unglazed background. The geometric
abstraction of nature, also crucial to Saarinen, is
simplified by Grotell in this primal rhythmic
pattern. The eloquence with which she marries
material, form and content, the seen and the
sensed, is evidence of her mastery.
 Marsha Miro

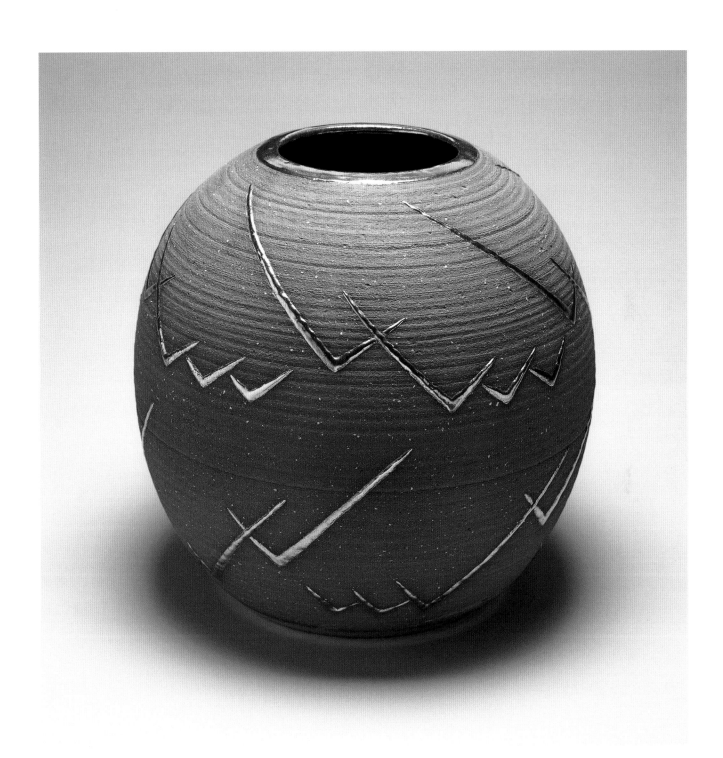

48 Zoltan Sepeshy
Dyers' Day, circa 1950

Born 1898, Kassa, Hungary (now Kosice, Czech Republic);
Cranbrook Academy of Art (CAA), Instructor, Department of
Painting, beginning 1931; CAA Director, Department of Painting,
beginning 1936; CAA Educational Director, 1944-1946; CAA
Director, 1946-1959; CAA President, 1959-1966; died 1974,
Bloomfield Hills, Michigan

Tempera on hardboard with original frame
32 x 20 inches
Museum Purchase with funds from The Cranbrook Foundation
and Carroll Barnes by exchange
CAM 2001.2

Zoltan Sepeshy
Rock Garden, circa 1955
Tempera on hardboard
Gift of Rose M. Shuey, from the
Collection of Dr. John and Rose M. Shuey
(CAM 2002.40)

A long series of steps leading from the bottom
edge of the painting invites us to enter into the
heart of Zoltan Sepeshy's *Dyers' Day*. Inside, we
are treated to an exotic revelry of colorful fabrics
festooning the narrow alley. Hung to dry on
sweeping clotheslines, they form a syncopated
arrangement of flat, multi-hued shapes.
The proliferation of geometric forms is countered
only by the circular shapes introduced by a tuba-
toting figure. Despite the otherwise ordinary
surroundings, the musician indicates that this is
an occasion worthy of special commemoration.
Such is the role that Sepeshy often played in his
own art, celebrating the commonplace and
drawing attention to the beauty of our everyday
surroundings. A cryptic yet credible scene,
Dyers' Day marks a transition from Sepeshy's
illustrative depictions of the 1940s to his more
overtly abstract paintings of the 1950s and
beyond. In his later works Sepeshy reflects the
spirit of the new era of postwar painting, in
which the formal elements of color, shape and
line form an expressive narrative less reliant on
anecdotal detail.
 Joe Houston

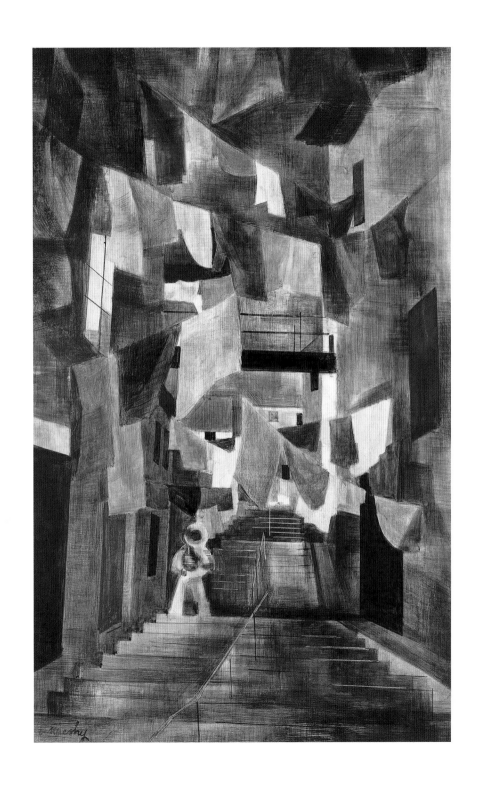

49 Marianne Strengell
Drapery Fabric, 1945, or earlier

Born 1909, Helsinki, Finland; Cranbrook Academy of Art (CAA),
Instructor of Weaving, Costume and Textile Design, 1937-1942;
CAA Head, Department of Weaving and Textile Design, 1942-1961;
died 1998, Wellfleet, Massachusetts

Cotton and rayon warp; rayon weft with silver threads
126 x 41 inches
Gift of the Artist
CAM 1945.30

Marianne Strengell
(Designer)
Taj Mahal (Upholstery
Fabric) for the 1959 Lincoln
Continental, circa 1959
Cotton, rayon and metallic
strands
Museum Purchase
(CAM 1981.5)

Born into an artistic Finnish family and raised
within the Saarinen family's inner circle of
friends, Marianne Strengell naturally gravitated
toward the arts, especially textile design, in her
native Finland. Heading design operations at
several Scandinavian textile firms and winning
many prizes for her work at both the hand and
powerloom, she was already a seasoned
professional by the time she left for America
in 1936.

At the invitation of Eliel Saarinen, Strengell
came to Cranbrook in 1937 to teach weaving and
textile design. As director of the weaving
department between 1942 and 1961, Strengell
constantly challenged her students to develop
their artistic skills with a view toward designing
for industry. Her own work, as exemplified by
this colorful fabric made of cotton and rayon
warp and rayon and silver thread weft, was
notable for its experimentation, use of new
fibers, materials, combinations and textures.
Though hand-woven, the fabric looks as though
it could be produced for the mass market on the
powerloom.

Mark A. Coir

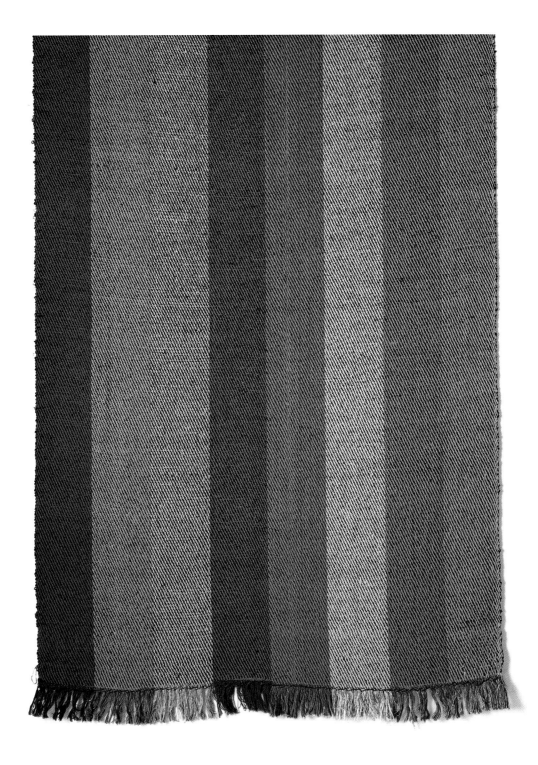

50 Marianne Strengell
Throw Blanket, circa 1950s

Born 1909, Helsinki, Finland; Cranbrook Academy of Art (CAA),
Instructor of Weaving, Costume and Textile Design, 1937-1942;
CAA Head, Department of Weaving and Textile Design, 1942-
1961; died 1998, Wellfleet, Massachusetts

Mohair warp; mohair and mylar weft; satin border
72 1/2 x 67 inches
Gift of Peggy deSalle
CAM 1984.89

Marianne Strengell
(Designer)
Manila Drapery Fabric,
circa 1954
Silkscreen printed cotton
Gift of Mrs. Walter P. Hickey
(CAM 1981.27)

The daughter of an architect and an interior
designer, Marianne Strengell placed utmost
value on the functional application of the art of
weaving. After she began teaching at Cranbrook
Academy of Art in 1937, pictorial weaving was
completely displaced by design for production.
Her progressive instruction stressed both the
technical and professional aspects of the craft,
from yarn dying to merchandising and client
relations. Shortly after Strengell inherited the
directorship of the Department of Weaving from
Loja Saarinen in 1942, a powerloom was installed
in the studios, allowing students to better
accommodate design for industrial manufacture,
an application further promoted through class
trips to local factories. The close proximity of the
automotive and furniture industries provided
numerous professional opportunities for
Strengell. She created exquisite prototypes for
upholstery, rugs, drapery and other household
fabrics for numerous manufacturers, often
integrating synthetic fibers and new screen-
printing techniques developed during the war
years. As an artist and teacher, Strengell
promoted greater aesthetic consideration in
modern textile design, imbuing products of mass
manufacture with the formal and material beauty
of the hand-crafted object.
Joe Houston

51 **Florence Knoll Bassett** (Designer)
Armchair, designed 1945, for the Rockefeller Family
Offices, Rockefeller Plaza, New York, New York,
completed 1946

Born Florence Schust, 1917, Saginaw, Michigan; Kingswood School
Cranbrook, Graduate, 1934; Cranbrook Academy of Art, Student,
Department of Architecture, 1934-1935, 1936-1937, 1939

Manufacturer: Knoll Associates, Inc., East Greenville, Pennsylvania
Wood; replacement upholstery
30 x 23 5/8 x 22 inches
Gift of Laurence S. Rockefeller
CAM 1986.35

Florence Knoll Bassett (Designer)
Rockefeller Family Offices,
Rockefeller Center, New York,
New York, photographed circa 1945

Florence Knoll Bassett is one of the most
significant women in twentieth-century design.
A close friend of the Saarinen family, she studied
under Eliel before taking classes and working with
such luminaries as Walter Gropius, Marcel Breuer
and Ludwig Mies van der Rohe. When she was
head of Knoll Furniture's Planning Unit, she helped
the firm become one of the most important design
companies in America. A recent recipient of the
Presidential National Medal of the Arts, Bassett's
design work has largely focused on refining
furniture forms and arrangements to maximize
their comfort, practicality, beauty and use.

Bassett's innovative interiors were often
realized in her designs for corporate offices.
This custom designed chair, from the Rockefeller
family offices at Rockefeller Center, exemplifies
concepts of comfort and beauty with its modernist
simplicity. With what is now a relatively common
practice, Bassett transformed the world of interior
design by carefully designing furnishings and
choosing upholstery to match the exacting needs
of her clients.

Ellen M. Dodington

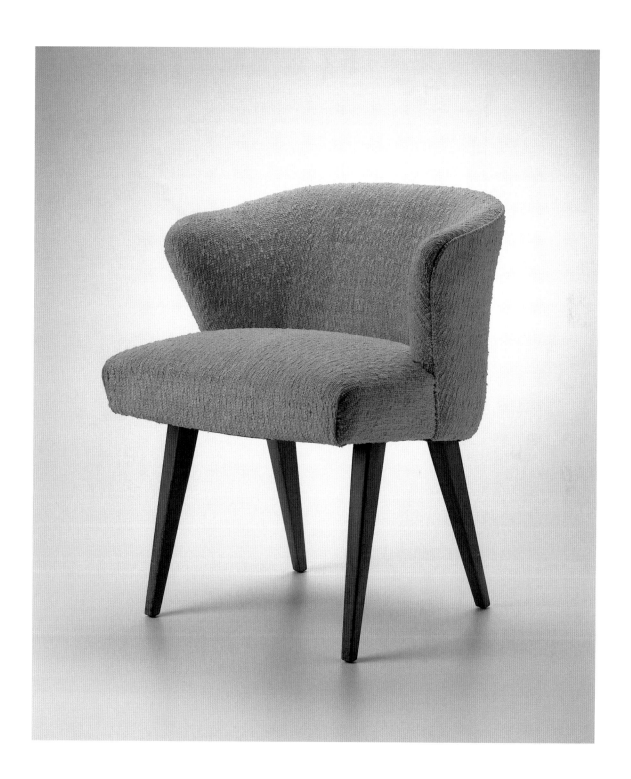

52 Charles and Ray Eames (Designers)
FSW (Folding Screen—Wood), designed circa 1946, in production 1946-1955

Charles: Born 1907, St. Louis, Missouri; Cranbrook Academy of Art (CAA), Student, Architecture, 1938-1939; CAA Instructor of Design, 1939-1941; died 1978, St. Louis, Missouri
Ray: Born Bernice Alexandra Kaiser, 1912, Sacramento, California; Cranbrook Academy of Art, Student, 1940-1941; died 1988, Venice, California

Manufacturer: Herman Miller, Inc., Zeeland, Michigan
Laminated plywood with ash veneers and canvas
68 x 59 1/2 inches
Museum purchase with funds from the Imerman
Acquisition Fund
CAM 1992.12

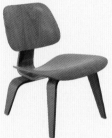

Charles and Ray Eames
(Designers)
**LCW (Lounge Chair
Wood)**, designed 1945-1946
Molded walnut plywood
Gift of Herman Miller, Inc.,
The Herman Miller Collection
(CAM 1990.76)

Charles and Ray Eames began their experiments with plywood furniture in 1940 while in residence at Cranbrook Academy of Art. During World War II, they successfully mass-produced molded plywood leg splints for the U.S. Navy. Thin sheets of wood were shaped and glued together under pressure into compound curves, taking advantage of the strength and flexibility of inexpensive materials.

The *FSW (Folding Screen—Wood)* is made up of molded panels joined with canvas "hinges" that are laminated between the wood layers.
The entire screen can be folded into a portable compact unit. Recalling the organic folds of heavy drapery, the self-supporting structure offers a simple and elegant way of dividing a room, screening off objects or activities, or serving as a background to other furniture. The modular construction made it feasible to offer a number of variations to suit one's taste. *FSW* was available in three wood veneers: birch, oak and calico ash. It also came in two heights: 30 inches and 68 inches; and three lengths: six, eight, or ten panels.
Craig Hoernschemeyer

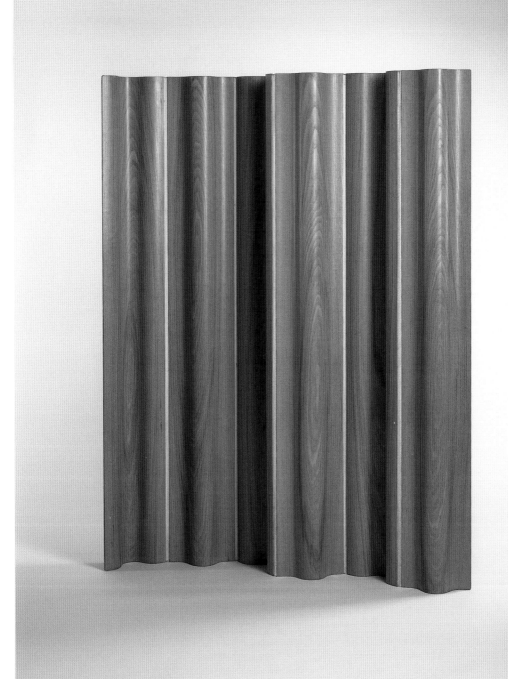

53 Charles and Ray Eames (Designers)
ESU (Eames Storage Units), designed 1949-1950; in production 1950-1955; 420-C-Birch White Glass Cloth Laminate Storage Unit, made 1951-1954; 200 Series-N-Birch Chest, made 1953-1954

Charles: Born 1907, St. Louis, Missouri; Cranbrook Academy of Art (CAA), Student, Architecture, 1938-1939; CAA Instructor of Design, 1939-1941; died 1978, St. Louis, Missouri
Ray: Born Bernice Alexandra Kaiser, 1912, Sacramento, California; Cranbrook Academy of Art, Student, 1940-1941; died 1988, Venice, California

Manufacturer: Herman Miller, Inc., Zeeland, Michigan
Steel, birch plywood and plastic laminate
Storage Unit: 58 3/4 x 47 x 15 3/4 inches
Chest: 32 1/4 x 47 x 15 3/4 inches
Gift of Herman Miller, Inc.
CAM 1989.32 and CAM 1989.33

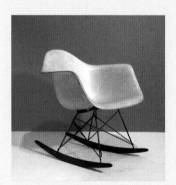

Charles and Ray Eames (Designers)
RAR (Rocker base Armchair),
designed 1950-1953
Molded fiberglass, wire and birch
Gift of Herman Miller, Inc.,
The Herman Miller Collection
(CAM 1990.74)

Charles and Ray Eames are one of the great design couples of all time. Their collaborative projects, which included toys, film, urban planning and furniture, influenced almost every aspect of late twentieth-century design. The Eameses met at Cranbrook, married, and moved to California where they began their joint practice initially focusing on furniture and interior design. They strove to dispel the belief that modern design was uninviting and created interiors that were warm and informal.

The *ESU* (*Eames Storage Unit*) series was inspired by industrial shelving as an inexpensive solution to the changing storage needs of mid-century families who were more mobile and informal than the previous generation. The series was offered in different sizes with the closed cabinets, number of shelves and bays varying to suit the owner's particular needs. By interchanging color panels and textures, the units could be further personalized while resonating with the contemporaneous trend in painting toward geometric abstraction. Originally offered as self-assembly and later as pre-assembled, the *ESU* storage units are perhaps one of the most recognizable furniture designs of the last century.
Ellen M. Dodington

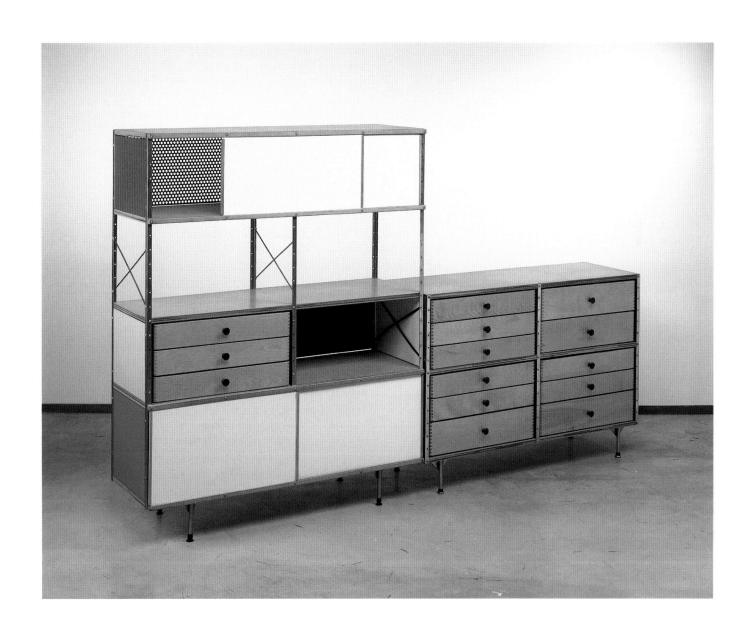

54 Ruth Adler Schnee (Designer)
A Selection of Printed Drapery Fabrics
(clockwise, from upper left)
Semaphore, designed 1950-1951, 34 1/4 x 51 5/8 inches
Germination, designed 1948, 34 7/8 x 51 3/4 inches
Wireworks, designed circa 1961-1963, 32 1/4 x 52 5/8 inches
Backgammon, designed 1950-1951, 32 3/4 x 51 7/8 inches

Born 1923, Frankfurt am Main, Germany; Cranbrook Academy
of Art, MFA, Department of Design, 1946

Manufacturer: Adler-Schnee Associates, Detroit, Michigan
Printer: Edward Schnee
Cotton warp; cotton and mohair weft; screen-printed
Gift of the Designer
ZO 1982.22, ZO 1982.23, ZO 1982.30 and ZO 1982.35

Schnee Residence featuring
Germination,
photographed in 1948
Photograph Collection of
Ruth Adler Schnee

Ruth Adler Schnee's artistic career began in
Germany where she trained under family friend
Paul Klee. After immigrating to the United States,
Schnee studied at the Rhode Island School of
Design before working with Walter Gropius at
Harvard and receiving her MFA under Eliel
Saarinen at Cranbrook. She next collaborated
with her husband, Edward Schnee, and formed
Adler-Schnee Associates, an interior design firm
in Detroit that enabled Schnee to design and
produce textiles and the environments that
would hold them.

Schnee activates her textile designs with
organic and geometric forms that appear to
undulate and interact with each other. Her work,
which resonates with the simple geometric
patterns created by postwar Scandinavian
designers and the biomorphic shapes of abstract
expressionist painting, won awards from the
Museum of Modern Art and the American
Institute of Decorators. Schnee was inspired by a
variety of sources—*Germination* resulted from
her sketches of the American Southwest while on
her honeymoon and *Wireworks* was inspired by
firetools designed by Alexander Calder. Many of
her designs are once again in production.
Ellen M. Dodington

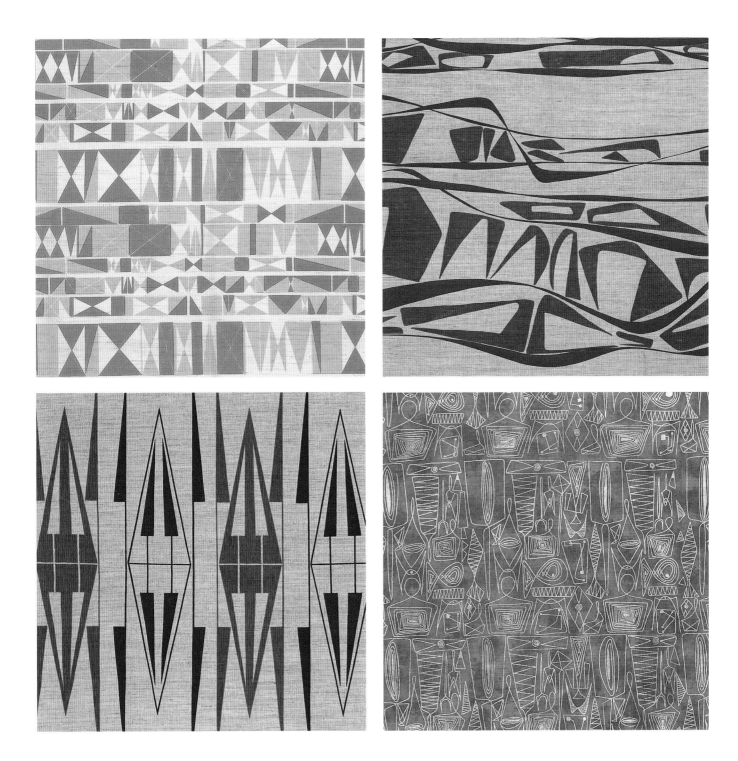

55 Maija Grotell
Vase, 1940-1942

Born 1899, Helsinki, Finland; Cranbrook Academy of Art, Head,
Department of Ceramics, 1938-1966; died 1973, Pontiac, Michigan

Stoneware; Albany slip over unglazed clay
21 1/2 x 8 1/4 (diameter) inches
Collection of Cranbrook Art Museum
CAM 1970.2

Maija Grotell
Plate, circa 1955-1960
Stoneware
Gift of Mrs. Benjamin Micou in
memory of Maija Grotell (CAM 1978.14)

Born in Finland, Maija Grotell studied in Helsinki
at the Central School of Arts and Crafts with
Belgian-English ceramist Alfred William Finch.
After immigrating to the United States in 1927,
she taught at the Henry Street Settlement,
Rutgers University, and several other institutions
in the New York City area until 1938, when she
was invited to join the faculty at Cranbrook
Academy of Art.

The strong, simple silhouette of this vessel is
characteristic of Grotell's production throughout
her career. To decorate the cylinder, she used
slip—a form of clay thinned to a creamy
consistency and painted on before firing; the
blackness of the Albany slip contrasts with the
lighter clay body. Grotell applied it in a geometric
pattern, allowing the opposition of positive and
negative spaces to establish a contrapuntal
rhythm across the surface. By the later forties,
Grotell's experiments would lead her to combine
the same Albany slip with a Bristol glaze to
create vessels with a pocked surface in which
dark and light areas bubbled together like lava.

Susan S. Waller

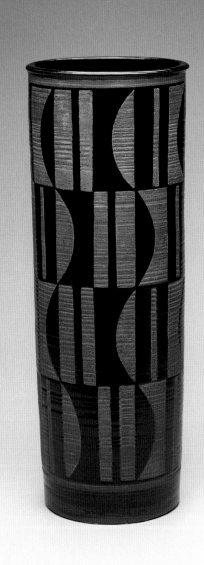

56 Wallace Mitchell
Double Pennants, 1949

Born 1911, Detroit, Michigan; Cranbrook Academy of Art (CAA),
Student, Department of Painting, 1934-1935; CAA Instructor,
Department of Drawing and Painting, 1936-1954; CAA Secretary
and Registrar, 1944-1963; Cranbrook Academy of Art Galleries,
Director, 1955-1970; CAA President, 1970-1977; died 1977,
Bloomfield Hills, Michigan

Casein on watercolor board
20 1/8 x 27 3/8 inches
Gift of Joan and LeRoy Bence
CAM 1994.60

Wallace Mitchell
Respite, 1949
Casein on hardboard
Museum Purchase with funds from
the Mitchell Memorial Fund
(CAM 1982.60)

Director of Cranbrook Academy of Art Galleries
from 1955 to 1971 and president of the Academy
of Art from 1970 until his death in 1977, Wallace
Mitchell continued to paint as he carried out his
duties as administrator. Mitchell had become
deeply rooted in Cranbrook. After studying
painting with Zoltan Sepeshy for a year, he was
hired to teach drawing and painting at the
Academy. While his work in the 1930s was
figurative, he turned to abstract art and geometric
forms in the 1940s, perhaps in part due to his
friendship with Harry Bertoia, who worked with
geometric forms at the same time. Mitchell's
paintings gained national attention when four
of his abstract works were acquired by the
Guggenheim Museum.

In *Double Pennants*, the color modulates from
warm orange-reds to cool pinks with olive-green
accents. The pennants undulate in soft waves as
if in changing light, with "eyes" animating some
of them. Mitchell's lively design and masterly use
of color evokes the spatial depth of the sea.

Mary Riordan

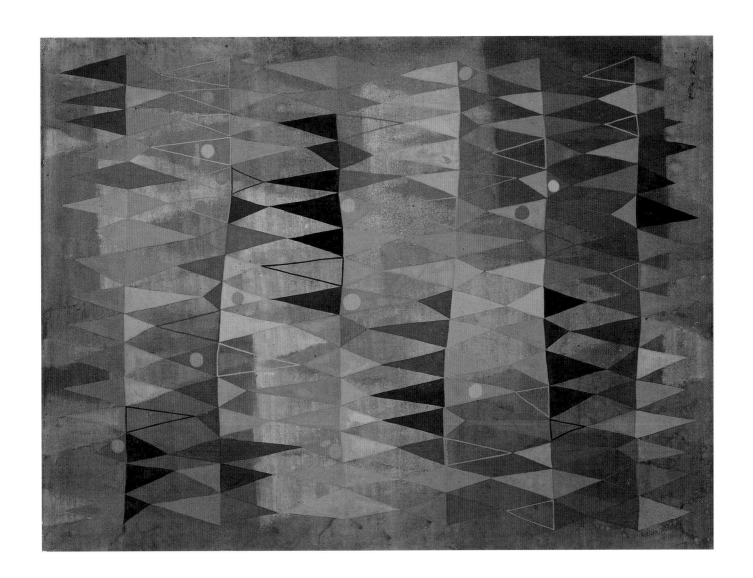

57 Harry Bertoia
Untitled (Wall Sculpture), 1958, for the Winkelman Residence, Detroit, Michigan

Born 1915, San Lorenzo, Udine, Italy: Cranbrook Academy of Art (CAA), Student, Silver and Metalsmithing, 1937; CAA Manager and Instructor in the Metalcraft Shop, 1937-1943; CAA Instructor of Graphic Art, 1942-1943; died 1978, Barto, Pennsylvania

Bronze
41 3/4 x 63 x 9 1/4 inches
Gift of Peggy and Stanley Winkelman
CAM 1984.34

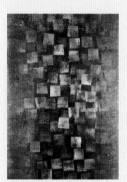

Harry Bertoia
Monoprint, circa 1943
Ink on Japanese paper
Gift of Dr. and Mrs. Irving
Burton (CAM 1981.42)

With its glistening metal surfaces, shapes and shadows, this wall sculpture was commissioned in 1957 by Peggy and Stanley Winkelman, and completed in 1958, hanging near the fireplace in their Detroit home. In a letter to them, Bertoia described the work as "light and airy" and noted that he kept it on his wall "for some time and liked it very much."

Bertoia taught metalwork and graphic art at Cranbrook Academy of Art before moving to California to work with Ray and Charles Eames. In 1950, he moved to Pennsylvania, working for Knoll and on his sculpture. Manipulating form, space, light, texture, color and movement, Bertoia was the most versatile of artists, and his work as a metalsmith, designer of jewelry and furniture, sculptor, painter and printmaker is innovative and varied.

Years ago in a Pennsylvania barn, his widow Brigitta Bertoia created a symphony of sound by striking over two hundred sculptures of varying sizes in a magical moment. The movement and melodies of the sound sculptures are implied in this wall sculpture, as if waiting to be activated by the flickering light of a fireplace.

Roy Slade

166

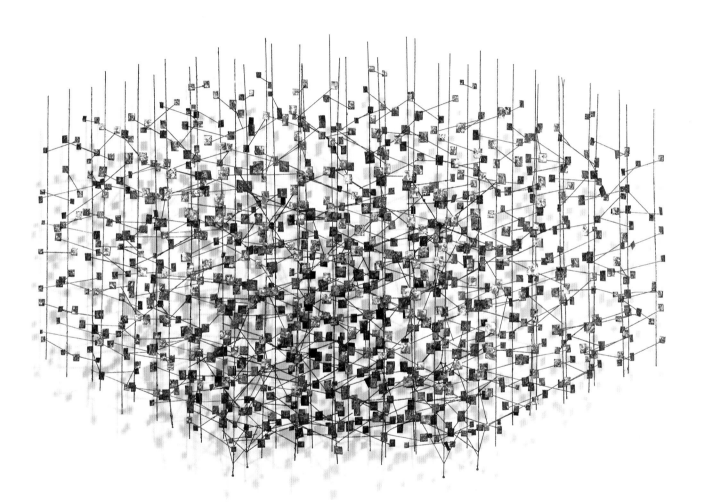

58 Toshiko Takaezu
Double-Spouted Vase, circa 1958

Born 1922, Pepeeko, Hawaii; Cranbrook Academy of Art (CAA),
Teaching Assistant, Department of Ceramics, 1953-1954;
CAA MFA, Department of Ceramics, 1954

Stoneware
14 5/8 x 17 3/8 x 7 3/8 inches
Gift of Eliel G. and Daniel A. Redstone in honor of Ruth R. and
Louis G. Redstone (CAA Master of Architecture, 1948)
CAM 2002.49

With a few deft alterations to the traditional vase
form, Toshiko Takaezu transforms the function of a
vase from that of holding flowers to holding its
own as ceramic sculpture. Like a dividing
biomorphic shape with nipple-like bumps and
lush brown glazes, the work assumes a dynamic
quality. In other vessel forms, such as her *Moon
Pot*, Takaezu would finalize the transformation
from utilitarian vessel to sculptural form by
closing the opening altogether while retaining the
beauty and power of the space-containing form.

This *Double-Spouted Vase* is a rare creation
and the last one of its kind Takaezu created in the
1950s. The body of the form and the two spouts
were thrown separately on a potter's wheel and
then joined together by hand. Although completed
a few years after Takaezu left Cranbrook as a
student, it beautifully represents the ground-
breaking work she completed under the tutelage
of master ceramist Maija Grotell.

David D.J. Rau

Toshiko Takaezu
Moon Pot, 1980
Stoneware
Gift of the Artist (CAM 1987.29)

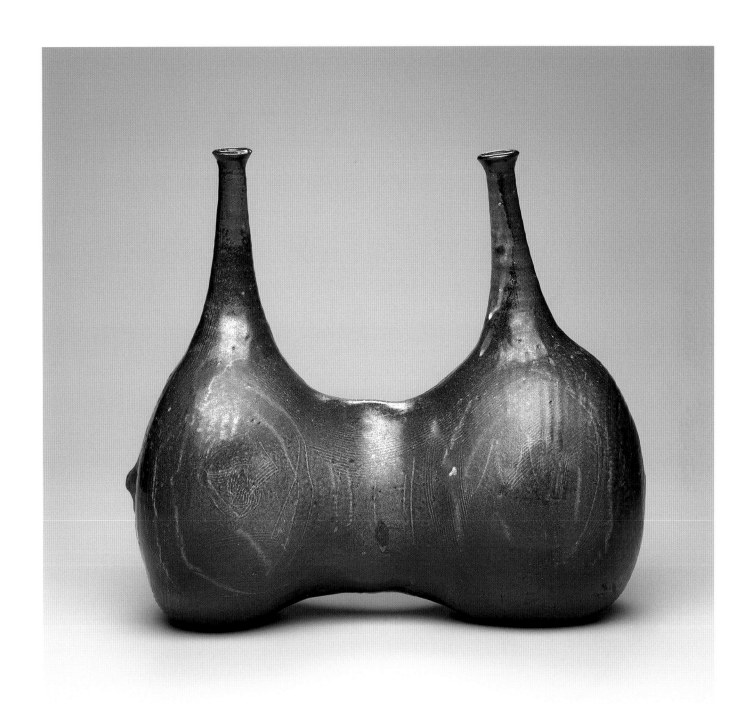

59 George Nelson (Designer)
MAA Swaged Leg Lounge Chair, designed circa 1958, in production 1958-1964, made 1958-1963

Born 1908, Hartford, Connecticut; died 1986, New York, New York

Design Office: George Nelson and Company
Manufacturer: Herman Miller, Inc., Zeeland, Michigan
Tubular steel, molded plastic shell and rubber
29 5/8 x 27 3/4 x 27 inches
Gift of Herman Miller, Inc.
ZO 1989.3

Man seated in **MAA Swaged Leg Lounge Chair**, photographed in 1958
From **Classic Herman Miller** by Leslie Piña, Schiffer Publishing Ltd., 1998

Architect, writer and designer George Nelson was one of the pioneers of postwar design in America. Made Herman Miller's first Director of Design in 1946, Nelson felt strongly that innovative design was needed to replace the impractical revival furnishings that appeared in most postwar homes. He continued the work of Gilbert Rohde, the first designer at Herman Miller to create modern objects, and enabled the company to become a forerunner in the creation and dissemination of modern industrial design. Under his leadership, Herman Miller employed forward-thinking designers whose experiments with material and form shaped what was, and still is, contemporary design.

This molded plastic chair formed part of a collection of tables and chairs called the "Swaged Leg Group." Nelson combined Charles Eames's design for shock-mounted connectors with flexible joins to make this ergonomic chair comfortable and able to flex with the sitter's movements. Typical of Nelson's work, it uses inexpensive yet innovative materials to create an object that is as beautiful as it is useful.

Ellen M. Dodington

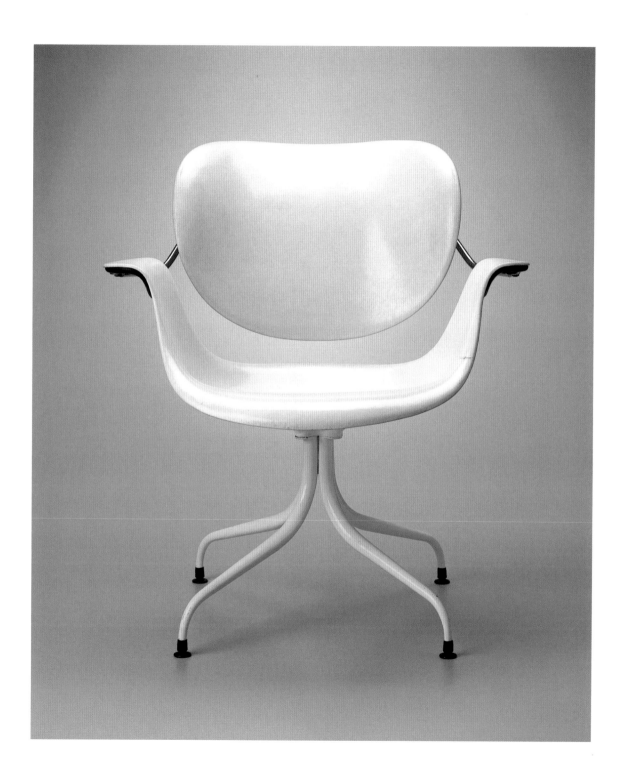

60 Eero Saarinen (Designer)
Pedestal or **Tulip Side Chair**, designed 1955-1957; made 1977, or earlier

Born 1910, Kirkkonummi, Finland; Cranbrook Academy of Art, Instructor, 1939-1941; died 1961, Bloomfield Hills, Michigan

Design Office: Eero Saarinen and Associates, Bloomfield Hills, Michigan
Manufacturer: Knoll Associates, Inc., East Greenville, Pennsylvania
Fiberglas-reinforced plastic, aluminum, upholstery
32 x 19 1/2 x 21 inches
Gift of Knoll International
ZO 1977.7

Eero Saarinen once considered pursuing a career as a sculptor. Some critics have suggested that he never strayed far from that path. Some of his most impressive buildings, such as the Ingalls Hockey Rink at Yale, the TWA Terminal in New York, Dulles Airport outside of Washington, D.C., and the St. Louis Arch, possess a decidedly sculptural form, with a free-flowing, curvilinear quality central to their design. In these and other buildings, Saarinen also showed a sculptor's concern for surface textures and treatments, selecting exterior materials that would best support the rhythm of the design and the function of the architecture.

Saarinen brought these same sensibilities to bear on his furniture designs, which he began at Cranbrook in his late teens while working on the Kingswood School project and later broadened at the Academy of Art through his experimentation, with Charles Eames, on molded plywood forms. Saarinen's pedestal furniture grouping, designed for Knoll Associates in the mid-1950s, fulfilled his quest to eradicate "the slum of legs" that had formerly cluttered the undercarriages of chairs.

Mark A. Coir

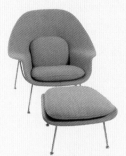

Eero Saarinen (Designer)
Womb Chair, designed 1946-1948
Tubular steel, foam over molded plywood platform, and original fabric upholstery
Gift of Glen Paulsen
(CAM 1998.12.1)

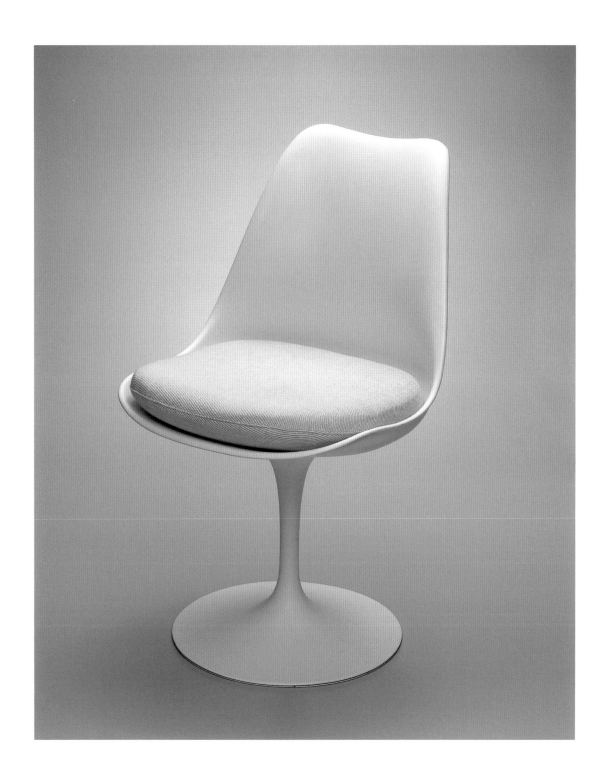

61 Eero Saarinen (Designer)
Model for Dulles International Airport Terminal Building, circa 1960

Born 1910, Kirkkonummi, Finland; Cranbrook Academy of Art, Instructor, 1939-1941; died 1961, Bloomfield Hills, Michigan

Maker: Eero Saarinen and Associates, Bloomfield Hills, Michigan, with Jim Smith
Wood, masonite, plastic, gesso and paint
18 1/2 x 144 3/4 x 46 1/2 inches
Gift of Rice University, School of Architecture
CAM 1983.15

J. Hendersen Barr
(Draftsman), born 1908
**Presentation Drawing
for Dulles International
Airport**, circa 1959-1960
Colored pencil on paper
Gift of W. Kent Cooper
(CAM 1996.6)

When Eero Saarinen designed the passenger terminal for the gateway to the nation's capital, he envisioned a building that expressed movement and the excitement of travel. Dulles International was the first commercial airport to be designed specifically for jet air travel. After completing extensive research into jet travel, Saarinen and his team developed a building that was meant to be practical, elegant and monumental. Two years after this model was constructed, the terminal opened for operation.

Angular concrete columns spaced forty feet apart on each side of the main concourse carry suspension cables that in turn support curved concrete roof panels. The columns are tapered and tipped outward to emphasize the dynamic structural system. The roof rises sixty-five feet above the passenger approach, and forty-five feet above the field. The passenger services are organized on two levels below the single roof plane. Mobile lounges carried passengers between the terminal and the jets, eliminating long walkways and the heavy cost of taxiing planes. Saarinen wrote, "I think this airport is the best thing I have done."

Craig Hoernschemeyer

SECTION V

POSTWAR EXPRESSIONS
Abstraction, Minimalism and Pop
1944-1977

The decades following World War II were marked by a rapid succession of modernist movements in art and design, with America as the geographical center of a new avant garde. The fervent gestures of Abstract Expressionists such as Bradley Walker Tomlin and Willem de Kooning exemplify an introspective tendency in painting and sculpture in the aftermath of global conflict. However, a less personal approach emerged in the 1960s, signaled by Pop artists like Andy Warhol and the Superrealist sculptor Duane Hanson who chose to comment on postwar American values by dispassionately reflecting the banal culture surrounding them.

The succeeding generation of artists eschewed both personal and cultural commentary, instead favoring an exploration of pure form. Through geometric abstraction and minimalist sculpture, 1970s artists Frank Stella and Donald Judd created work that focused on elements of color, volume, material and architectural space, a cerebral approach that achieves a nearly transcendent quality in the spare abstractions of Agnes Martin. At the other end of the painting spectrum, Bridget Riley and her Op Art colleagues experimented with the sensational optical effects aroused by illusionistic patterns. Such shocking tactics signaled a growing restlessness with traditional art forms in an era of television, fast food and space travel.

As social and economic conditions fluctuated throughout the postwar decades, Cranbrook Art Museum's collection and mission evolved apace. By the end of the 1970s, its focus shifted to the acquisition of work by Academy artists, a long-standing area of strength for the institution. However, the Museum's postwar collection was significantly enhanced in 2001 by the unprecedented gift of modern painting and sculpture from the Dr. John and Rose M. Shuey Collection. These modern masterworks allow the Museum to offer a comprehensive view of the diverse currents in international art of the late twentieth century, reaffirming George Booth's inclusive vision for The Cranbrook Collection.

Joe Houston

Bradley Walker Tomlin
Music Rack, 1944

Born 1899, Syracuse, New York; died 1953, New York, New York

Oil on canvas
42 1/8 x 24 15/16 inches
Gift of George Gough Booth and Ellen Scripps Booth through
The Cranbrook Foundation
CAM 1945.25

Bradley Walker Tomlin gained notoriety in 1951 as part of an alliance of painters who protested The Metropolitan Museum of Art's conservative exhibition program. Dubbed by *Life Magazine* as "The Irascible 18," the New York group included rising luminaries such as Willem de Kooning, Robert Motherwell and Tomlin's close friend, Jackson Pollock. The Irascibles represented a radical break with the European modernist tradition and solidified the American postwar movement of Abstract Expressionism. Tomlin's career was brief compared to most of his illustrious colleagues. Plagued by poor health, which prohibited him from active duty in the armed forces, he died of a heart attack in 1953.

Music Rack illustrates the strong influence of Cubism on Tomlin's formative work. In this visual evocation of music, a still-life disintegrates into an array of random fragments. A songbird and music staff are among the few recognizable elements that can be gleaned from the restless composition. This improvisational approach to line and shape prefigures the overall calligraphic surface that characterized Tomlin's mature paintings by the end of the decade.

Joe Houston

Robert Motherwell, 1915-1991
Black and White Striped, 1984
Collage and acrylic on canvas panel
Gift of Rose M. Shuey, from the Collection of Dr. John and Rose M. Shuey (CAM 2002.25)

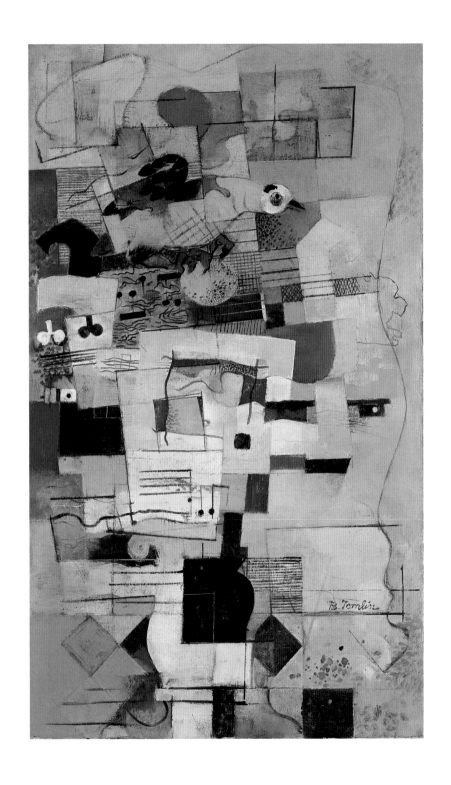

63 **Mary and Edwin Scheier**
Bowl, 1951

Mary: Born Mary Goldsmith, 1909, Salem, Virginia
Edwin: Born 1910, New York, New York

Earthenware
7 x 13 1/2 (diameter) inches
Museum Purchase with funds from The Cranbrook Foundation
CAM 1951.9

Mary and Edwin Scheier's life-long collaboration began in the 1930s when both worked for the federal Works Progress Administration. After spending a year as traveling puppeteers, they were given the opportunity to experiment with ceramics at the Tennessee Valley Authority Ceramic Laboratory and turned to pottery. Although they were largely self-taught, they were soon winning awards in national competitions.
From 1940 to 1960, they taught at the University of New Hampshire, Durham.

Mary threw their small and medium sized vessels, such as this one, which came into the Art Museum's collection from the "Third Biennial Exhibition of Ceramics and Textiles" in 1951. Its flaring shape and thin walls show her mastery of the wheel and her admiration for Japanese and Chinese ceramics traditions. Edwin was responsible for the glazing and decoration. The abstracted linear patterns he used here relate to late Surrealist and early Abstract Expressionist imagery, but also have a playful quality that reflects his whimsical sense of humor.

Susan S. Waller

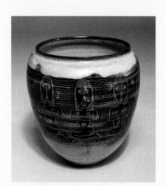

Mary and Edwin Scheier
Bowl, 1948
Stoneware
Gift of The Cranbrook
Foundation (CAM 1949.4)

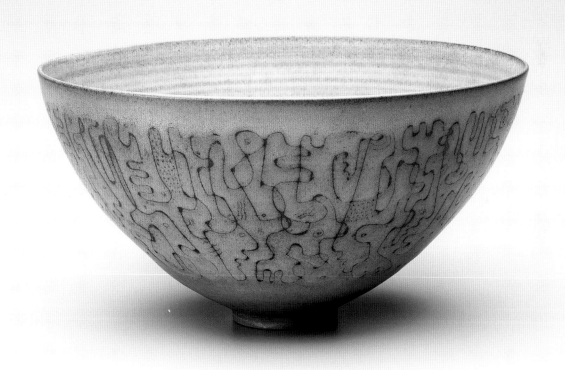

64 Peter Voulkos
Storage Jar, 1952

Born 1924, Bozeman, Montana; died 2002, Bowling Green, Ohio

Stoneware
18 1/2 x 12 1/2 (diameter) inches
Museum Purchase
CAM 1953.6

Peter Voulkos
Plate, 1973
Stoneware
Transferred from Cranbrook Academy
of Art (CAM 1980.29)

Following a period of teaching at the vanguard Black Mountain College in North Carolina in 1953, ceramist Peter Voulkos traveled to New York City where he came in contact with the leading Abstract Expressionist painters of the period. His work changed dramatically, and he is credited with revolutionizing the concept of ceramics as an art form and with encouraging the use of ceramics as a means of deep personal expression.

This jar was completed early in the artist's career when Voulkos had just finished the graduate program at California College of Arts and Crafts, where he wrote his master's thesis on lidded jars. It demonstrates his skill at expertly thrown functional objects with innovative design work, using native Montana clays, earth slips and glazes. The body of the jar is decorated with wax-inlaid line drawings, an adaptation of the wax-resist technique used in batik. His whimsical figures foreshadow the gestural expressiveness of form for which he became well known.

Voulkos was a visiting artist to the Academy's Department of Sculpture at the invitation of Michael Hall in the early 1970s.

Judy Dyki

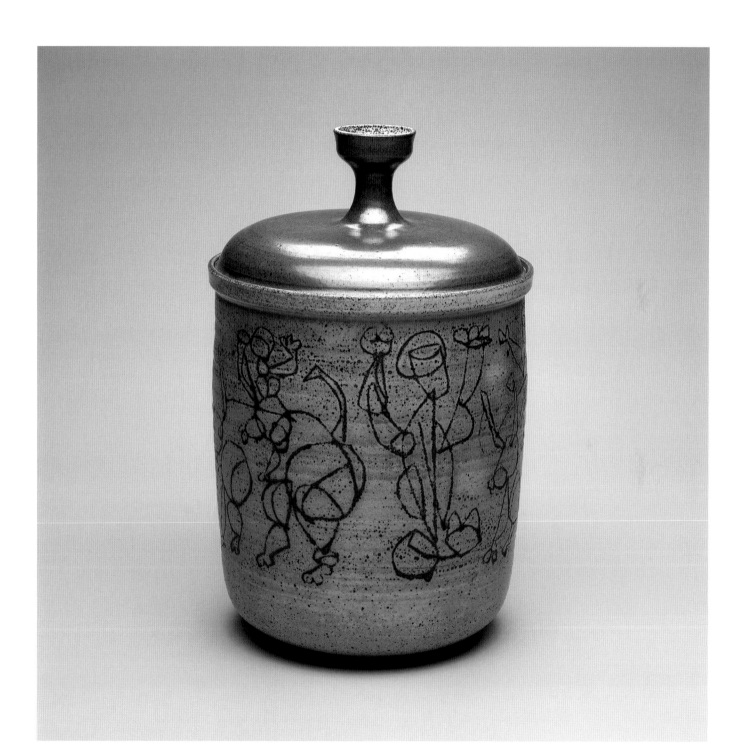

65 Lucienne Day (Designer)
Calyx (Drapery Fabric), 1951

Born 1917, Coulson, Surrey, England

Manufacturer: Heal Fabrics, Ltd., London, England
Distributor: Greeff Fabrics, Inc., New York, New York
Screen-printed linen
43 1/2 x 90 inches
Gift of Greeff Fabrics, Inc.
CAM 1953.1

British-born Lucienne Day graduated from the Royal College of Art, London, in 1940 before working as an art teacher, freelance designer and design partner with husband Robin Day. Together the Days pioneered new production techniques and design methods in postwar Britain. Although well known for her apparel and furnishing fabrics as well as her wallpaper, carpet and porcelain designs, Day's work also includes unique wall hangings.

Designed to accompany Robin's products for the "Home" section of the Festival of Britain in 1951, *Calyx* was an immediate success. It received the prestigious gold medal at the IX Milan Triennale in 1951 and was rated the best textile on the American market by the American Institute of Decorators in 1952. The printed textile, with abstracted botanical forms, embodies designers' tendencies in the 1950s to move away from the utilitarian fabrics of the war years to designs that were more decorative in nature. This trend continued throughout the following decades and still influences designers today.

Ellen M. Dodington

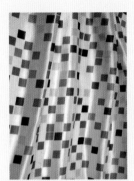

Alexander Girard (Designer),
1907-1993
Squares (Drapery Fabric), 1952
Silkscreen print on silk gauze
Museum Purchase
(CAM 1953.2)

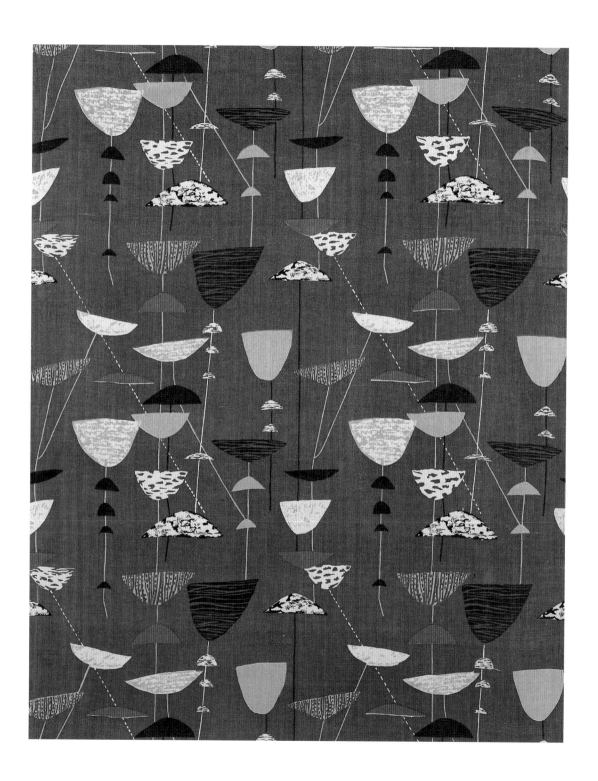

66 Anni Albers (Designer and Manufacturer)
Bedspread for Harvard Graduate Center, 1950

Born Annelise Fleischmann, 1899, Berlin, Germany; died 1994, Orange, Connecticut

Linen and cotton; plain weave
102 x 55 3/4 inches
Museum Purchase with funds from the Founders Fund
CAM 1951.7

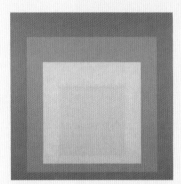

Josef Albers, 1888-1976
Homage to Square: "Festive," 1967
Oil on board
Gift of Rose M. Shuey, from the
Collection of Dr. John and Rose M.
Shuey (CAM 2002.2)

Anni Albers moved to the United States with her husband, Josef Albers, via the sponsorship of Philip Johnson, in order to escape Germany's unstable political climate in 1933. Honored with the first exhibition devoted to the work of a single textile artist at the Museum of Modern Art in New York in 1949, Albers had a profound effect on textile designers in the second half of the twentieth century. Albers's work ranged from designing textiles for mass production by companies like Knoll and Sunar to hand weaving to printmaking.

Like her husband, Albers's designs were based on geometric shapes to form patterns. She often used a variety of materials to create fabrics that were durable and beautiful to suit the needs of her clients. Albers considered texture a formal design element and altered a fabric's surface as a way to explore a design. This is evident in her fabric designed for the Harvard Graduate Center in which the visually perceptible tactile quality of the fabric lends richness and complexity to the pattern of the bedspread.

Ellen M. Dodington

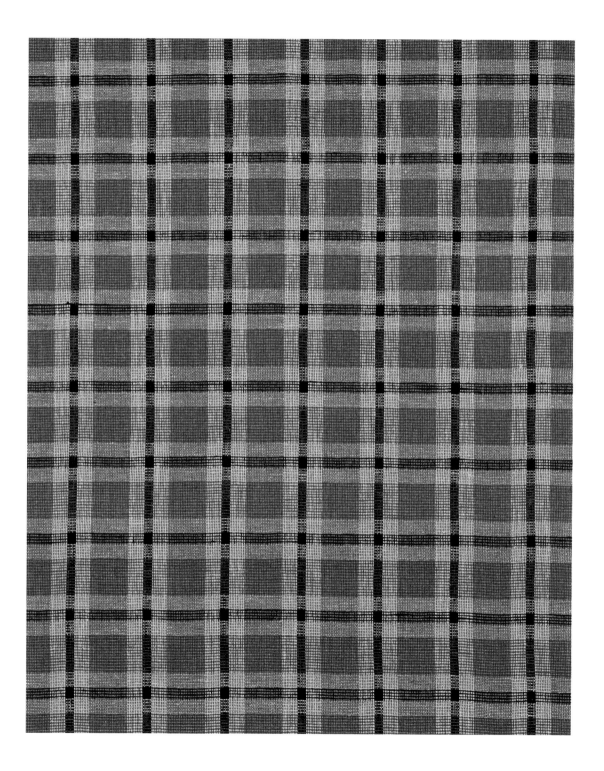

67 Wharton Esherick
Spiral Three—Step Ladder, 1966

Born 1887, Philadelphia, Pennsylvania; died 1970, Paoli, Pennsylvania

Cherry with hickory legs
48 x 16 1/2 x 17 1/2 inches
Gift of S. C. Johnson and Son, Inc.
CAM 1977.7

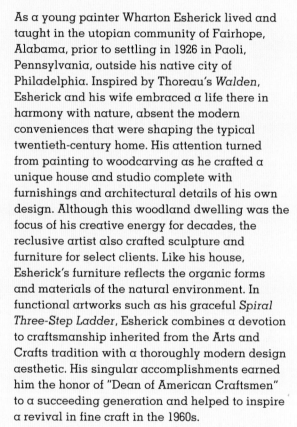

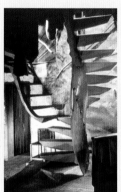

Wharton Esherick
(Architect and Designer)
Spiral Stair, 1930, in
Esherick House, Paoli,
Pennsylvania (now the
Wharton Esherick
Museum)

As a young painter Wharton Esherick lived and taught in the utopian community of Fairhope, Alabama, prior to settling in 1926 in Paoli, Pennsylvania, outside his native city of Philadelphia. Inspired by Thoreau's *Walden*, Esherick and his wife embraced a life there in harmony with nature, absent the modern conveniences that were shaping the typical twentieth-century home. His attention turned from painting to woodcarving as he crafted a unique house and studio complete with furnishings and architectural details of his own design. Although this woodland dwelling was the focus of his creative energy for decades, the reclusive artist also crafted sculpture and furniture for select clients. Like his house, Esherick's furniture reflects the organic forms and materials of the natural environment. In functional artworks such as his graceful *Spiral Three-Step Ladder*, Esherick combines a devotion to craftsmanship inherited from the Arts and Crafts tradition with a thoroughly modern design aesthetic. His singular accomplishments earned him the honor of "Dean of American Craftsmen" to a succeeding generation and helped to inspire a revival in fine craft in the 1960s.

Joe Houston

68 Gertrud and Otto Natzler
Tall Double-Curved Bottle with Lip, 1963

Gertrud: Born Gertrud Amon, 1908, Vienna, Austria; died 1971, Los Angeles, California
Otto: Born 1908, Vienna, Austria

Ceramic; blue-green and sang reduction glaze with crystals and melt fissures (molybdenum crystalline glaze)
20 1/2 x 7 1/4 (diameter) inches
Gift of Peggy deSalle in memory of Albert deSalle
CAM 1980.22

The work of Gertrud and Otto Natzler has become synonymous with complete harmony between form and glaze. After meeting in Vienna, the couple became interested in ceramics and studied together at the workshop of Franz Iskra. They established their own workshop in Vienna in 1935 and were awarded a Silver Medal at the World Exposition in Paris in 1937. Gertrud and Otto married in 1938 and moved to California, where they taught and collaborated until Gertrud's death in 1971.

With Gertrud throwing the pots and Otto formulating the glazes, their ceramic work found a complete unity of expression. This vase, with its molybdenum crystalline glaze, is a fine example of Otto's experiments with reduction firing (the extraction of oxygen from the oxides in the glaze) and the special effects he achieved with melt fissures. The beautifully proportioned shape of the vase is typical of the closed forms Gertrud preferred in her later years.

Judy Dyki

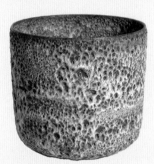

Gertrud and Otto Natzler
Vase, 1954
Ceramic with iron crater glaze
Gift of Peggy deSalle in memory of
Albert deSalle (CAM 1980.19)

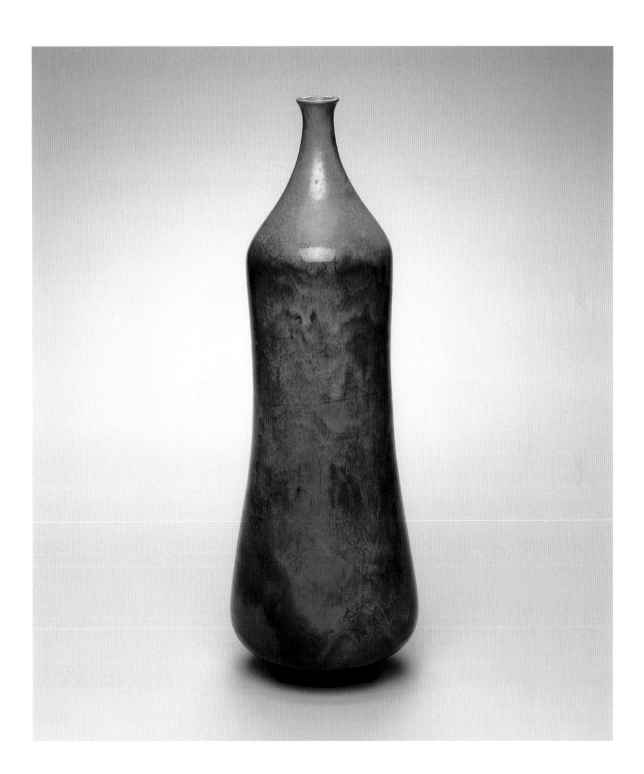

69 Willem de Kooning
Cross-Legged Figure (previously published as **Floating Figure**), 1972

Born 1904, Rotterdam, The Netherlands; died 1997, East Hampton, New York

Foundry: Modern Art Foundry, Astoria, New York
Bronze (Edition 1 of 7)
24 x 14 x 14 inches
Gift of Rose M. Shuey, from the Collection of Dr. John and Rose M. Shuey
CAM 2002.19

Willem de Kooning
Devil at the Keyboard, 1977
Lithograph (Artist's Proof)
Gift of Dr. and Mrs. Edward Alpert (ZO 1980.86)

Willem de Kooning is best known as a leading New York Abstract Expressionist painter. Trained in art and design in Rotterdam, he moved to New York in 1927. Seeking intensity, he transformed his early elegant Cubo-Surrealist canvases into the dramatic rough surfaces and vigorous shapes of his mature female figures and landscapes. One critic dubbed his brawny ladies "tipsy trollops." In Rome in 1969, he began a five-year exploration of the figure in three-dimensional bronze. Some were life-size. Many, like *Cross-Legged Figure*, are of a more intimate scale.

Created with closed eyes to intensify the "feel" of the shapes, these bronze figures seem ripped from the paintings into three-dimensional space, exchanging their ponderous painterly womanhood for a pan-human vitality. This jaunty dancing figure appears to have been fashioned in an instant, recalling Rodin's practice of squeezing coils of clay into figures as he watched models move about the studio.

Diane Kirkpatrick

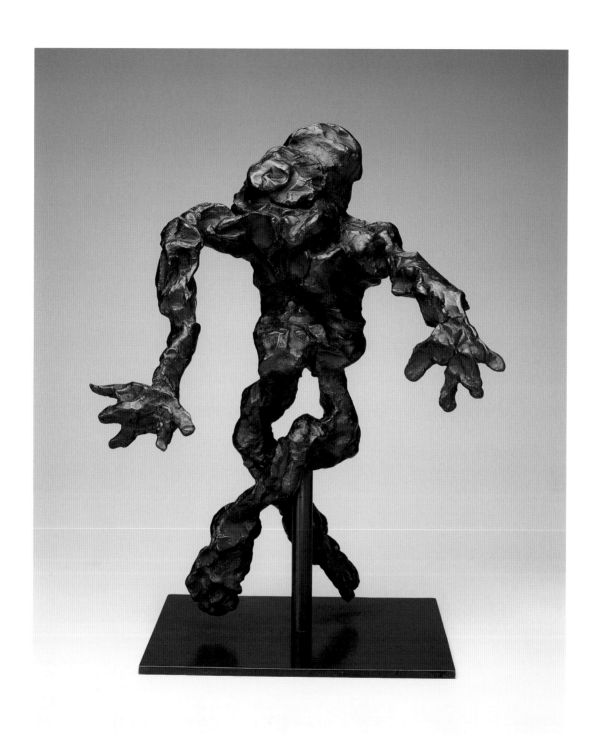

70 Joan Mitchell
Preface for Chris, 1973

Born 1926, Chicago, Illinois; died 1992, Paris, France

Oil on canvas
102 1/4 x 141 1/2 inches (overall)
Gift of Rose M. Shuey, from the Collection of Dr. John and
Rose M. Shuey
CAM 2002.23

Joan Mitchell
Sunflower 7, 1972
Color etching (Artist's Proof
from an edition of 75)
Gift of Peggy deSalle
(CAM 1984.59)

Joan Mitchell found inspiration in the surrounding world, although her preoccupation was not with the appearance of place but with her personal response to it, her feelings, thoughts and memories. In *Preface for Chris*, the original place that triggered the artist's imagination could be the lakefront in Chicago, her hometown, or her garden in Paris, the city where she spent most of her life. However, this place became completely transformed and reconfigured by the artist's broad and energetic brushwork. Large buoyant forms, punctuated by streaks of dripping paint, evolve and elapse, embroiled in a dynamic interaction with each other, like glimpses of the past or dreamlike visions. Although her painting technique evoked associations with Abstract Expressionism, Mitchell abhorred being called a "Second Generation Abstract Expressionist" or an "Abstract Impressionist." She felt equally distanced from the fascination with the subconscious typical of the originators of the style and from the existentialist searches of its younger practitioners. Mitchell maintained that her working method was informed by visual forms in nature rather than by intellectual constructs.

Elena Ivanova

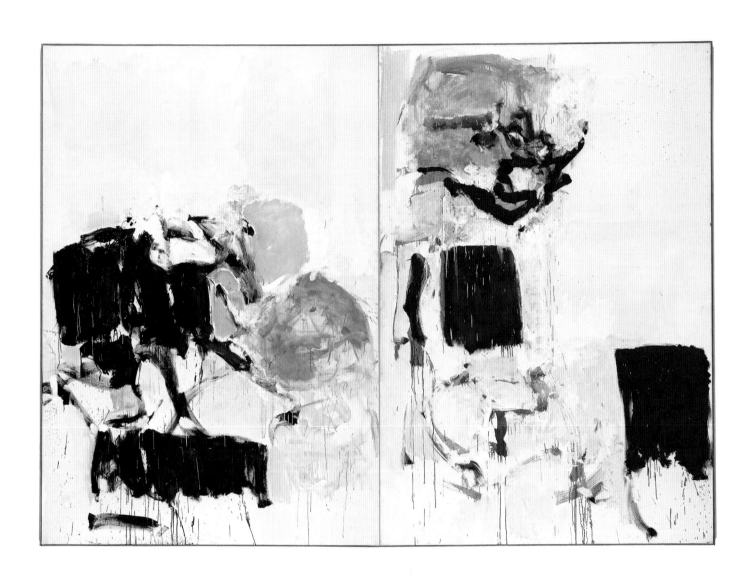

71 Frank Stella
Takht-i-Sulayman Variation I from the
Protractor Series, 1969

Born 1936, Malden, Massachusetts

Acrylic and fluorescent acrylic on canvas
120 x 240 inches
Gift of Rose M. Shuey, from the Collection of Dr. John and
Rose M. Shuey
CAM 2002.42

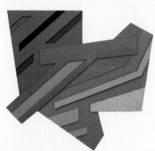

Frank Stella
Warka II, 1974
Wood, felt and canvas collage
on board
Gift of Rose M. Shuey, from the
Collection of Dr. John and Rose
M. Shuey (CAM 2002.43)

From 1967-1970, Frank Stella painted the Protractor series of more than one hundred paintings based on variations of the protractor-drawn shape. Most of the paintings are shaped canvases, one of Stella's important inventions. The artist created thirty-one canvas formats and presented each format in three variations, which he identified by the Roman numerals: I – interlaces, II – rainbows, and III – fans. In the special variation of *Takht-i-Sulayman Variation I*, protractors interlace, forming shapes like butterflies, circles and semi-circles, and fill out the canvas to produce a traditional rectangle. All colors are carefully chosen according to their saturation and value to strike a balance between the illusion of space and flatness. To achieve this effect, Stella mixed colors himself, combining acrylic and fluorescent pigments.

Almost all titles in the series are names of ancient circular cities in Asia Minor. Takht-i-Sulayman, which means "Throne of Solomon," was a medieval Islamic capital in northwestern Persia. This name evokes associations with interlacing geometric patterns and opulent colors typical of Islamic art and adds another layer of meaning to the formalist one.

Elena Ivanova

72 Roy Lichtenstein
Modular Painting with Four Panels, No. 7
from the Modern Series, 1970

Born 1923, New York, New York; died 1997, New York, New York

Oil and Magna on canvas
108 x 108 inches (overall)
Gift of Rose M. Shuey, from the Collection of Dr. John
and Rose M. Shuey
CAM 2002.21

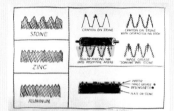

Roy Lichtenstein
Litho-litho, 1970
Lithograph (Edition: 43/54)
Gift of the J. L. Hudson Company
Gallery (CAM 1974.7)

Roy Lichtenstein began a series of paintings
called the Modern series in 1966 in which he
paraphrased art history using the language of
Pop Art. In *Modular Painting with Four Panels,
No. 7* the source of inspiration was the geometric
Art Deco style of the 1930s, such as ocean liner
lounges and theatre foyers, and the commercial
reproduction of Art Deco designs in the mass
media. Lichtenstein cleverly parodied the typical
Art Deco fascination with the world of technology
and industry by creating a pattern based on four
gigantic mechanical-looking shapes, which
employ an inexpensive product of mass culture
as their monumental subject. The high art
simulation of this strongly geometricized and
rigorously structured composition is deflated by
the use of the comic strip vocabulary—benday
dots and stenciled shapes outlined in black.
Notwithstanding its implicit humor and
playfulness, the painting makes an important
statement about the postwar explosion of
commercial imagery, which was recognized by
Pop artists as a vital force in American culture.
　　Elena Ivanova

73 Andy Warhol
Electric Chair, 1971

Born 1928, Pittsburgh, Pennsylvania; died 1987, New York, New York

Publisher: Factory Editions/Editions Bischofberger Zurich
Printer: Silkprint Kettner, Zurich, Switzerland
Screenprint (Edition: 98/250)
Image: 35 1/8 x 47 3/4 inches
Gift of Frank M. Edwards and Ann Williams
CAM 2003.11

Andy Warhol
Edson-Pelé, 1977
Acrylic and silkscreen on canvas
Gift of Rose M. Shuey, from the
Collection of Dr. John and Rose M. Shuey
(CAM 2002.46)

The quintessential Pop artist, Andy Warhol strove to make art like a machine, adopting the mass-production technique of silkscreen printing to represent the popular culture that surrounded him. His paintings and prints of supermarket goods, celebrities and other objects of conspicuous consumption vividly reflect the optimism of postwar America. While Warhol embraced modern consumer culture, his appropriations of car crashes, suicides, riots and other disasters offer a covert critique of its excesses.

Electric Chair is one of the most iconic images from Warhol's grim Death and Disaster series begun early in his career. He first used the ominous image, based on a newspaper photograph from Sing Sing prison, in 1963, the year the last executions took place in New York state. In 1971, Warhol adapted the subject to a portfolio of eight screenprints, each with a distinctly different color palette, the most somber of which was printed in subtly contrasting shades of blue and mauve. He later used the infamous chair in a poster protesting capital punishment, underscoring a moral dimension to his deadpan reproductions.

Joe Houston

Born 1931, Cincinnati, Ohio

Oil on canvas
89 3/4 x 91 3/4 inches
Gift of Rose M. Shuey, from the Collection of Dr. John
and Rose M. Shuey
CAM 2002.47

Tom Wesslemann is linked to Pop Art by his
intense scrutiny of the mythic world of American
advertising where abundant goods and beautiful
women promise eternal delight. Primed by the
study of psychology and art in his native
Cincinnati and art training in New York City,
he began as an Abstract Expressionist. Then
Madison Avenue's iconography and the graphic
intensity of Matisse inspired works like the
Great American Nude series. In each nude, a
female silhouette, with ecstatic open mouth,
poses in a life-scale interior containing actual
objects and flat painted shapes. The dialogue of
"real" and "represented" intensifies a sense of
voyeuristic invasion of intimate space.

The gaze moves in close in the Smoker series.
The sensual pleasures of smoking are condensed
to feminine hand, smoldering cigarette, gaping
mouth and curling smoke, evoking classic
tobacco ads and vintage movies where stylized
cigarette-play stoked courtship dances of male
and female stars.

Diane Kirkpatrick

James Rosenquist, born 1933
The Light That Won't Fail I, 1972
Lithograph (Edition: 13/75)
Gift of Dr. and Mrs. Edward Alpert
(ZO 1981.41)

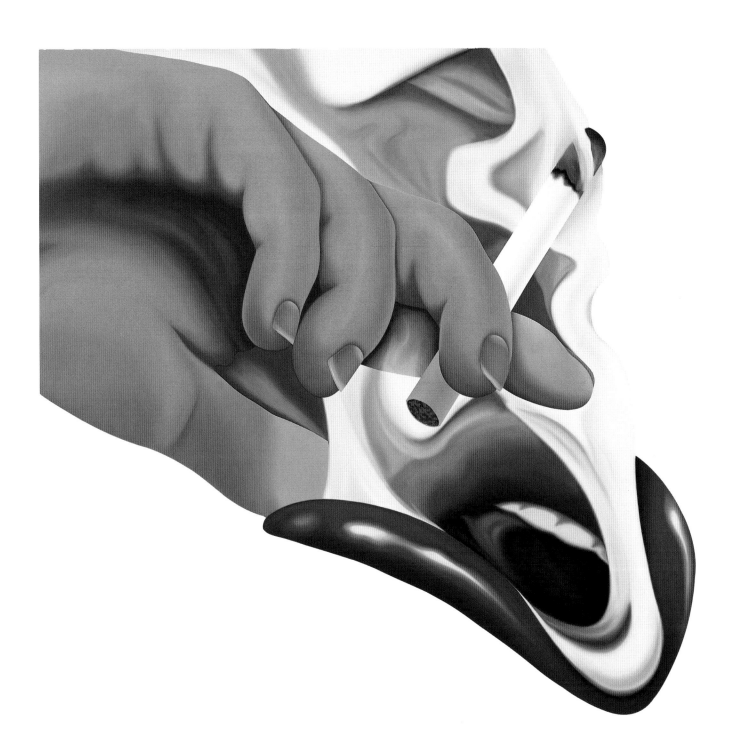

75 Harry Bertoia
Untitled (Sound Sculpture), circa 1975

Born 1915, San Lorenzo, Udine, Italy; Cranbrook Academy of Art
(CAA), Student, Silver and Metalsmithing, 1937; CAA Manager
and Instructor in the Metalcraft Shop, 1937-1943; CAA Instructor
of Graphic Art, 1942-1943; died 1978, Barto, Pennsylvania

Metal with forty-one rods
96 x 16 x 16 inches
Gift of Raymond Zimmerman, from the Collection of Raymond
and Kathleen Zimmerman
CAM 2001.13

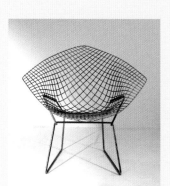

Harry Bertoia (Designer)
Diamond Chair, designed 1952
Polished steel wire
Gift of The Knoll Group (CAM 1995.19)

Harry Bertoia, renowned artist and furniture
designer, also achieved international success as
a sculptor. In 1960, he began making sculptures
that introduced movement. The sculptures
resemble reeds or other organic forms that emit
melodic sounds when affected by air currents or
in response to the human touch. The reverberations
created were similar to the layering of shapes
and colors in Bertoia's earlier monotypes
(produced while he was at Cranbrook) where he
visualized in two dimensions the production and
radiation of sound waves. Bertoia used different
metals in his sculptures to produce rich melodious
tones, favoring bronze, beryllium copper, nickel
alloys and Monel. While varying the material
and proportion, the visual effect of the sculptures
remains cohesive. In this sound piece, forty-one
metal rods with drums on their tips are attached
to a metal base. One of his taller variations,
Sound Sculpture is a commanding presence.
Bertoia intended his sound sculptures to be
played as naturalistic/ mechanical instruments,
and recorded several sound performances under
the title *Sonambient* in the 1970s.
 Sarah Schleuning

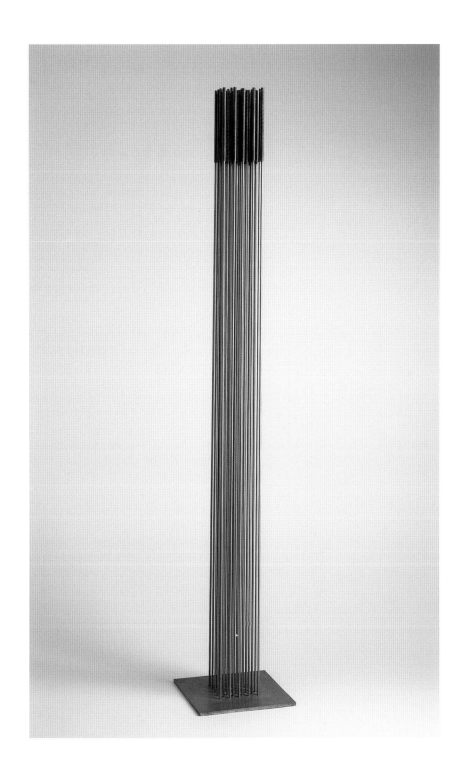

Jack Lenor Larsen and **Win Andersen** (Designers)
Magnum (Upholstery and Wallcovering Fabric),
designed 1970

Larsen: Born 1927, Seattle, Washington; Cranbrook Academy of
Art MFA, Department of Weaving, 1951
Winifred Doris Andersen: Born 1922, Fairview, Montana;
Cranbrook Academy of Art MFA, Department of Weaving, 1952

Manufacturer: Jack Lenor Larsen, New York, New York
Fabricator: Artistocrat Embroidery, Guttenberg, New Jersey
Layered mylar, cotton flannel, sheer polyester, organza and
wool, cotton and synthetic threads; machine embroidered
Hemmed: 144 1/4 x 49 inches
Museum Purchase with funds from the Wetsman Foundation
CAM 2000.5

Jack Lenor Larsen with the
Larsen Design Studio
(Designer)
Interplay (8102/00), 1960
100% Rovana, saran flat
monofilament; warp-knit
Gift of the Designer
(CAM 1987.9)

Distinguished textile designer Jack Lenor Larsen
designed *Magnum* to serve as curtain fabric for
the Phoenix Opera House before it was released
to the public as upholstery and wallcovering
fabric. Characteristic of his work, this luxurious,
futuristic textile is composed of vibrant colors,
rich textures and innovative materials such as
mirrored Mylar polyester film. Unlike most
textiles designed for production, however, this
piece requires such highly specialized and slow
methods of manufacture that it is almost as time-
consuming and costly to produce as it would be
if handmade.

Through teaching, organizing exhibitions and
writing, Larsen helped challenge other fabric
designers to find new materials and production
techniques while being true to the medium's
history. Among other accomplishments, Larsen
created the first printed velvet upholstery fabrics,
designed draperies for New York's landmark
Lever House as well as Pan Am and Braniff
airlines, and received the 1964 Milan Triennale
gold medal.

Ellen M. Dodington

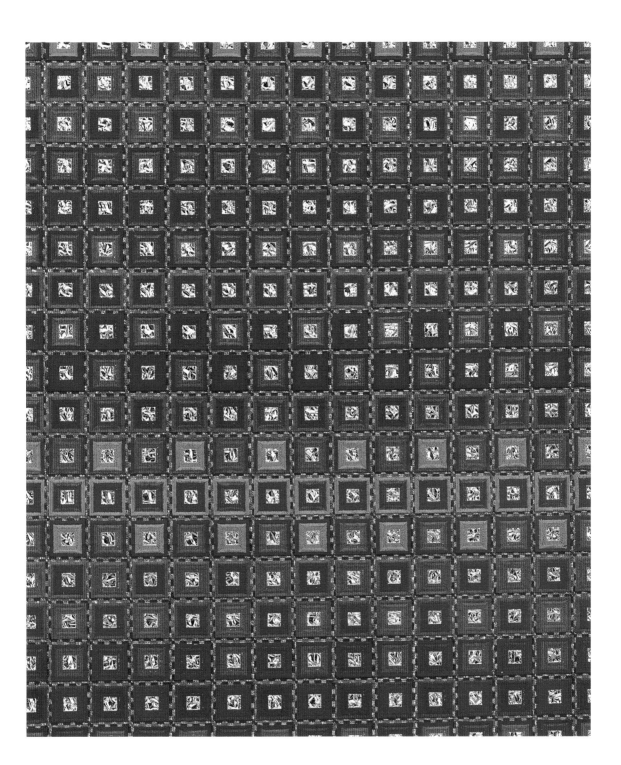

77 Bridget Riley
Shih-Li, 1975

Born 1931, London, England

Acrylic on linen
63 x 140 inches
Gift of Rose M. Shuey, from the Collection of Dr. John and
Rose M. Shuey
CAM 2002.36

Bridget Riley
Ch'i-Yün, 1974
Acrylic on linen
Gift of Rose M. Shuey, from the Collection
of Dr. John and Rose M. Shuey
(CAM 2002.35)

Bridget Riley's sensational paintings define the
unique strain of formalist abstraction dubbed Op
Art for its enhanced optical effects. Coinciding
with the psychedelic revolution of the 1960s, Op
Art demonstrated a modern scientific perspective
on human perception and psychology. Riley and
colleagues such as Victor Vasarely and Richard
Anuszkiewicz created patterns of form and color
calculated to stimulate visual response, thus
making the viewer's own physiological experience
the ultimate subject of their work.

In the vibrant *Shih-Li*, Riley weaves a
repeating pattern of undulating stripes against
an expansive white ground. Each stripe is
comprised of twisting red, green and blue bands
which yield shifting optical color mixtures as
they snake across the canvas. As a result, the
linear pattern appears to pulsate electrically over
the surface of the painting, causing disorientation
and discomfort as our eyes attempt to synthesize
its dynamic interactions. Like parallel experiments
in sound and kinetic art of the 1960s and 1970s,
Riley's delirious abstractions succeeded in
liberating art from historical stasis by awakening
the senses to new possibilities.

Joe Houston

78 Agnes Martin
Untitled, 1974

Born 1912, Maklin, Saskatchewan, Canada

Acrylic, pencil and Shiva gesso on canvas
72 x 72 inches
Gift of Rose M. Shuey, from the Collection of Dr. John and
Rose M. Shuey
CAM 2002.22

Jo Baer, born 1929
Untitled, 1968-1969
Oil on canvas
Gift of Rose M. Shuey, from the Collection
of Dr. John and Rose M. Shuey
(CAM 2002.6)

An Agnes Martin painting opens the door to stilled perception. In *Untitled* (1974), the square format denies primacy of direction. Attention is caught by the subliminal sense of a wavering grid underlying the delicate yet radiant blue and red horizontal banding. Here is "a world without objects, without interruption" (Martin, 1966). No point captures the eye's focus for long. The gaze lingers within a sense of beauty and calm and moves beyond the world of time.

Raised in western Canada, Martin studied and taught across the United States and moved to Manhattan in 1957. Early still-lifes and portraits yielded to biomorphic abstraction on the path to the spare elegance of her mature works. Critics linked these to Minimalism, though its central vision was more austere. Martin's visual journey deepened after she relocated to New Mexico in 1968. "I hope I have made it clear that the works are *about* perfection as we are aware of it in our minds," she wrote in 1972.

Diane Kirkpatrick

79 Donald Judd
Untitled, 1972

Born 1928, Excelsior Springs, Missouri; died 1994, New York,
New York

Anodized aluminum
14 1/2 x 76 1/2 x 25 1/2 inches
Gift of Rose M. Shuey, from the Collection of Dr. John
and Rose M. Shuey
CAM 2002.17

The coolly elegant sculpture of Donald Judd has
become an anchor in every significant museum
collection of contemporary art. Considered the
progenitor of Minimalist sculpture, he proposed
a new vocabulary of non-art materials and
processes that were in direct opposition to the
emotive Abstract Expressionist work that he
encountered in the 1950s. His education in art
history and philosophy helped develop his
interest in what he termed "specific objects,"
which gave rise to his systematic method of
making pure and ordered forms. By incorporating
geometric formulas to determine the physical
form and utilizing plywood, Plexiglass, cast steel
and extruded aluminum that were commercially
fabricated, Judd reinvented conventions of beauty
that were rapidly adopted by other artists.
While the stacked boxes on the wall are his most
widely recognized works, this *Untitled* piece also
incorporates Judd's signature ability to establish
negative space as a tangible presence. Like the
concept of "ma" in classical Japanese architecture
and music, "the space between" evokes the beauty
of silence and nothingness.

 Gerry Craig

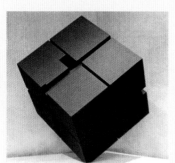

Tony Rosenthal, born 1914
Cranbrook Cube, designed 1965,
executed 1983
Painted aluminum
Gift of Mr. and Mrs. Bernard
Rosenthal (CAM 1988.62)

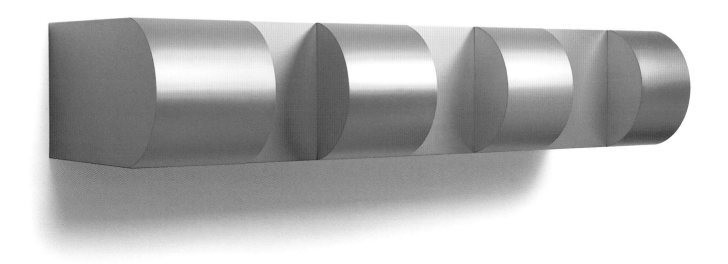

80 Robert Rauschenberg
Moon Burn (Scale Series), 1977

Born 1925, Port Arthur, Texas

Mixed media Combine
84 3/4 x 144 1/2 x 40 inches
Gift of Rose M. Shuey, from the Collection of Dr. John
and Rose M. Shuey
CAM 2002.34

Robert Rauschenberg
Breakthrough II, 1965
Lithograph (Edition: 22/34)
Cranbrook Academy of Art
Purchase, transferred to
Cranbrook Art Museum
(CAM 1972.3)

Robert Rauschenberg combines discarded objects and mass media imagery in works that blur the boundaries between art and everyday life. Beginning in the 1950s, he eschewed the introspective approach of Abstract Expressionism in favor of cultural exploration, finding the material for his art on the streets surrounding his New York studio. By juxtaposing photographs, newspaper clippings and assorted urban detritus, Rauschenberg reflected the diverse social and economic fabric of postwar America. His revolutionary Combines and photographic montages prefigured the tactics of 1960s Pop artists. Ever the innovator, Rauschenberg also helped develop new printmaking techniques and, in collaboration with composers, choreographers and scientists, pioneered seminal forms of performance, installation and electronic art.

Moon Burn is from the artist's mixed-media Scale series executed from 1977 through 1981. Incorporating found materials and photographic transfers, it summarizes the diverse processes and themes that have engaged Rauschenberg throughout his career. The random images of nature, technology, art and commerce evoke the complexity of twentieth-century experience, a condition doubly reflected in a hanging mirrored panel with a row of dangling lights emphatically illuminating its multi-layered messages.

Joe Houston

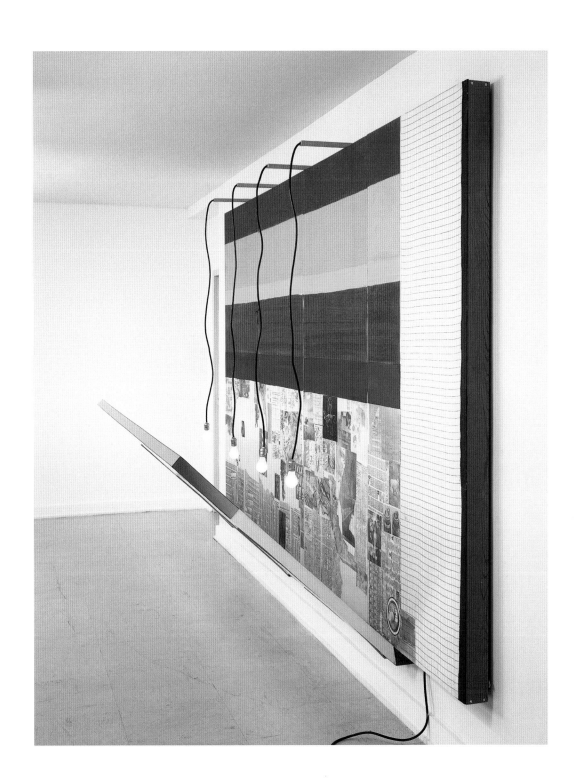

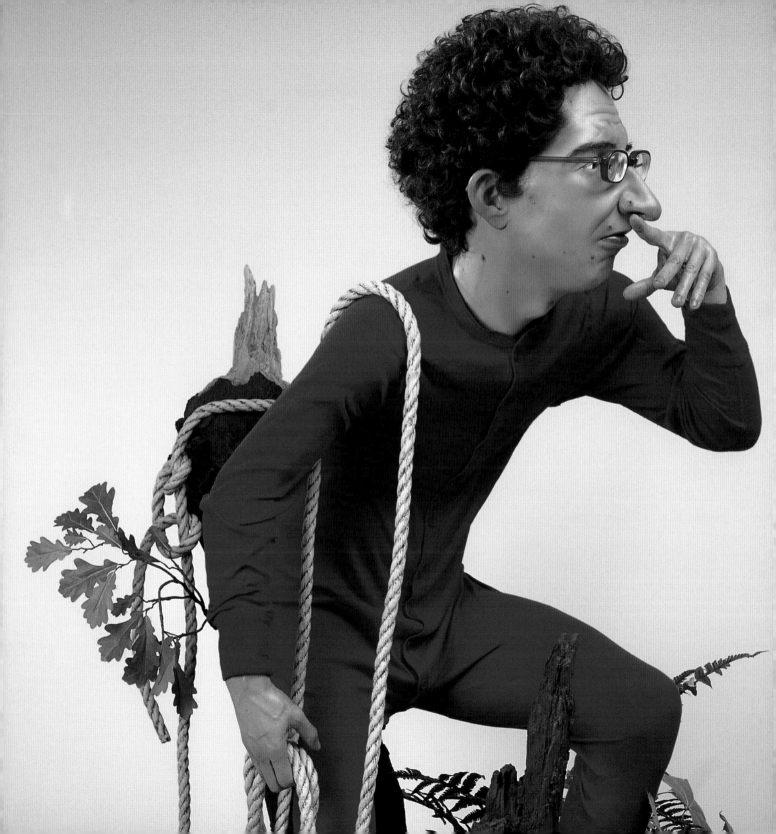

WEAVING DIVERSE TRADITIONS
Art, Craft and Design Now
1979-2003

Feminism, earthworks, performance art and electronic media contributed to a redefinition of aesthetics by the late 1970s, one that was inclusive of diverse techniques, styles and subject matter. This plurality of expression provided evidence of what philosophers like Jean-Francois Lyotard considered our burgeoning postmodern condition characterized by a crisis of faith in the established order of things. Modern cultural theories (and the language used to describe those beliefs) were suddenly cast into doubt, fomenting a reexamination of knowledge and tradition across many disciplines. In the 1980s, this prompted artists and designers to critique their own methods and freely combine art historical sources to reflect a more multicultural world view.

Architect Daniel Libeskind and designers Katherine and Michael McCoy vividly illustrate the subversive postmodern perspective through their rigorous deconstruction of the formal languages of design. They were among the recent generation of artists-in-residence at the Academy of Art that promoted a revision of conventional aesthetics and encouraged cross-disciplinary experimentation. Academy graduates Donald Lipski and Anne Wilson demonstrate this tendency through very tactile means, weaving disparate materials into evocative new objects. Technology has now provided artists with additional tools with which to reinterpret the postmodern world. Painter Amy Yoes and sculptor Tony Matelli utilize digital manipulation to generate fanciful distortions which vividly invoke a future made more malleable by technological intervention.

Cranbrook Art Museum chronicles this evolving visual practice through its exhibitions and international collection of leading-edge art, design and craft. A century after the founding of Cranbrook, the contemporary spirit of diversity is evoked in work cutting across every creative field in the community and beyond. As the centennial acquisition of metalsmith Myra Mimlitsch-Gray's melting antique candelabrum symbolizes, artists in the new millennium continue to reconstitute the past into potent new forms, crafting art that engages tradition while resisting convention.

Joe Houston

81 Chunghi Choo
Decanter, 1980

Born 1938, Inchon, Korea; Cranbrook Academy of Art, MFA,
Department of Metalsmithing, 1965

Silver-plated electroformed copper
5 7/8 x 4 7/8 x 8 1/8 inches
Gift of Dr. Charles H. Read
CAM 1982.64

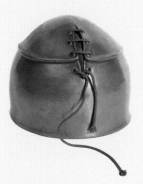

Chunghi Choo
Vessel with Laces, circa 1982
Electroformed copper
Gift of Richard Thomas (CAM 1984.9)

Chunghi Choo says of her work, "I like to see
simplicity, harmony, and grace. I would like each
piece to appear sensuous and celebratory, a
pleasure to use and a pleasure to view." In Choo's
Decanter, which references traditional tableware,
we observe such harmony through the dialogue
between surface and form. The reflective qualities
of silver paired with the graceful curves of the
decanter recall silver in its molten form and
produce a sensuous work that begs to be held.

Choo works without boundaries and explores
the medium of metal through a variety of processes.
Decanter is the result of her experiments with
electroforming, a highly technical and time-
consuming process. However difficult, the
electroforming process affords Choo limitless
possibilities and freedom in the forms her work
can take. Although a skilled metalsmith, Choo
does not limit herself to metalwork and creates
innovative objects in a wide range of media that
are technically and visually stunning.

Ellen M. Dodington

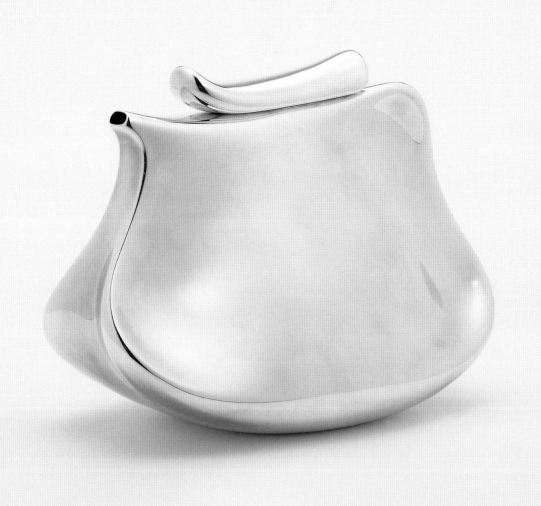

82 David Gresham and Martin Thaler (Designers)
View-Master 50th Anniversary Slide Viewer
(Prototypes and Production Model), 1986

Gresham: Born 1956, Rome, Georgia; Cranbrook Academy of
Art, MFA, Department of Design, 1986
Thaler: Born 1954, New York, New York

Design Studio: Design Logic, Chicago, Illinois
Manufacturer: View-Master Manufacturing, Inc., Portland,
Oregon, a subsidiary of View-Master Ideal Group, Inc.
Injection-molded plastic
Prototype (left): 4 1/2 x 4 7/8 x 2 1/4 inches
Production Model (center): 5 3/8 x 4 3/4 x 2 1/2 inches
Prototype (right): 5 1/4 x 4 3/4 x 2 1/2 inches
Gift of David Gresham and Martin Thaler through Design Logic
CAM 1990.80

David Gresham and Martin
Thaler (Designers)
**View-Master Talking
Projector** (Prototype), 1987
Plastic
Gift of David Gresham and
Martin Thaler through
Design Logic (CAM 1990.83)

In the 1980s, architecture and design clearly
reflected a new aesthetic that diverged from the
reductive forms of twentieth-century international
style design. Social activism and new critical
theory emerged in the 1970s, inspiring a new
generation of designers to invest their forms with
more profound meaning. The Chicago firm of
Design Logic, a partnership between David
Gresham and Martin Thaler, exemplified this
postmodern viewpoint. As their company's name
implies, they advocated a functional approach to
design, creating stylish and witty forms that
emphatically revealed or overtly symbolized the
use of a product, a strategy known as "design
semantics." Design Logic's redesign of the
universally recognized View-Master reflects the
team's rationale and daring. Commissioned for
the fiftieth anniversary of the beloved toy, their
design features a transparent plastic front that
exposes its operation to the user. This model,
which underwent several modifications in the
design process, was introduced to the public in
1986, but ceased production shortly thereafter
when View-Master Manufacturing, Incorporated
changed hands. Other View-Master products
conceived by Design Logic, including a *Talking
Projector*, were never manufactured as a result.
 Joe Houston

83 Katherine McCoy
Cranbrook Architecture 1979/80, 1979

Born 1945, Decatur, Illinois; Cranbrook Academy of Art, Artist-in-Residence and Co-Chairman, Department of Design, 1971-1995

Printer: Signet Printing, Detroit, Michigan
Offset lithograph
28 x 22 inches
Gift of Katherine and Michael McCoy
T 2002.66.10

Katherine McCoy, P. Scott Makela and Mary Lou Kroh (Designers)
Cranbrook Design: The New Discourse, book for exhibition curated by Katherine McCoy and Michael McCoy and presented at Cranbrook Art Museum, 1990

Daniel Libeskind's appointment as chair of the Academy's Architecture program in 1978 rankled many traditionalists, for, despite his academic qualifications, the young architect had never built a single building. But Libeskind's theoretical investigations into the meaning and poetics of architecture have achieved international prominence with his Jewish Museum in Berlin and his winning proposal for rebuilding Ground Zero in New York. Libeskind stressed a postmodernist perspective sensitive to the historical, cultural, linguistic and conceptual experiences that shape our daily lives. These ideas continue to inform the work of Cranbrook's Department of Architecture today.

Katherine McCoy, co-director of the Department of Design with her husband Michael McCoy from 1971 to 1995, advanced a similar postmodernist aesthetic in her typographic work, creating deliberately challenging compositions heavily layered with text and imagery. McCoy incorporated many of Libeskind's ideas in designing this 1979 promotional poster for the Architecture program. Over images of student models from Libeskind's first year at Cranbrook, McCoy configured quotations dealing with the poetics of space to imply a nine-square grid, a reference to the year's previous poster as well as the structural power of language.

Mark A. Coir

Cranbrook | Architecture 1979/80

Daniel Libeskind, Chairman
Department of Architecture
Roy Slade, President, CAA

A 2-year graduate Masters
of Architecture program,
structured on an indepen-
dent basis and directed
towards a design thesis.

This rigorous and selective
course of study, involving
creative and theoretical
work, is concerned with the
Poetics of Architecture. It is
about visible, plastic form
and the ambiguities of
invisible meaning; about
design and its history.

intended for the imaginative,
talented and committed
student, this program is
located in a unique studio
setting and in a Saarinen
landscape renowned for its
beauty and heritage.

For information write to
Admissions Office
Cranbrook Academy of Art
500 Lone Pine Road
Bloomfield Hills
Michigan 48013
313 645.3300

John Hejduk

Aldo Rossi

Raimund Abraham

Visiting Studio Masters

Robert Maxwell
University of London

Anthony Vidler
Princeton University

Alvin Boyarsky
Architectural Association

Visiting in History and Theory

Juhani Pallasmaa
Museum of Finnish
Architecture

Kenneth Frampton
Columbia University

Dalibor Vesely
Cambridge University

84 Michael McCoy (Designer)
Door Chair Prototype, 1981

Born 1944, Eaton Rapids, Michigan; Cranbrook Academy of Art,
Artist-in-Residence and Co-Chairman, Department of Design,
1971-1995

Maker: John Guse for McCoy & McCoy, Inc., Bloomfield Hills,
Michigan
Manufacturer: Arkitektura, Inc., Princeton, New Jersey
Lacquered wood with metal hardware
30 7/8 x 21 5/8 x 17 inches
Gift of the Designer
CAM 1989.42

Michael McCoy (Designer)
John Cage Listens to John Cage,
1974
Offset lithograph
Gift of Katherine and Michael McCoy
(T 2002.66.50)

Michael McCoy designed the *Door Chair* during
his tenure as Head of Cranbrook Academy of Art's
Department of Design, which he co-chaired with
his wife Katherine. In 1986 the chair based on this
prototype was produced in limited edition for
Arkitektura, marking a shift in the role of design.

The modernist dictum of "form follows
function" had been a mantra for decades, leading
to the design of slick, corporate glass-box
buildings and anonymous, beige typewriters in
the 1970s. By the 1980s young designers were
desperate for a more expansive vision of design
and McCoy's chair began a new discussion.
Its whimsical and metaphorical references
alluded both to how it works and to its context
within an architectural space. Suddenly,
designed objects could (once again) speak about
more than utilitarian "function" and shifted to
"product as text." With research into semiotics and
communication, postmodern design thinkers like
Robert Venturi, Ettore Sottsass and Michael McCoy
revitalized the design scene and inspired the next
generation of young designers to "inform" their
designs with metaphor, narrative, decoration,
fashion and imagination.

Scott Klinker

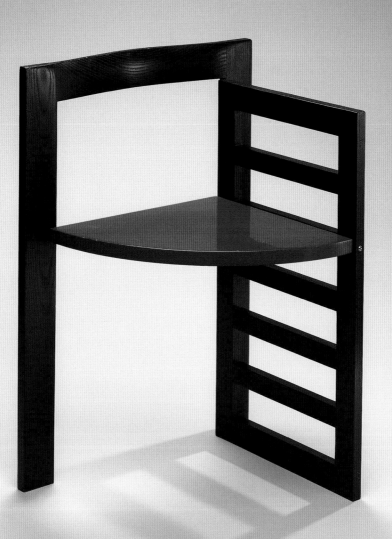

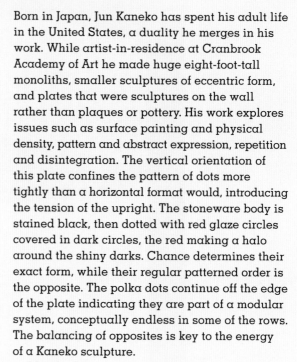

85 Jun Kaneko
Plate, 1982

Born 1942, Nagoya, Japan; Cranbrook Academy of Art, Artist-in-Residence and Head, Department of Ceramics, 1979-1986

Glazed and stained stoneware
25 1/4 x 20 1/4 x 3 1/4 inches
Gift of the Artist
CAM 1984.19

Born in Japan, Jun Kaneko has spent his adult life in the United States, a duality he merges in his work. While artist-in-residence at Cranbrook Academy of Art he made huge eight-foot-tall monoliths, smaller sculptures of eccentric form, and plates that were sculptures on the wall rather than plaques or pottery. His work explores issues such as surface painting and physical density, pattern and abstract expression, repetition and disintegration. The vertical orientation of this plate confines the pattern of dots more tightly than a horizontal format would, introducing the tension of the upright. The stoneware body is stained black, then dotted with red glaze circles covered in dark circles, the red making a halo around the shiny darks. Chance determines their exact form, while their regular patterned order is the opposite. The polka dots continue off the edge of the plate indicating they are part of a modular system, conceptually endless in some of the rows. The balancing of opposites is key to the energy of a Kaneko sculpture.
Marsha Miro

Jun Kaneko
Plate, 1984
Stoneware
Gift of the Artist (CAM 1987.52)

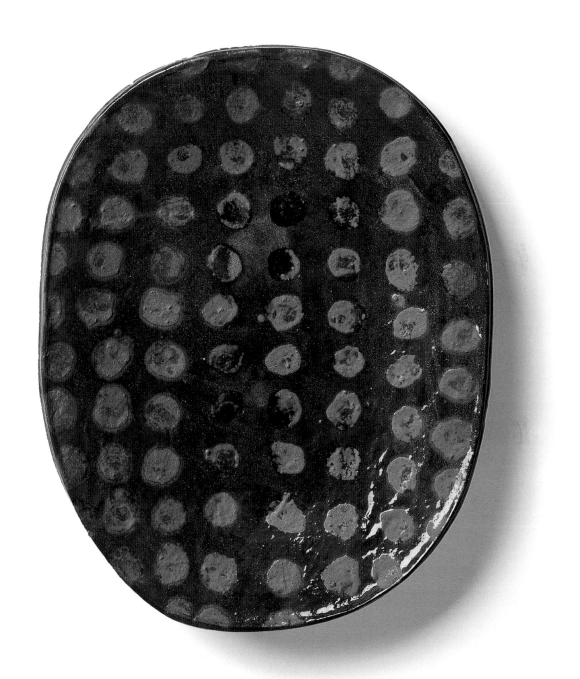

86 Richard DeVore
Vessel, 1981

Born 1933, Toledo, Ohio; Cranbrook Academy of Art (CAA), MFA,
Department of Ceramics, 1957; CAA Artist-in-Residence and Head,
Department of Ceramics, 1966-1978

Ceramic
15 x 13 x 8 5/8 inches
Gift of Kempf Hogan in honor of the Roger and Helen Kyes Family
CAM 1986.7

Richard DeVore graduated from Maija Grotell's
ceramics program at Cranbrook in 1957 only to
return in 1966 as Artist-in-Residence. Trained in
the vessel tradition as opposed to functional
pottery making, DeVore creates objects of
metamorphosis. Usually tall and enclosing, or
shallow and opening, his containers have holes,
crevices, swelling and shifting walls that recall
aspects of both the human figure and geological
formations smoothed together by hand. *Vessel* is
a classic example. While this tall form appears to
have regular sides, subtle indentations mark the
human touch and carefully incised lines near the
bottom provide sensual variety. The lip with its
cut edge rises and dips, establishing front and
back with the energy of a dancing line. Multiple
firings make the layers of golden beige tones
appear intrinsic, like those in rock or flesh,
though drips on the interior make the liquid
nature of the material visible too. Darker crackle
glaze near the top of the inside draws the eye
into the container's depths. The work's multiple
natures embody a sense of transformation.
 Marsha Miro

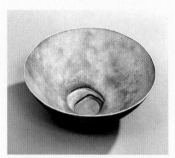

Richard DeVore
Vessel, 1977
Ceramic
Gift of the Artist (CAM 1978.11)

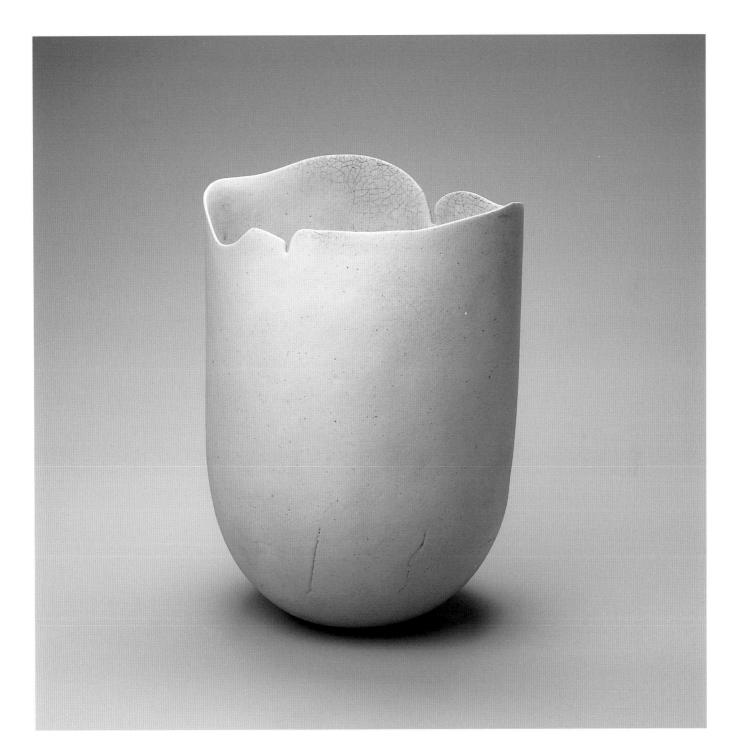

87 Donald Lipski
Building Steam No. 121, 1983

Born 1947, Chicago, Illinois; Cranbrook Academy of Art, MFA,
Department of Ceramics, 1973

Air filter, plasma bottle, metal cage, leather band and fluids
37 7/8 x 8 7/8 (diameter) inches
Museum Purchase with funds from the Awards in the Visual
Arts III Purchase Grant
CAM 1985.1

Donald Lipski's sculpture is characterized by tension between disparate materials brought together in a new context, rendering alternate meanings through the sum of the parts. His use of found objects often generates metaphysical pressure cookers, where the evolution of time is felt as a force equal to the physical presence of the objects. Like his series Gathering Time and Passing Time, the Building Steam series continues to reference the compression and expansion of what we call time. A bottle for human plasma is filled with heavy particles suspended in liquid, trapped inside the metal cage of a boat lamp cover, all literally hung below the belt. The industrial language of materials under pressure—a paper filter held in by a metal screen held tight by a belt, the liquid held in glass—suggests containment in a precarious balance. Arching off the wall, caught in a freeze frame of the intangible, the progression of time will bring about the explosion that is captured in a frame forever out of view.
 Gerry Craig

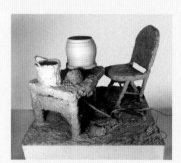

Donald Lipski
For Richard, 1973
Included in "Student Degree Show"
exhibition at Cranbrook Art Museum,
1973

88 James Surls
Long Distance, 1987

Born 1943, Terrell, Texas; Cranbrook Academy of Art, MFA,
Department of Sculpture, 1969

Carved, burnt and sealed redwood and painted steel
123 x 110 x 108 inches
Gift of James Surls with assistance from the Imerman
Acquisition Fund
CAM 1994.82

David Frej (Designer), born
1959
James Surls: Recent Works,
poster for exhibition organized
by Cranbrook Art Museum,
1987

In a large studio in his native Texas, James Surls
builds powerful, constructed forms of steel and
wood. In *Long Distance*, the hanging, swirling
sculpture references the hanging mobiles of
Calder, but only in format, not in content. The
organic gesture of the wooden leaf forms sprouting
from the steel rods disrupts the mathematical
symmetry of their structure, acknowledging both
the inspiration of nature and Native American
images. The drawn and burned eyes inside of the
spiky leaves are similar in style to Northwest
Coast native carved wooden masks and totems,
and offer a potent animism that is embraced by
traditional native cultures. There is also an
element of ecological threat in the burned wooden
leaves and their extrusion from cast metal stems.
In both the carving and the drawing, the hand of
the artist is left very present by the roughness of
surface or line. These qualities lend Surls's work
a romanticism that is not seen in many of the
modern or Minimalist sculpture in the Art
Museum's collection.
 Gerry Craig

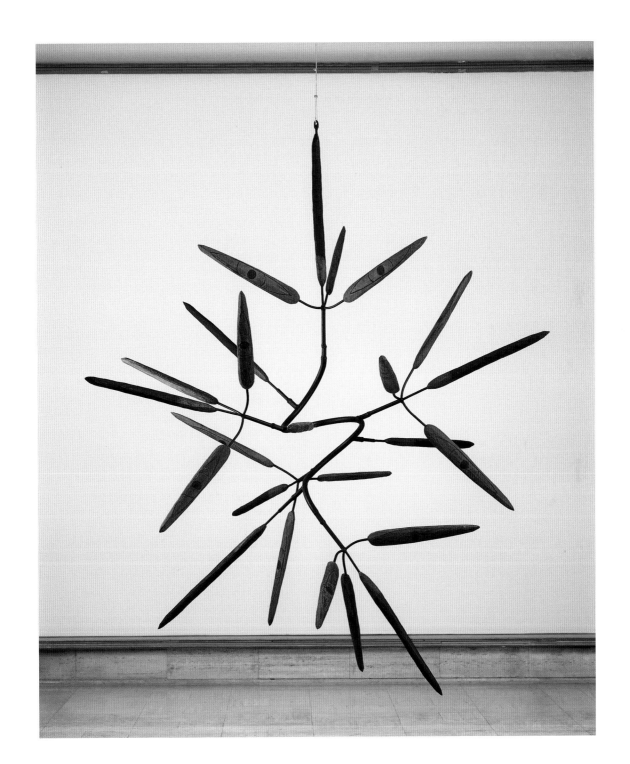

89 Duane Hanson
Bodybuilder, designed 1989, executed 1992

Born 1925, Alexandria, Minnesota; Cranbrook Academy of Art,
MFA, Department of Sculpture, 1951; died 1996, Boca Raton,
Florida

Bronze, polychromed in oil, mixed media with accessories
48 1/2 x 35 x 70 1/2 inches (Edition: 3/3)
Gift of the Artist and Lila and Gilbert Silverman with assistance
from the Imerman Acquisition Fund
CAM 1994.67

Duane Hanson
Self-Portrait with Model, 1979
Polyvinyl acetate, polychromed
in oil, mixed media
Displayed in "Sculptures by
Duane Hanson" exhibition
organized by the Edwin A. Ulrich
Museum of Art and presented at
Cranbrook Art Museum, 1990

Duane Hanson believed that art was about life
and realism best represented truth. During his
forty-five-year-long career, Hanson created
numerous highly mimetic sculptures of middle-
class Americans, using both traditional materials,
such as wood and plaster, and new industrial
materials, such as polyester resin and fiberglass.
A keen interest in everyday life links Hanson
with Pop artists, while his ability to fool the eye
is reminiscent of Photo-Realist painting. However,
Hanson's art is different from both trends in its
commitment to social and, in his earlier works,
political issues. According to Hanson, his intention
was "to confront people with themselves," not to
trick them.

Although Hanson worked with life casts of
familiar individuals, he insisted that his
sculptures were not portraits, but "types."
The model for *Bodybuilder* was a young man
whom Hanson met at a health club in Hollywood,
Florida. The basic figure was cast in bronze and
then meticulously painted to imitate the skin,
shiny with perspiration. Positioned in a natural,
relaxed pose, the figure conveys an emotional
state of self-immersion.

Elena Ivanova

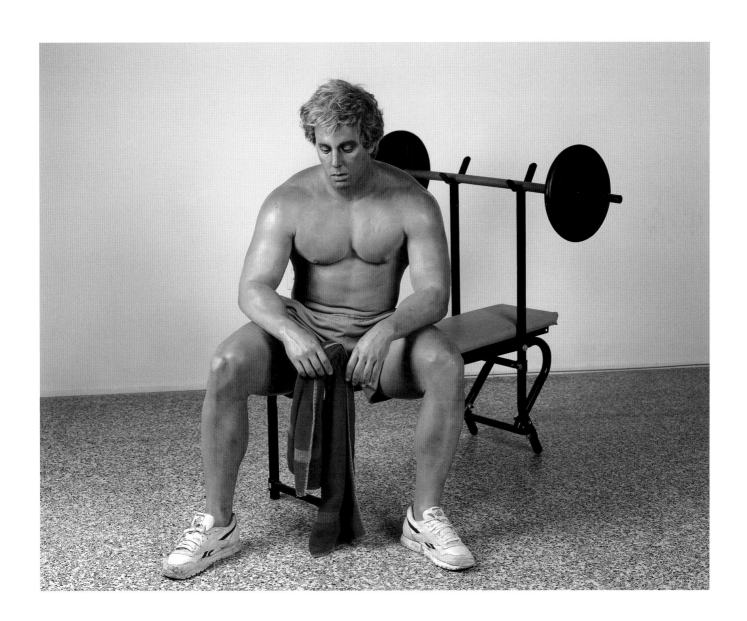

90 John Coplans
Self Portrait (Back and Hands), 1984

Born, 1920, London, England; died 2003, New York, New York

Silver gelatin print mounted on board (Edition: 6/6)
31 3/8 x 24 5/8 inches
Partial and Promised Gift of Burt Aaron
T 2003.27

Although John Coplans's work falls into the category of the male nude, it seems out of sync with the art world's youth oriented dynamic. This disconnect is in large part because Coplans began his artistic production when he was in his sixties and chose his own body as primary subject. In relation to most contemporary nudes, his work stands as a powerful address to questions of aging and death.

Utilizing studio assistants, video monitors and Polaroid tests, Coplans has produced hundreds of precisely composed images that are ultimately a testament to the infinite possibilities of a single subject. *Self Portrait (Back and Hands)* is a subtle transformation of flesh into forms and tones. In addition, however, by concentrating on that part of the body that none of us can see directly—the back—he gives his picture a psychological nuance that cuts across the grain of the familiar face-to-face experience of the self-portrait. That nuance strangely culminates when we, as viewers, relinquish his photograph to memory and turn our back to his.

Carl Toth

Philip Pearlstein, born 1924
**Female Model Reclining on Red and
Black American Bedspread**, 1976
Watercolor on paper
Gift of Rose M. Shuey, from the
Collection of Dr. John and Rose M. Shuey
(CAM 2002.32)

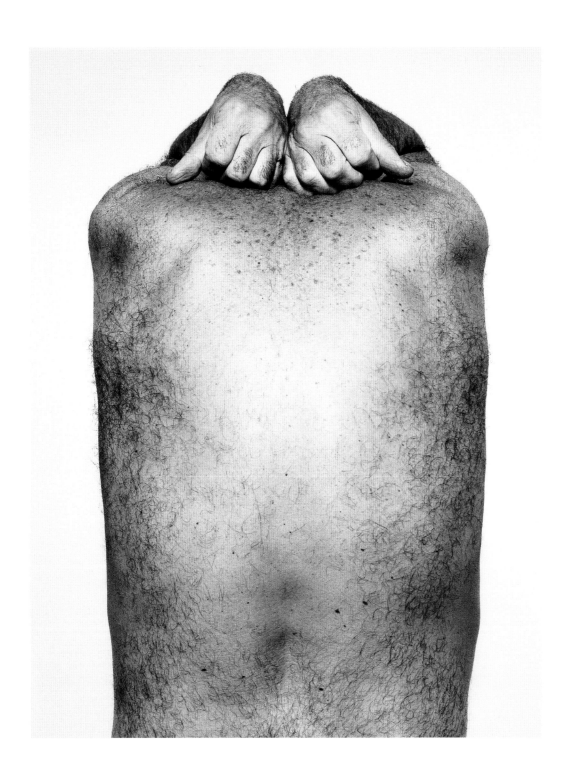

91 Anne Wilson
Bull's Roar, 1986

Born 1949, Detroit, Michigan; Cranbrook Academy of Art, BFA,
Department of Fiber, 1972

Stitched and painted synthetic felt and linen, with acrylic and
alkyd paint
75 x 71 x 5 inches
Gift of the Artist
CAM 1994.61

Anne Wilson's visceral works examine issues
related to nature, memory and the body.
Employing both organic and synthetic materials
that suggest skin or hair, her art also explores the
histories and evocative qualities of materials.
Between 1985 and 1991, Wilson created a series of
wall-hung works that were inspired by animal
skins. The monumental *Bull's Roar* is from this
seminal Hide series. Made entirely from synthetic
fibers and materials, *Bull's Roar* simulates the
natural hide of an animal with a bristly and
scarred surface marked by folds, wounds,
fissures and patches of woven fur. The trace of a
formidable animal's existence and demise is
suggested in this seemingly fragile and
distressed surface. Wilson imitates the natural
world to poignantly express nature's delicacy,
vulnerability and the passage of time.

From the bristly synthetic furs and artificial
skins of the Hide series, she turned her attention
to creating works that feature human hair and
found linens, speaking to issues of gender,
domesticity and the human body while generating
many of the same visceral qualities as *Bull's Roar*.
Irene Hofmann

Anne Wilson
Mendings, no. 2, 1995
Human hair, found linens
Collection of Cleve Carney
Included in "Art on the Edge of
Fashion" exhibition organized by
Arizona State University Art Museum
and presented at Cranbrook Art
Museum, 1998

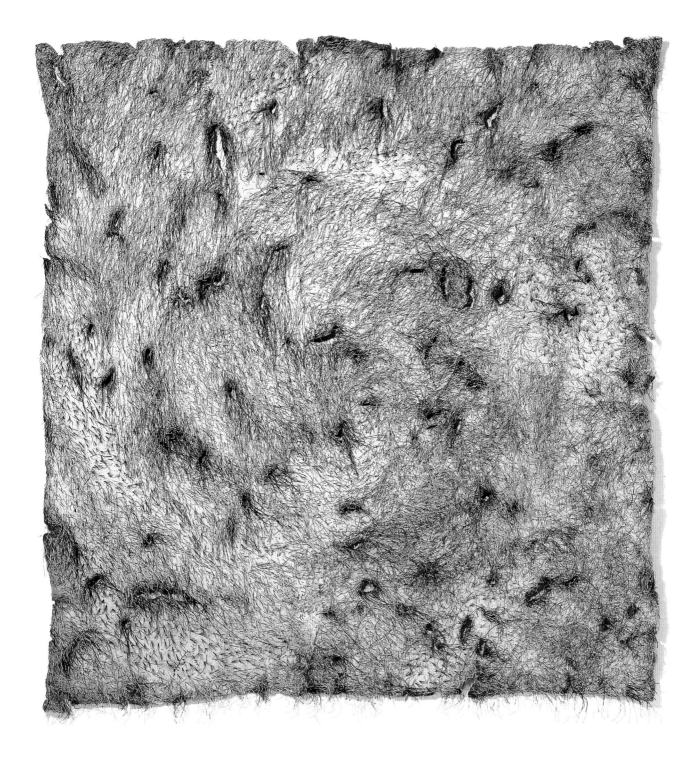

92 Graham Marks
Untitled Vessel, 1991

Born 1951, New York, New York; Cranbrook Academy of Art,
Artist-in-Residence and Head, Department of Ceramics, 1986-1992

Earthenware; coil construction and sandblasted
23 7/8 x 24 3/8 x 24 1/2 inches
Academy Purchase for Cranbrook Art Museum and
Partial Gift of the Artist to Cranbrook Academy of Art
CAM 1991.18

Graham Marks
Untitled Vessel, 1975
Earthenware; coil
construction and
sandblasted
Gift of the Artist
(CAM 1988.66)

Graham Marks's early fascination with geology
is evident in his geomorphic forms that take the
shape of mysterious pods, eggs and geodes,
all appearing to have been cracked open, as in
Untitled Vessel. His work displays his interest in
the interplay between inside and outside space,
sometimes including just a crack to provide
access to the inner sections of the forms. Marks
often used the sandblasting process to layer his
surfaces with further geological references.

As in *Untitled Vessel*, Marks's increasing
involvement with environmental issues was
reflected in his work of the early nineties—the
surfaces are darker, more agitated, often sooty,
and with natural fissures in the tops. The frequent
inclusion of scrap metal in the slip suggests
shrapnel and other pollutants. Marks wanted
his art "to reflect the brutality of what mankind
has done to nature and nature's response"
(*Detroit Free Press*, December 14, 1990). His
growing commitment to natural processes and
systems led him to the field of acupuncture when
he left his position at Cranbrook.

Judy Dyki

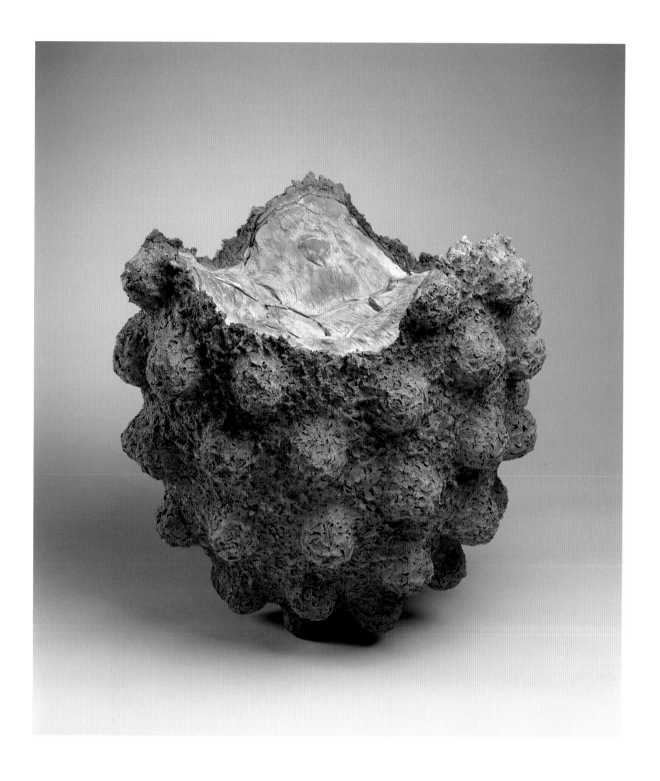

93 Barbara Cooper
Spiritus, 1990

Born 1949, Philadelphia, Pennsylvania; Cranbrook Academy of Art, MFA, Department of Fiber, 1977

Oak and Babinga woods, interlaced and glued
65 1/4 x 19 1/2 x 23 inches
Promised Gift of Drs. Joan and Bernard Chodorkoff
T 2003.24

Barbara Cooper's sculptures wed form and content in an interlocking relationship. Technically, her sculptures from 1988 through 1995 are improvisational variations on three dimensional fiber techniques such as plaiting, in which Cooper freely manipulates strips of thin wood veneer in a repetitive overlapping process of layering and gluing to achieve undulating surfaces. Employing materials left over from furniture manufacturing, Cooper recycles and transforms these scraps of wood veneer into sensuous sculptural contemplations of time, growth and renewal.

The involuted form of *Spiritus* merges a sense of protective armored strength with a mysterious inner fragility. A substantial sinewy mass of interwoven material forcefully spirals inward, enclosing and protecting a negative, shadowed recess. The dramatic play of light and shadow across the unadorned surface of wood heightens the contrast of interior and exterior, visible and hidden. Simultaneously abstract and figural, *Spiritus* hovers seductively, both revealing and obscuring the animating forces of nature, mediated here by human intervention.

Jane Lackey

Barbara Cooper
Tool #33 and Tool #32, 1986
Polychromed bronze
Gift of the Artist (CAM 1994.70 and 1994.69)

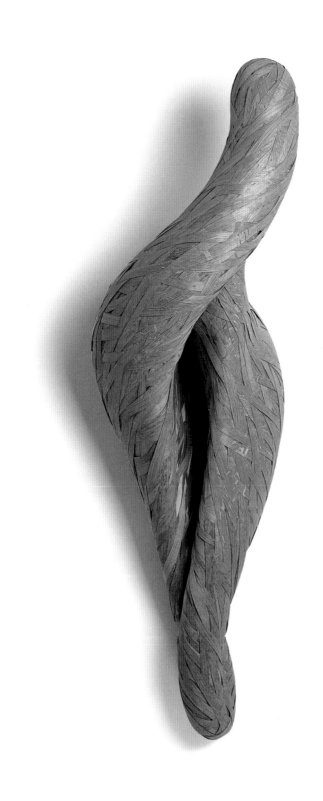

94 Ed Rossbach
Ceremonial Vessel with Shells, 1991

Born 1914, Chicago, Illinois; Cranbrook Academy of Art, MFA,
Department of Ceramics, 1947; died 2002, Berkeley, California

Plaited ash splints and string with heat transfer and color xerography
9 3/4 x 8 x 8 inches
Gift of Linda and Allan Ross and Arlene and Richard Selik
CAM 1992.5

As an artist, educator and author, Rossbach
succeeded in bringing critical attention to the
fields of basketry, found-object art making, and
non-loom weaving, making him one of the most
significant figures in the history of fiber art.
Rossbach began his career at Cranbrook, where
he studied ceramics with Maija Grotell and
weaving with Marianne Strengell, earning an
MFA in 1947.

Rossbach's study of the history and structural
composition of textiles and baskets from around
the world informed the objects he made.
Ceremonial Vessel with Shells, with its plaited
wood structure and dramatic colored xerography,
demonstrates Rossbach's interest in Japanese
and African objects and his ability to distill these
distinct cultural references into a singular and
integrated artwork. His focus on the vessel,
especially ethnographic baskets, and his creative
use of materials in the creation of art objects also
lends this piece humor and irony by creating a
vessel within a vessel, perhaps more than a
passing nod to Marcel Duchamp.

Fabio J. Fernández

Ed Rossbach
Upholstery Material, 1956
Silk; warp ikat; twill weave
Gift of the Artist (CAM 1992.13)

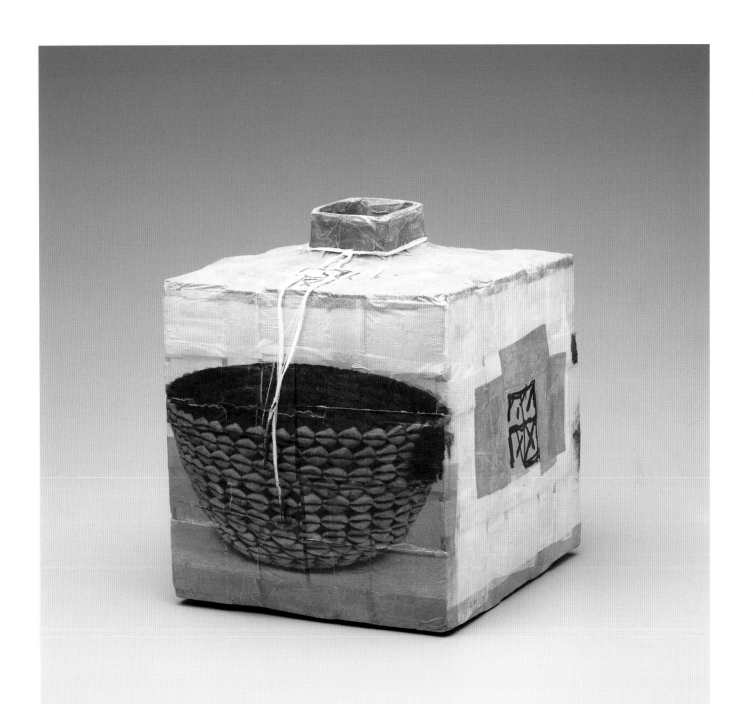

95 Daniel Libeskind
Plate I (of the Vertical Series) for the folio **Chamber Works: Architectural Meditations on Themes from Heraclitus**, 1983

Born 1946, Lodz, Poland; Cranbrook Academy of Art, Architect-in-Residence and Head, Department of Architecture, 1978-1985

Printer: Michael Thomas, Cranbrook Academy of Art
Folio Publisher: Architectural Association, London, England
Lithograph (Artist's Proof)
30 1/4 x 22 1/4 inches
Gift of the Artist
CAM 1983.34

Daniel Libeskind
Diamonds Are Forever,
1980
Collotype (Edition: 5/5)
Museum Purchase, Gift of
the Artist to Cranbrook
Academy of Art
(CAM 1981.29)

Chamber Works is one of a number of suites of drawings and prints created by Daniel Libeskind during his tenure as CAA architect-in-residence from 1978-1985. These works took the architectural community by storm in the early 1980s. In the precise and inhospitable spaces of Libeskind's drawings, many architects and critics (John Hejduk, Aldo Rossi, Hal Foster, Alvin Boyarsky, and Juhani Pallasmaa) saw the promise of a third path for architecture—an alternative to neo-avant garde modernism, with its overtones of mastery and dogma, and to the shoddy irony of postmodernism. Although Libeskind's drawings did not represent or specify constructible spaces, they were immediately understood as the sign and spirit of a possible architecture.

Libeskind's drawings were read as pure notations, resembling those of avant garde composers. Not only is the title a reference to music, but the folio of twenty-eight prints, published by the Architectural Association, was packaged like a boxed set of LPs. Libeskind's marks call to mind associations that are also painterly, historical and scientific. His melancholy drawings seem to represent the scrap heap of modern culture.

Peter Lynch

246

96 Amy Yoes
Hands Off, She's Mine, 2001

Born 1959, Heidelberg, Germany

Oil and acrylic on linen
60 3/16 x 48 1/8 inches
Gift of Stephen Earle in memory of Barbara Plamondon Earle
CAM 2003.10

Joe Houston (Author)
Christian Unverzagt and
Craig Somers (Designers)
Post-Digital Painting,
catalogue for exhibition
including Amy Yoes,
organized by Cranbrook Art
Museum, 2002

Amy Yoes conjures ebullient abstractions from the decorative details of the material world. Baroque flourishes, gingham ruffles and calligraphic embellishments tangle within the fluid, heterogeneous space of her dynamic canvases, gleefully eroding any presumed hierarchy between high and low culture. Yoes draws her multifarious imagery from art, architecture, furniture, fashion and printed ephemera of diverse historical and cultural origins. Sketched and scanned into the computer for manipulation, the morphed imagery is then recombined into skillfully painted compositions. Our perceptual logic is challenged by the centrifugal fusion of these disparate visual motifs, a product of the creative interplay between imaginative draftsmanship and digital manipulation. The resulting formal and spatial mutation vividly symbolizes our evolving post-technological condition. Far from rendering the hand painted image irrelevant in the new millennium, the computer offers artists a new perspective on a world being dramatically transformed by technology. Yoes exemplifies an emerging generation of painters who combine art historical tradition and technological innovation to create expressive new forms of visual experience.
Joe Houston

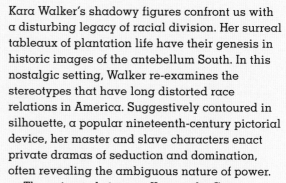

97 Kara Walker
Keys to the Coop, 1997

Born 1969, Stockton, California

Linoleum block print (Edition: 31/40)
46 1/4 x 60 1/2 inches
Gift of a Friend of Cranbrook Art Museum
CAM 1999.13

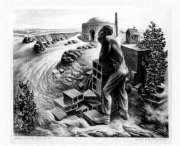

John Stockton de Martelly, 1903-1980
Looking at the Sunshine, 1938
Lithograph
Gift of The Cranbrook Foundation
(CAM 1949.16)

Kara Walker's shadowy figures confront us with
a disturbing legacy of racial division. Her surreal
tableaux of plantation life have their genesis in
historic images of the antebellum South. In this
nostalgic setting, Walker re-examines the
stereotypes that have long distorted race
relations in America. Suggestively contoured in
silhouette, a popular nineteenth-century pictorial
device, her master and slave characters enact
private dramas of seduction and domination,
often revealing the ambiguous nature of power.

The animated vignette *Keys to the Coop*
features Walker's recurrent archetype of the exotic
"pickaninny," a mischievous child with
disparagingly exaggerated features. She is
pictured in hot pursuit of a chicken, clutching its
severed head in one hand, twirling a master key
in the other. Atypically attired in a frilly dress and
high-top boots, the slave girl represents a violent
upset of the established social order, the fear of
the retribution by the oppressed. While *Keys to the
Coop* allegorizes a colonial view of the primitive,
its dark humor provokes discomfort in modern-day
viewers, throwing into stark relief our personal
prejudices and persisting cultural myths.

Joe Houston

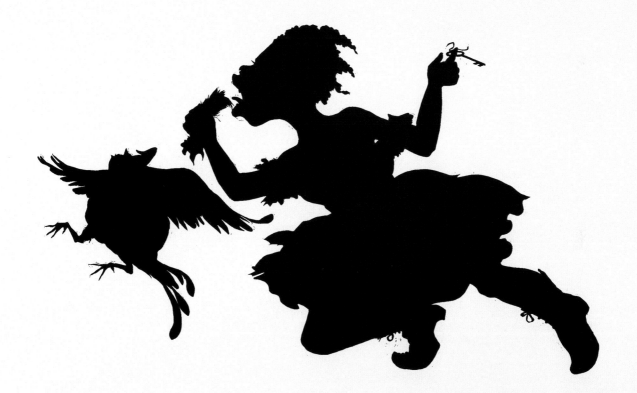

98 Tony Matelli
The Hunter, 2002

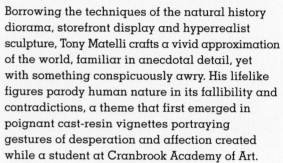

Born 1971, Chicago, Illinois; Cranbrook Academy of Art, MFA,
Department of Sculpture, 1995

Silicone, artificial hair, fabric, foam, reinforced aqua resin,
polyester, wire and oil paint (Edition: 3/3)
71 x 29 3/4 x 41 1/2 inches
Cranbrook Centennial Acquisition, Museum Purchase with funds
from George Gough Booth and Ellen Scripps Booth by exchange
CAM 2003.7

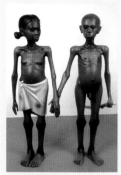

Tony Matelli
Couple, 1995
Resin and paint (Edition of 3)
Collection of Leo Koenig Inc.,
New York, New York
Included in "Student Degree
Show" exhibition at Cranbrook
Art Museum, 1995

Borrowing the techniques of the natural history
diorama, storefront display and hyperrealist
sculpture, Tony Matelli crafts a vivid approximation
of the world, familiar in anecdotal detail, yet
with something conspicuously awry. His lifelike
figures parody human nature in its fallibility and
contradictions, a theme that first emerged in
poignant cast-resin vignettes portraying
gestures of desperation and affection created
while a student at Cranbrook Academy of Art.

Matelli explores this existential frontier with
an increasingly acerbic viewpoint in *The Hunter*,
one of a trio of self-portrait caricatures from his
provocative Sexual Sunrise series. In this absurd
tableau, a man dressed flimsily in a red union
suit gazes at the horizon in awkward anticipation,
sniffing out his next conquest. With only a rope in
hand, the myopic urban nerd seems ill-equipped
to prevail in the backwoods far from the
conveniences and rule of civilization. With this
hapless swashbuckler, Matelli cleverly lampoons
his, and our, ineptness in an alienating environment,
allegorizing a very real postmodern cultural
dysfunction with his disarming sculptural
burlesque.

Joe Houston

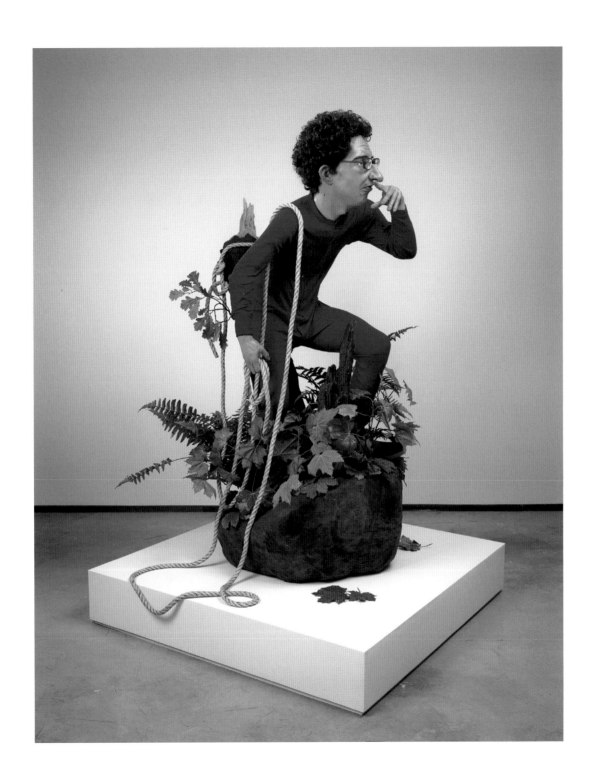

99 Myra Mimlitsch-Gray
Candelabrum, Seven Fragments, 2002-2003

Born 1962, Camden, New Jersey; Cranbrook Academy of Art,
MFA, Department of Metalsmithing, 1986

Sterling silver; hollow form and repoussé
Fragment Seven height: 6 1/4 inches
Cranbrook Centennial Acquisition, Museum Purchase with funds
from George Gough Booth and Ellen Scripps Booth by exchange
CAM 2003.6

Following a tradition of functional silversmithing, Myra Mimlitsch-Gray reflects upon traditional craft practice within a contemporary sculptural context. As a highly skilled technician and an intellectually alert artist, she challenges representations of social and cultural inheritances, domestic norms as well as art historical convention. Material and process as the basis of craft contribute to this work as traditional object; at the same time it is a bold contemporary response to traditional practice. Sterling silver has always been of intrinsic value, always a commodity. The melting forms of Mimlitsch-Gray's candelabrum not only signify and incorporate the common re-smelting of silver, but also the aesthetic demands of this contemporary practitioner, bringing the past into the present. The use of sterling silver formed through traditional technique also radicalizes her intention to confront the known, the familiar and the understood. Simultaneously amusing and sad, this candelabrum examines the expressive potential of a recognizable yet unfamiliar domestic object.

Gary S. Griffin

Johan Rohde (Designer),
1856-1935
Georg Jensen,
Copenhagen, Denmark
(Manufacturer)
Candelabrum,
circa 1926-1930
Silver
Gift of George Gough Booth
and Ellen Scripps Booth
through The Cranbrook
Foundation (CAM 1931.12)

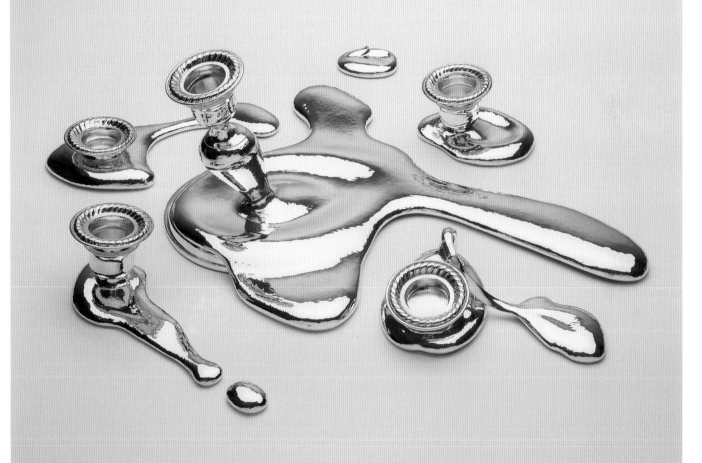

100 Moon-Joo Lee
Landscape of Residue, 2003

Born 1972, Seoul, Korea; Cranbrook Academy of Art, MFA,
Department of Painting, 2003

Acrylic and photocopy on canvas
106 x 191 3/4 inches (overall)
Museum Committee 2003 Graduate Degree Exhibition Purchase
Award through the Lila and Gilbert Silverman Acquisition Fund
CAM 2003.8

Steven Rost, born 1953
Untitled from the Urban Series, 1990
Gelatin silver print
Gift of Eric S. Silverman (CAM 1993.7)

Korean-born painter Moon-Joo Lee relocated to the
United States to study at Cranbrook Academy of
Art, where she began to document the ubiquitous
construction sites skirting Detroit and similar
cities across the country. The transitory urban
fabric became her compelling subject, emblematic
of fluctuating socio-economic conditions and a
widespread culture of uncertainty. Lee's mixed-
media painting *Landscape of Residue*
dramatically portrays the cycle of sprawl, decay
and reconstruction that perpetually transforms the
American environment. In this composite image,
a prefab housing complex sprouts in the distance
above a mountainous terrain of cast-off street
signs, tires, traffic pylons and assorted industrial
refuse. Lee implicates us in the dereliction that we
too often ignore, fixing our viewpoint from within
the valleys of debris, the instability of which is
reinforced by the fractured arrangement of
adjoining canvases. By invoking the panoramic
vistas of nineteenth-century painters such as
Frederic Church and Thomas Moran, Lee's
contemporary landscape underscores the extent
to which nature has been supplanted by a
manufactured environment, portraying rampant
cultural transformation as a modern expression
of manifest destiny.
 Joe Houston

ESSAY CONTRIBUTORS

Dora Apel

Dora Apel is W. Hawkins Ferry Chair in Modern and Contemporary Art in the Department of Art and Art History at Wayne State University in Detroit. She has been a contributing writer and editor for several exhibition catalogues published by Cranbrook Art Museum. She holds a Ph.D. in the History of Art from the University of Pittsburgh, an MA in Art History from Wayne State University in Detroit, and dual Bachelor degrees in Studio Art and Anthropology from the State University of New York in Binghamton.

Ashley Callahan

Ashley Dawn Brown Callahan is Curator of the Henry D. Green Center for the Study of the Decorative Arts at the Georgia Museum of Art in Athens. She was Collections Fellow at Cranbrook Art Museum from 1998 to 2000. She holds an MA in the History of American Decorative Arts from Parsons School of Design/The Smithsonian Associates in Washington, D.C., and a BA in Art History from The University of the South in Sewanee, Tennessee.

Mark A. Coir

Mark Coir is Director of Cranbrook Archives and Cultural Properties. Before coming to Cranbrook in 1983, he worked as a librarian at the Detroit Public Library and headed his own consulting firm. He holds a BA in Psychology and a Master of Science in Library Science from Wayne State University in Detroit.

Gerry Craig

Gerry Craig is Assistant Director for Academic Programs at Cranbrook Academy of Art. Prior to her arrival at Cranbrook in 2001, she was Curator of Fine and Performing Arts at the Detroit Zoo and Executive Director at Detroit Artists Market. She holds an MFA from Cranbrook Academy of Art and two Bachelor degrees in History of Art and Textile Design from the University of Kansas in Lawrence.

Ellen M. Dodington

Ellen Dodington is Collections Fellow at Cranbrook Art Museum. She holds an MA in the History of Decorative Arts from Parsons School of Design/Cooper-Hewitt, National Design Museum in New York, and a BA in Art History from Newcomb College, Tulane University, in New Orleans.

Judy Dyki

Judy Dyki is Library Director at Cranbrook Academy of Art. Before coming to Cranbrook in 1984, she was Instructional Services Librarian at the University of Detroit. She holds a Master of Science in Library Science and a BA in Art History, both from Wayne State University in Detroit.

Leslie S. Edwards

Leslie Edwards is the Archivist at Cranbrook Archives. Before coming to Cranbrook in 2002, she was the Administrative Director of the Oakland County Pioneer and Historical Society in Pontiac, Michigan. She holds a master's degree in Library and Information Science with a Certificate in Archival Administration from Wayne State University in Detroit, and a BA in Art Education from Michigan State University in East Lansing.

Fabio J. Fernández

Fabio Fernández is an artist and Associate Curator in charge of Cranbrook Academy of Art's Network Gallery at Cranbrook Art Museum. He holds an MFA in Sculpture from Cranbrook Academy of Art as well as an MA in Sculpture from Montclair State University in Upper Montclair, New Jersey, and a BA in Business from Seton Hall University in South Orange, New Jersey.

Gary S. Griffin

Gary Griffin is Artist-in-Residence and Head of the Department of Metalsmithing at Cranbrook Academy of Art. Prior to coming to Cranbrook

in 1984, he was Assistant Professor of Metalsmithing and Jewelry at the School for American Craftsmen, Rochester Institute of Technology, New York. He holds an MFA from Tyler School of Art, Temple University, in Philadelphia, and a BA from California State University, Long Beach.

Michael D. Hall

Michael Hall is a sculptor, educator, collector and critic. He was Artist-in-Residence and Head of the Department of Sculpture at Cranbrook Academy of Art from 1970-1990. He holds an MFA in sculpture from the University of Washington, Seattle, and a BA in Art from the University of North Carolina, Chapel Hill.

Craig Hoernschemeyer

Craig Hoernschemeyer is a Project Manager in the Capital Projects Office at Cranbrook Educational Community. He holds a Master of Architecture degree from the College of Architecture and Urban Planning at the University of Michigan in Ann Arbor, and an MFA in Sculpture from the University of Illinois, Champaign-Urbana.

Irene Hofmann

Irene Hofmann is Curator of Contemporary Art at the Orange County Museum of Art in Newport Beach, California. She was Assistant Curator and then Curator of Exhibitions at Cranbrook Art Museum from 1996 to 2001. She holds an MA in Modern Art History, Theory and Criticism from The School of the Art Institute of Chicago, and a BA in Art History from Washington University in St. Louis.

Joe Houston

Joe Houston is Curator of Exhibitions at Cranbrook Art Museum. Before coming to Cranbrook in 2002, he was the Curator for Rockford Art Museum in Rockford, Illinois. He holds an MFA in Painting and Criticism from Northwestern University in Evanston, Illinois.

258

Elena Ivanova

Elena Ivanova is Curator of Education at Cranbrook Art Museum. Before coming to Cranbrook in 2001, she worked as Assistant Curator of Education at the Contemporary Art Center in Cincinnati, Ohio. She holds a Master of Liberal Studies degree from the University of Oklahoma in Norman, and a Ph.D. in Education from the Academy of Pedagogical Sciences in St. Petersburg, Russia.

Diane Kirkpatrick

Diane Kirkpatrick is Professor Emerita of the History of Art, University of Michigan, Ann Arbor, and a member of the Museum Committee of Cranbrook Art Museum. She holds a Ph.D. in the History of Art from the University of Michigan in Ann Arbor, an MFA in Painting and Sculpture from Cranbrook Academy of Art, and a BA in History from Vassar College in Poughkeepsie, New York.

Scott Klinker

Scott Klinker is Designer-in-Residence and the Head of the Department of 3-D Design at Cranbrook Academy of Art. He holds an MFA in Design from Cranbrook Academy of Art and a BS in Industrial Design from The University of the Arts in Philadelphia.

Gerhardt Knodel

Gerhardt Knodel has been Director of Cranbrook Academy of Art since 1995 and a Vice President of Cranbrook Educational Community since 1997. From 1970-1995 he was Artist-in-Residence and Head of the Academy's Department of Fiber. He holds an MA from California State University, Long Beach, and a BA from the University of California, Los Angeles.

Mary Beth Kreiner

Mary Beth Kreiner is Librarian/Slide Curator at Cranbrook Academy of Art Library. She came to Cranbrook in 1990 to work at Cranbrook Archives, and transferred to her present position at the Library in 1992. She holds a master's degree in Library Science with a Certificate in Archival Adminstration, and an MA in Art History, both from Wayne State University in Detroit.

Jane Lackey

Jane Lackey is Artist-in-Residence and Head of the Department of Fiber at Cranbrook Academy of Art. Prior to coming to Cranbrook in 1997, she was Professor and Department Chair of the Fiber Department at Kansas City Art Institute. She received an MFA from Cranbrook Academy of Art and a BFA from California College of the Arts in Oakland.

Peter Lynch

Peter Lynch has been Architect-in-Residence and Head of the Department of Architecture at Cranbrook Academy of Art since 1996. His architecture practice, in Bloomfield Hills, previously was located in Providence, Rhode Island, and New York City. He received a Bachelor of Architecture with honors from Cooper Union in 1984.

Diane VanderBeke Mager

Diane Mager is a Museum Committee member and Saarinen House docent at Cranbrook Art Museum. She holds an MA in the History of Decorative Arts from Parsons School of Design/Cooper-Hewitt, National Design Museum in New York, and a BA in Art History from Kalamazoo College in Kalamazoo, Michigan.

Marsha Miro

Marsha Miro has been Architectural Historian at Cranbrook since 1995. Previously she was art critic at the *Detroit Free Press* from 1974 to 1995. She earned an MA in Art History from Wayne State University in Detroit, and a BA, with a minor in Art History, from the University of Michigan in Ann Arbor.

David D.J. Rau

David Rau is Director of Education and Outreach at the Florence Griswold Museum, the home of the Lyme Art Colony in Old Lyme, Connecticut. He was Assistant Curator and then Curator of Education at Cranbrook Art Museum from 1989 to 1998. He holds an MA in Art History and a Certificate in Museum Practice from the University of Michigan in Ann Arbor.

Mary Riordan

Mary Riordan was Director of the Muskegon Museum of Art in Muskegon, Michigan, from 1979 until she retired in 1984. From 1962-1979 she was Assistant to the Director, Curator of the Galleries, Curator of Collections, and Curator of Exhibitions at Cranbrook Academy of Art Museum. She received an MFA in Design from Cranbrook Academy of Art.

Sarah Schleuning

Sarah Schleuning is Assistant Curator at The Wolfsonian–Florida International University in Miami Beach. She was Collections Fellow and then Assistant Curator at Cranbrook Art Museum from 2000 to 2002. She holds an MA in the History of Decorative Arts from Parsons School of Design/Cooper-Hewitt, National Design Museum in New York, and a BA in cultural anthropology from Cornell University in Ithaca, New York.

Roy Slade

Roy Slade is Director Emeritus of Cranbrook Academy of Art and was President of the Academy and Director of Cranbrook Academy of Art Museum from 1977 through 1994. Prior to coming to Cranbrook, he was Director of the Corcoran Gallery of Art in Washington, D.C., from 1972 through 1977. Born and educated in Wales, United Kingdom, he holds degrees from the University of Wales and Cardiff College of Art.

Carl Toth

Carl Toth is Artist-in-Residence and Head of the Department of Photography at Cranbrook Academy of Art. He holds both an MFA in Photography and a BA in English from the State University of New York at Buffalo, and an Associate in Applied Science degree from the Rochester Institute of Technology in New York.

Susan S. Waller

Susan Waller is Assistant Professor of Art History at the University of Missouri-Saint Louis. She came to Cranbrook Art Museum in 1981 and was Curator of Collections from 1984 to 1986. She holds a Ph.D. in Art History from Northwestern University in Evanston, Illinois, and an MA in Art History from Boston University.

Jeffrey Welch

Jeffrey Welch is an Academic Dean at Cranbrook Kingswood Upper School and has been a member of the English Department for twenty-five years. He received a Ph.D. in English Language and Literature from the University of Michigan in Ann Arbor in 1978 and an AB *Cum Laude* from Harvard College in 1971.

Gregory Wittkopp

Gregory Wittkopp is Director of Cranbrook Art Museum. He came to Cranbrook in 1985 and was Curator of Collections and Museum Administrator when he became Director in 1994. He holds an MA in Art History from Wayne State University in Detroit, and a BS in Architecture from the College of Architecture and Urban Planning at the University of Michigan in Ann Arbor.

COPYRIGHT AND PHOTO CREDITS

Cranbrook Art Museum has made a concerted effort to contact all copyright holders for the images and objects in its collection. If a copyright holder notes that he or she has not been properly credited, please contact the Registrar at Cranbrook Art Museum. All color photography by R. H. Hensleigh and Tim Thayer, unless otherwise noted. All images from the Collection of Cranbrook Archives are © Cranbrook Archives, unless otherwise noted.

p. 3: Courtesy of Chicago Historical Society. Photograph by Ken Hedrich for Hedrich-Blessing Studio (7630-F).
p. 6: Photograph by Harvey Croze.
p. 8: Photograph by Harvey Croze.
p. 10: Courtesy of Chicago Historical Society. Photograph by Ken Hedrich for Hedrich-Blessing Studio (7630-C).
p. 13: Photograph by Max Habrecht.
p. 14: Photograph by Max Habrecht.
p. 16: Figure 4 and Figure 5, photographs by Richard G. Askew.
p. 18: Figure 7, photograph by Richard G. Askew.
p. 19: Photograph by Harvey Croze.
p. 27: © Cranbrook Art Museum
p. 28: © Cranbrook Art Museum/Balthazar Korab. Photograph by Balthazar Korab.
p. 33: Photograph by Max Habrecht.
p. 34: Photograph by Richard G. Askew.
p. 35: Photograph by Richard G. Askew.
p. 36: Photograph by Richard G. Askew.
p. 37: Photograph by Richard G. Askew.
p. 40: Photograph by Harvey Croze.
p. 41: Courtesy Florence Knoll Bassett. Photograph by Scott Hyde.
p. 42: Photograph originally published in **Illustrated Newsweek**, September 4, 1972. A copy of this photograph was inscribed by the artist to John and Rose Shuey. Photograph by Lawrence Fried.
p. 43: Photograph courtesy of James Surls. Photograph by Michele Rowe-Shields.
p. 44: Photograph courtesy of

Tony Matelli.
p. 45: Photograph courtesy of Moon-Joo Lee. Photograph by Japeth Mennes.
p. 51: Photograph by R. H. Hensleigh.
p. 54: Photograph by John Wallace Gillies.
p. 55: Photograph by R. H. Hensleigh.
p. 60: Reprinted by permission of David R. Godine, Publisher. © 1983, 1990 by Christopher Skelton. Engraving © Petra Tegetmeier, Douglas Cleverdon Estate, St Bride Printing Library.
p. 68: Photograph by Max Habrecht.
p. 70: Photograph courtesy of Clare Yellin, Samuel Yellin Metalworkers Co., Bryn Mawr, Pennsylvania.
p. 73: © 2003 Artists Rights Society (ARS), New York, New York/ADAGP, Paris, France.
p. 74: © Cranbrook Art Museum/Balthazar Korab. Photograph by Balthazar Korab.
p. 78: © Estate of Arthur Nevill Kirk.
p. 79: © Estate of Arthur Nevill Kirk.
p. 83: © Estate of Zoltan Sepeshy.
p. 84: © Detroit News, Detroit, Michigan.
p. 87: Photograph by R. H. Hensleigh.
p. 88: Photograph by Richard G. Askew.
p. 89: © The Detroit Institute of Arts, Detroit, Michigan. Photograph by Dirk Bakker.
p. 92: Courtesy Millesgården Archives, Lidingö, Sweden.
p. 95: © Cranbrook Art Museum/Balthazar Korab. Photograph by Balthazar Korab.
p. 97: © The Detroit Institute of Arts, Detroit, Michigan. Photograph by Dirk Bakker.
p. 98: Courtesy of The Metropolitan Museum of Art, New York, New York.
p. 99: © Cranbrook Art Museum/Balthazar Korab. Photograph by Balthazar Korab.
p. 103: Photographer unknown.
p. 104: Photographer by Max Habrecht.
p. 106: Photograph by Richard G. Askew.
p. 107: Photograph by R. H. Hensleigh.
p. 108: Photograph by Haanel Cassidy/House & Garden © 1947

Condé Nast Publications Inc.
p. 114: © Estate of George Grosz/Licensed by VAGA, New York, New York.
p. 115: © 2003 Artists Rights Society (ARS), New York, New York/VG Bild-Kunst, Bonn, Germany. Photograph by John Seyfried.
p. 118: © Marshall M. Fredericks Sculpture Museum, Saginaw Valley State University.
p. 119: © Marshall M. Fredericks Sculpture Museum, Saginaw Valley State University.
p. 122: © Clemente V. Orozco.
p. 123: © T. H. Benton and Rita P. Benton Testamentary Trusts/Licensed by VAGA, New York, New York.
p. 124: Photograph courtesy of Three Rivers Historical Society, Three Rivers, California.
p. 127: Photograph by R. H. Hensleigh.
p. 128: © Estate of Zoltan Sepeshy.
p. 129: © Estate of Zoltan Sepeshy.
p. 130: © Estate of Zoltan Sepeshy.
p. 131: © Estate of Zoltan Sepeshy.
p. 132: © Estate of Zoltan Sepeshy.
p. 133: © Estate of Doris Lee.
p. 135: © Estate of Jack Keijo Steele.
p. 138: © 1941, The Museum of Modern Art, New York, New York.
p. 139: © 2003 Lucia Eames dba Eames Office (www.eamesoffice.com) Santa Monica, California, and © the Estate of Eero Saarinen.
p. 140: © the Artist.
p. 141: © the Artist.
p. 142: © 2003 Estate of Harry Bertoia/Artists Rights Society (ARS), New York, New York.
p. 143: © 2003 Estate of Harry Bertoia/Artists Rights Society (ARS), New York, New York.
p. 144: Photograph by Harvey Croze.
p. 148: © Estate of Zoltan Sepeshy. Photograph by R. H. Hensleigh.
p. 149: © Estate of Zoltan Sepeshy. Photograph by R. H. Hensleigh.
p. 155: © Florence Knoll Bassett.
p. 156: © 2003 Lucia Eames dba Eames Office (www.eamesoffice.com), Santa Monica, California.
p. 157: © 2003 Lucia Eames dba Eames Office (www.eamesoffice.com), Santa Monica, California.

p. 158: © 2003 Lucia Eames dba Eames Office (www.eamesoffice.com), Santa Monica, California.
p. 159: © 2003 Lucia Eames dba Eames Office (www.eamesoffice.com), Santa Monica, California.
p. 160: Photograph courtesy of Ruth Adler Schnee.
p. 161: © Ruth Adler Schnee.
p. 164: © Estate of Wallace M. Mitchell.
p. 165: © Estate of Wallace M. Mitchell. Photograph by John Seyfried.
p. 166: © 2003 Estate of Harry Bertoia/Artists Rights Society (ARS), New York, New York.
p. 167: © 2003 Estate of Harry Bertoia/Artists Rights Society (ARS), New York, New York.
p. 168: © the Artist.
p. 169: © the Artist.
p. 170: Courtesy of Leslie Piña. Photograph by Rooks Photography.
p. 171: © Herman Miller.
p. 172: © Knoll, Inc.
p. 173: © Knoll, Inc.
p. 176: Detail of Robert Rauschenberg's **Moon Burn (Scale Series)**, 1977. © Robert Rauschenberg/Licensed by VAGA, New York, New York.
p. 178: © Dedalus Foundation, Inc./Licensed by VAGA, New York, New York. Photograph by R. H. Hensleigh.
p. 180: © the Artists.
p. 181: © the Artists.
p. 182: © Estate of Peter Voulkos.
p. 183: © Estate of Peter Voulkos.
p. 184: © Herman Miller.
p. 185: © the Artist.
p. 186: © The Josef and Anni Albers Foundation/Arists Rights Society (ARS), New York, New York. Photograph by R. H. Hensleigh.
p. 187: © 2003 The Josef and Anni Albers Foundation/ Artists Rights Society (ARS), New York, New York.
p. 188: Photograph courtesy of Wharton Esherick Museum, Paoli, Pennsylvania.
p. 189: © Estate of the Artist.
p. 190: © The Natzler Trust.
p. 191: © The Natzler Trust.
p. 192: © 2003 The Willem de Kooning Foundation/Artists Rights Society (ARS), New York, New York.
p. 193: © 2003 The Willem de Kooning Foundation/Artists Rights Society (ARS), New York, New York.

p. 194: Courtesy Cheim & Read, New York, New York.
p. 195: Courtesy Cheim & Read, New York, New York. Photograph by R. H. Hensleigh.
p. 196: © 2003 Frank Stella/Artists Rights Society (ARS), New York, New York. Photograph by R. H. Hensleigh.
p. 197: © 2003 Frank Stella/Artists Rights Society (ARS), New York, New York. Photograph by R. H. Hensleigh
p. 198: © Estate of Roy Lichtenstein.
p. 199: © Estate of Roy Lichtenstein. Photograph by R. H. Hensleigh.
p. 200: © 2003 Andy Warhol Foundation for the Visual Arts/Artists Rights Society (ARS), New York, New York. Photograph by R. H. Hensleigh.
p. 201: © 2003 Andy Warhol Foundation for the Visual Arts/Artists Rights Society (ARS), New York, New York.
p. 202: © James Rosenquist/Licensed by VAGA, New York, New York.
p. 203: © Tom Wesselmann/Licensed by VAGA, New York, New York. Photograph by R. H. Hensleigh.
p. 204: © Knoll, Inc.
p. 205: © 2003 Estate of Harry Bertoia/Artists Rights Society (ARS), New York, New York.
p. 206: © Cowtan & Tout.
p. 207: © Jack Lenor Larsen and Win Anderson.
p. 208: © the Artist. Photograph by R. H. Hensleigh.
p. 209: © the Artist. Photograph by R. H. Hensleigh
p. 210: © Jo Baer. Courtesy Rhona Hoffman Gallery, Chicago, Illinois. Photograph by R. H. Hensleigh.
p. 211: © Agnes Martin. Photograph by R. H. Hensleigh.
p. 212: © the Artist.
p. 213: Art © Donald Judd Foundation/Licensed by VAGA, New York, New York. Photograph by R. H. Hensleigh.
p. 214: © Robert Rauschenberg/Licensed by VAGA, New York, New York.
p. 215: © Robert Rauschenberg/Licensed by VAGA, New York, New York. Photograph by R. H. Hensleigh.
p. 218: © the Artist.
p. 219: © the Artist.

p. 220: © David Gresham and Martin Thaler.
p. 221: © David Gresham and Martin Thaler, 50th Anniversary View-Master 3D Viewer.
p. 222: Courtesy of Cranbrook Academy of Art and Cranbrook Art Museum. © 1990 Rizzoli International Publications, Inc.
p. 223: © Katherine McCoy.
p. 224: © Michael McCoy.
p. 225: © Michael McCoy.
p. 226: © the Artist.
p. 227: © the Artist.
p. 228: © the Artist.
p. 229: © the Artist.
p. 230: Photograph courtesy of the Artist.
p. 231: Courtesy of the Artist and Galerie Lelong, New York, New York.
p. 232: © 1987 Cranbrook Art Museum, Bloomfield Hills, Michigan.
p. 233: © the Artist.
p. 234: Art © Estate of Duane Hanson/Licensed by VAGA, New York, New York.
p. 235: Art © Estate of Duane Hanson/Licensed by VAGA, New York, New York. Photograph by Robert Nelson.
p. 236: © Philip Pearlstein. Courtesy Robert Miller Gallery, New York, New York. Photograph by R. H. Hensleigh.
p. 237: © Estate of John Coplans. Courtesy Andrea Rosen Gallery, New York, New York. Photograph by Editha Mesina.
p. 238: © the Artist.
p. 239: © the Artist.
p. 240: © Graham Marks.
p. 241: © Graham Marks. Photograph by R. H. Hensleigh.
p. 242: © the Artist.
p. 243: © the Artist.
p. 244: © Estate of Ed Rossbach.
p. 245: © Estate of Ed Rossbach.
p. 246: © Daniel Libeskind.
p. 247: © Daniel Libeskind.
p. 248: © 2002 Cranbrook Art Museum, Bloomfield Hills, Michigan.
p. 249: © the Artist.
p. 251: © Kara Walker.
p. 252: © 2003 Tony Matelli. Courtesy of Leo Koenig Inc., New York, New York.
p. 253: © 2003 Tony Matelli.
p. 254: Courtesy Georg Jensen Museum, Copenhagen, Denmark.
p. 255: © the Artist.
p. 256: © the Artist.
p. 257: © the Artist. Photograph by Tim Thayer.

ESSAY ENDNOTES

(for pages 10-28)

1. Letter from Esther S. Sperry to Henry S. Booth, April 10, 1948, Cranbrook Academy of Art (hereafter abbreviated CAA), Personnel Files, Esther Sperry Folder.

2. I am indebted to Mark Coir, Director of Cranbrook Archives, for generously sharing with me many of the resources that shaped this essay.

3. Arthur Pound, **The Only Thing Worth Finding: The Life and Legacies of George Gough Booth** (Detroit: Wayne State University Press, 1964), pp. 209-226.

4. This history of the Craft Studios is based on the collaborative research done by the author and David Rau for the exhibition "A Glorious Finale: The Arts & Crafts Movement at Cranbrook," June 17-November 1, 1992, Cranbrook Art Museum (hereafter abbreviated CAM).

5. Florence Davies, "St. Martin Smiles," **Detroit News**, no date (winter 1930), Cranbrook Academy of Art Library (hereafter abbreviated CAA Library), CAM Clippings.

6. "Decorative Arts at Cranbrook Museum," **Detroit News**, May 7, 1930, CAA Library, CAM Clippings.

7. "Cranbrook Museum Exhibits Illustrate Art In Nature," **Eccentric**, April 17, 1930, CAA Library, CAM Clippings.

8. A newspaper article noted, "Mr. Macomber will conduct parties through the rooms on appointment." "A Wealth of Beauty is Stored in Cranbrook Museum of Art," **Eccentric**, April 17, 1930, CAA Library, CAM Clippings.

9. Steven Conn, **Museums and American Intellectual Life, 1876-1926** (Chicago: University of Chicago Press, 1998), pp. 192-232.

10. Michael Steven Shapiro, ed., with Louis Ward Kemp, **The Museum: A Reference Guide** (New York: Greenwood Press, 1990), p. 41.

11. See both Pound, **Only Thing Worth Finding**, p. 139, and Jeffrey Abt, **A Museum on the Verge: A Socioeconomic History of the Detroit Institute of Arts, 1882 to 2000** (Detroit: Wayne State University Press, 2001), pp. 51-79.

12. Pound, **Only Thing Worth Finding**, Appendix II, pp. 476-477.

13. "The George G. Booth Collection," in **Bulletin of the Detroit Institute of Arts**, no date, p. 34, saved in "Society of Arts and Crafts [Scrapbook] Nov. 1918-June, 1923," Archives of American Art, Detroit Society of Arts and Crafts Records (hereafter abbreviated AAA, DSACR).

14. Pound, **Only Thing Worth Finding**, Appendix II, pp. 480-481.

15. "The George G. Booth Collection," in **Bulletin of the Detroit Institute of Arts**, no date, pp. 34-35, saved in "Society of Arts and Crafts [Scrapbook] Nov. 1918-June, 1923," AAA, DSACR.

16. Undocumented newspaper clipping, "New Plan at Art Museum," circa 1919, saved in "Society of Arts and Crafts Scrapbook, 1915-1918," AAA, DSACR.

17. Undocumented newspaper clipping, "Fine Bronzes in Booth Gift," circa 1919, saved in "Society of Arts and Crafts [Scrapbook] Nov. 1918-June, 1923," AAA, DSACR.

18. Pound, **Only Thing Worth Finding**, p. 400.

19. Letter from George G. Booth to William R. Valentiner, May 2, 1930, Cranbrook Archives, George Gough Booth Papers (1981-1), box 12, folder 16.

20. Letter from William R. Valentiner to George G. Booth, May 6, 1930, Cranbrook Archives, George Gough Booth Papers (1981-1), box 12, folder 16.

21. Noted in "Excerpt from the Proceedings of the Common Council, December 12, 1944," reporting on "Arts Commission, December 6, 1944," The Detroit Institute of Arts, Registrar's Files.

22. Cranbrook Archives, Cranbrook Academy of Art Records (hereafter abbreviated CAAR) (1998-5), CAA Announcements.

23. Letters from Richard Raseman to George Booth and the Trustees of The Cranbrook Foundation serving as the Annual Reports of Cranbrook Academy of Art, Cranbrook Archives, The Cranbrook Foundation Records (hereafter abbreviated CFR) (1981-5), CAA Annual Reports.

24. By June 1936 Richard Raseman had decided to use Academy scholarship students as Museum attendants allowing him to announce to The Cranbrook Foundation trustees in his Annual Report (June 8, 1936) that Museum salaries could be completely eliminated from the following year's budget. Cranbrook Archives, CFR (1981-5), CAA Annual Reports.

25. Semi-annual report from Richard Raseman to the Foundation trustees, January 23, 1940, Cranbrook Archives, CFR (1981-5), CAA Annual Reports.

26. "Cranbrook-Life Exhibit Planned for Two Weeks," **Detroit News**, April 6, 1940, CAA Library, CAM Clippings.

27. Florence Davies, "'Cranbrook-Life Show," **Detroit News**, May 12, 1940, CAA Library, CAM Clippings.

28. Florence Davies, "A New Museum," **Detroit News**, Sunday, June 9, 1940, CAA Library, CAM Clippings.

29. Ibid.

30. Cranbrook Archives, CAAR (1998-5), Trustees' Records, vol. 1, pp. 157-159.

31. CAA, Personnel Files, Richard S. Davis Folder.

32. Minutes of the Meetings of the Board of Trustees, June 7 and October 25, 1945, Cranbrook Archives, CAAR (1998-5), Trustees' Records, vol. 1, pp. 122-124 and 132.

33. Minutes of the Meetings of the Board of Trustees, January 7, 1947, and January 26, 1950, Cranbrook Archives, CAAR (1998-5), Trustees' Records, vol. 1, pp. 174 and 239-243.

34. Letter from Esther Sperry to Eugene Kingman, August 2, 1948, CAM Archives, Loan Files, Joslyn Memorial Art Museum Folder.

35. Memo from Esther Sperry to the Trustees of Cranbrook Academy of Art, October 1948, CAA, Personnel Files, Esther Sperry Folder.

36. "Report of the Curator to the Trustees for the Year Ending June 30, 1950," Cranbrook Archives, CAAR (1998-5), Museum Committee Folder.

37. Minutes of the Meeting of the Museum Committee, April 18, 1950, Cranbrook Archives, CAAR (1998-5), Museum Committee Folder.

38. "Report of the Curator to the Trustees for the Year Ending June 30, 1952," Cranbrook Archives, CAAR (1998-5), Museum Committee Folder.

39. Memo from Eva I. Gatling to Henry S. Booth, January 13, 1953, Cranbrook Archives, Henry Scripps Booth and Carolyn Farr Booth Papers (hereafter abbreviated HSBandCFBP) (1982-5), box 33, folder 16.

40. Letter from Warren S. Booth to Michael A. Gorman, November 13, 1953, Cranbrook Archives, HSBandCFBP (1982-5), box 33, folder 13.

41. "Report of the Curator to the Trustees for the Year Ending June 30, 1950," Cranbrook Archives, CAAR (1998-5), Museum Committee Folder.

42. CAM Archives, Policy—Museum Folder.

43. Cranbrook Archives, HSBandCFBP (1982-5), box 33, folder 16.

44. Memorandum of conference of Henry S. Booth and Lee A. White with Eva Gatling, June 29, 1954, Cranbrook Archives, HSBandCFBP (1982-5), box 33, folder 14.

45. Minutes of the Meeting of the Board of Trustees, October 28, 1954, Cranbrook Archives, CAAR (1998-5), Trustees' Records, vol. 2, pp. 77-78.

46. Final Report of the Curator to the Museum Committee, December 31, 1954, Cranbrook Archives, CAAR (1998-5), Museum Committee Folder.

47. **The Museum News**, January 15, 1955, Cranbrook Archives, Public Relations Office Clippings Scrapbook.

48. Letter from Henry S. Booth to Edgar P. Richardson, December 7, 1954, CAA, Personnel Files, Eva Gatling Folder.

49. This was amended in 1964 to read: "The Chairman shall be appointed by the Board of Trustees." Minutes of the Meeting of the Board of Trustees, January 23, 1964, Cranbrook Archives, CAAR (1998-5), Trustees' Records, vol. 2, p. 293.

50. Minutes of the Meeting of the Board of Trustees, November 18, 1971, and April 2, 1970, Cranbrook Archives, CAAR (1998-5), Trustees' Records, vol. 3, pp. 310-315 and 155.

51. Minutes of the Meeting of the Board of Trustees, September 24, 1970, Cranbrook Archives, CAAR (1998-5), Trustees' Records, vol. 3, p. 228.

52. Letter from Ernest A. Jones to Henry S. Booth, December 7, 1971, Cranbrook Archives, HSBandCFBP (1982-5), box 33, folder 11.

53. Letter from Henry S. Booth to Ernest A. Jones, December 2, 1971, Cranbrook Archives, HSBandCFBP (1982-5), box 33, folder 11.

54. Minutes of the Meeting of the Board of Trustees, November 18, 1971, Cranbrook Archives, CAAR (1998-5), Trustees' Records, vol. 3, p. 311.

55. Letter from Henry S. Booth to Ernest A. Jones, December 28, 1971, Cranbrook Archives, HSBandCFBP (1982-5), box 33, folder 11.

56. The net profit from the auctions was $2,741,355. Cranbrook Archives, CAAR (1998-5), Trustees' Records, vol. 3, p. 373.

57. The American Association of Museums' guidelines governing deaccessions that limit the use of the proceeds of sales to the "acquisition or direct care of collections" were not codified until the publication of AAM's 1993 **Code of Ethics for Museums**.

58. The Art Museum has been accredited three times by the American Association of Museums: 1977, 1986 and 2000.

59. CAM Archives, Galleries—Museum Accreditation Folder.

60. Abt, **Museum on the Verge**, pp. 153-201.

61. Cranbrook Archives, CAAR (1998-5), Trustees' Records, vol. 3, pp. 227, 241.

62. Christ Church Cranbrook, the sixth of the original Cranbrook institutions established by the Booths, became a separate not-for-profit organization in 1973. Cranbrook no longer has any formal religious affiliation.

63. Minutes of the Meeting of the Board of Trustees, November 30, 1972, Cranbrook Archives, CAAR (1998-5), Trustees' Records, vol. 3, p. 367.

64. Address to the Cranbrook Academy of Art Board of Governors, April 1977, Cranbrook Archives, CAAR (1998-5).

EXHIBITION AND CATALOGUE SPONSORS

CRANBROOK ART MUSEUM: 100 TREASURES

IS PRESENTED BY

ADDITIONAL SPONSORSHIPS PROVIDED BY

Artpack Services Inc. & A.I.R.
Herman Miller
The Locniskar Group

CRANBROOK ART MUSEUM: 100 TREASURES also is generously
supported by the Museum Committee of Cranbrook Art Museum
with individual sponsorships provided by

Adele and Michael Acheson
Maggie and Robert Allesee
Jonathan and Sheri Boos
Joanne Danto
Keenie and Geoffrey Fieger
David Klein and Kathryn Ostrove
Gilbert and Lila Silverman
Pamela Applebaum Wyett

Cranbrook Art Museum is equally indebted to the artists and patrons
that originally donated most of these 100 TREASURES and those that
donated the other nearly 4,500 objects in the collection, beginning with
George Gough Booth and Ellen Scripps Booth.